Dracula

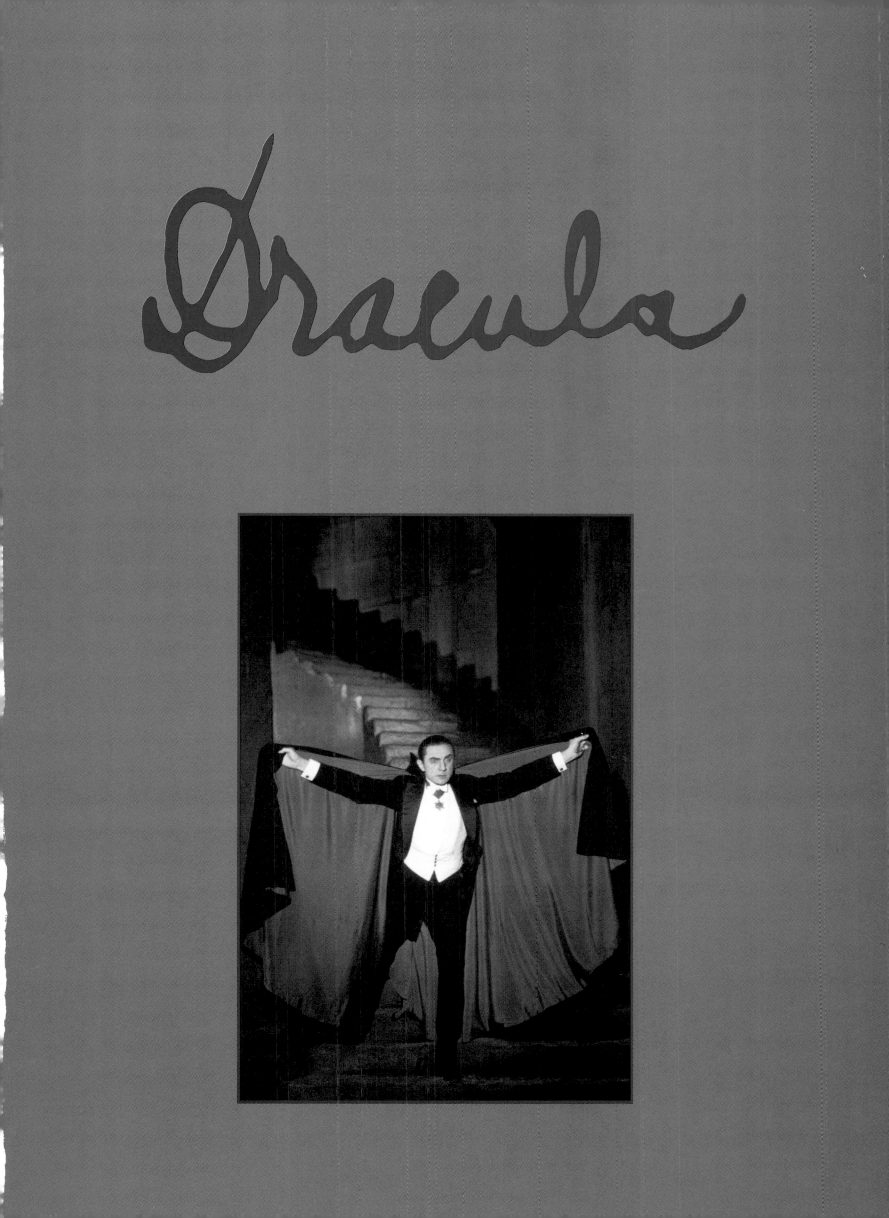

Publishing editor: Jean-Paul Manzo

Editor: Amélie Marty

Text: Elizabeth Miller

Design by: Julien Depaulis

Publishing assistant: Stéphane-Marie Laverrière

We are very grateful to:

Mr. Radu Lungu

Mr. Mihai Oroveanu (Art Expo Foundation, Bucarest)

ISBN 1 85995 780 3

© Parkstone Press , New York, USA, 2000

Dracula

Elizabeth Miller

Parkstone

PARKSTONE PRESS

— CONTENTS —

CHAPTER I

DRACULA THE VOIVODE 7

CHAPTER II

"THE BLOOD IS THE LIFE" 75

— CONTENTS —

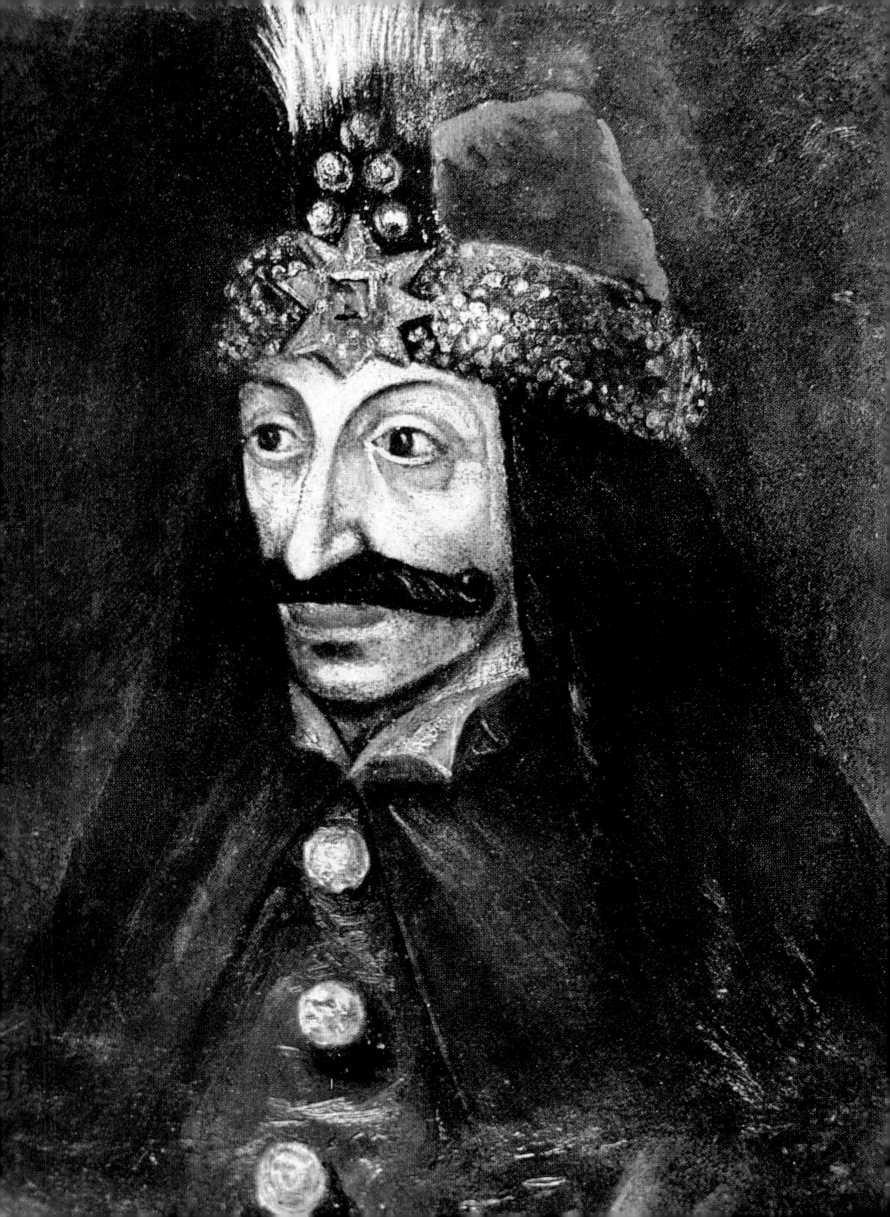

CHAPTER 1

DRACULA THE VOIVODE

The name "Dracula" signifies for most people the figure of the vampire immortalized in the novel Dracula (1897) by Irish author Bram Stoker. But behind the name are two major traditions: the folkloric and literary vampire that culminated in Stoker's novel, and the history of a fifteenth-century Wallachian prince best known in Romania as Vlad Tepes (Vlad the Impaler). While many westerners are surprised to discover that there was indeed a Dracula and are puzzled that he is still considered a national hero, just as many Romanians are dismayed when their voivode is confused with vampire legends. The best way to unravel these incongruities is to explore the separate histories of both Dracula the voivode and Dracula the vampire, to examine how each has had his own impact on contemporary culture and to ascertain the exact nature of the connection between the two.

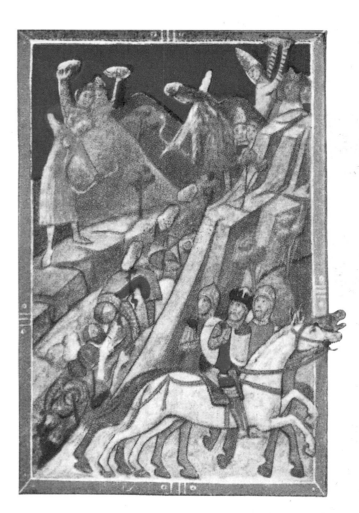

2 *The Battle of Posada* in 1330 where Basarab I, founder of Wallachia, defeated the invading Hungarian army, illumination from The Pictured Chronicle of Vienna started around 1458.

1 *Portrait of Vlad the Impaler*, 15th century, oil on canvas. Vienna, Kunsthistorisches Museum.

SEPT:

MERI:

3 Central and Oriental Europe,
French map, XVIIth century.

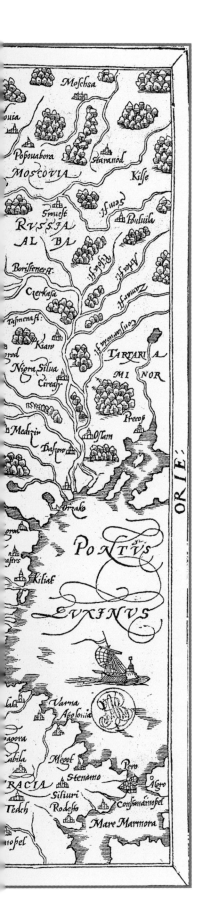

EARLY HISTORY OF WALLACHIA

The origins of Wallachia date back to the late thirteenth century when Romanians (descended from the ancient Dacians) migrated south out of Transylvania across the Carpathian range into the foothills and plains. Generally credited with founding this new state in the fourteenth century is Basarab I, who defeated an invading Hungarian army at Posada in 1330. His work was expanded and consolidated by later rulers such as Nicolae Alexandru and Vladislav-Vlaicu. By 1385, Wallachia was a clearly distinct and independent state, with its capital at Târgoviste. The dominant religious power in Wallachia was the Romanian Orthodox church. Though it had connections with the central Orthodox authority of Constantinople, the Romanian church was essentially autonomous, with its own chief bishop whose see was located at the original Wallachian capital, Curtea-de-Arges, where the first church had been built by Basarab I. The first Metropolitan of Wallachia, Iachint, was officially installed in 1359. In addition, scattered throughout Wallachia were several monasteries which were centres of temporal as well as spiritual power. Many of the early voivodes supported the monasteries with significant endowments. There were some vestiges of Roman Catholicism in the form of a few abbeys, but this faith was far more prominent in Transylvania to the north. The Roman Catholic church had very little power and influence in Wallachia.

Indeed, it was viewed with suspicion, as it was the religious faith of foreigners, including Germans and Hungarians.

Wallachia's history for the next several centuries would be inextricably linked with the presence in southeastern Europe of the Ottoman Empire. The Turks made their first incursion into Europe in 1353, summoned by the Byzantine emperors who wanted assistance in holding off the threats of Balkan (especially Serbian) challenges to their leadership. Once established, the Turks developed expansionist ambitions of their own. By 1371, they occupied much of Bulgaria, and in the decisive Battle of Kosovo (1389) they achieved a major victory over Serbia, thus expanding their sphere of influence to the Danube River. While the invaders did not force their new subjects to abandon their Christian Orthodox faith, they recruited the best of the young male population, converted them to Islam and inducted them into the Turkish army. Thus they were able to secure a foothold that was to change the course of domestic and external politics in the region for centuries.

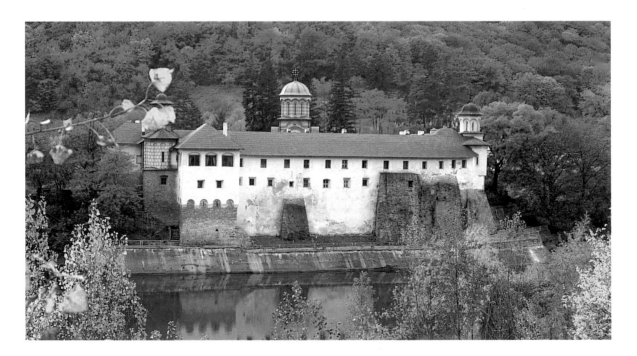

5　The setting of the Cozia Monastery.

4　Fresco, above the stalls,
　　inside the Cozia Monastery.

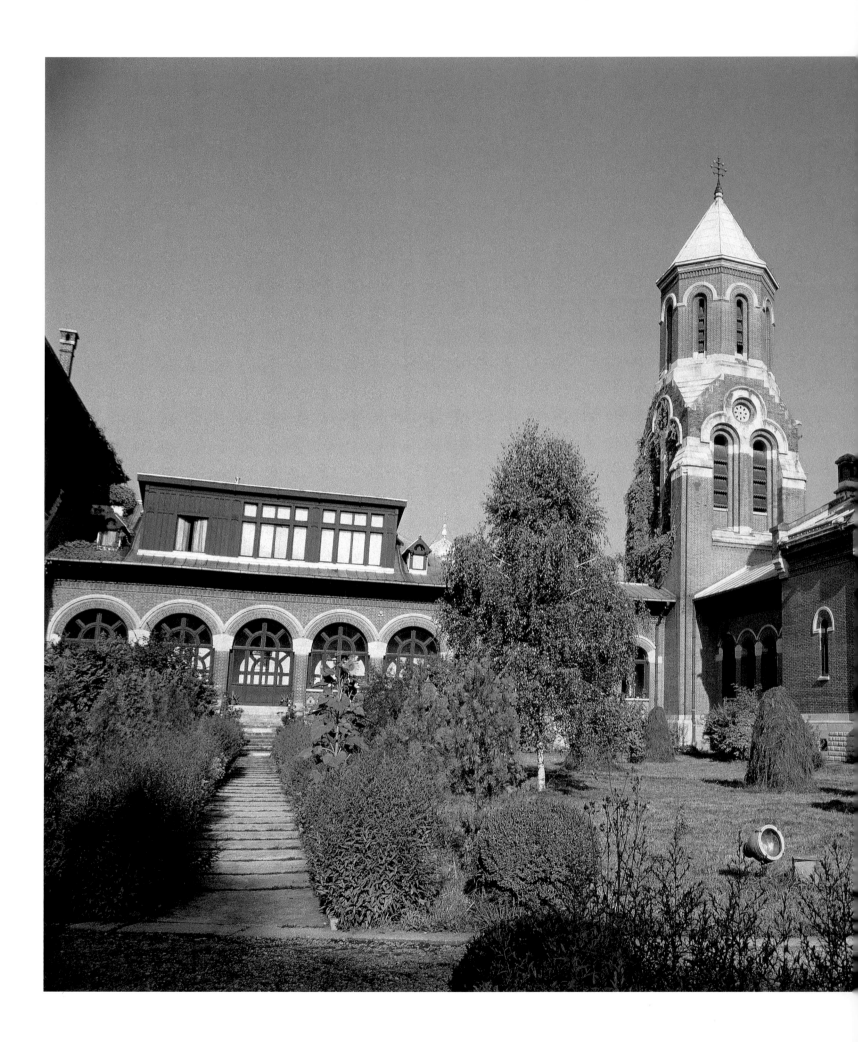

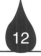

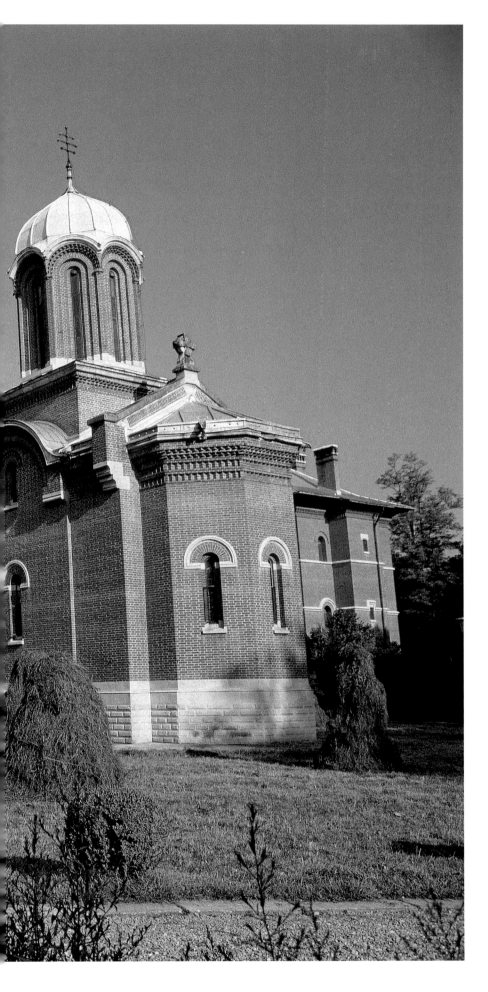

6 The Church of Curtea de Arges.

Next page :
7 *Portrait of Mircea Cel Batrin,*
Vlad Tepes' grandfather,
ruler of Wallachia and known as Voïvode.

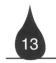

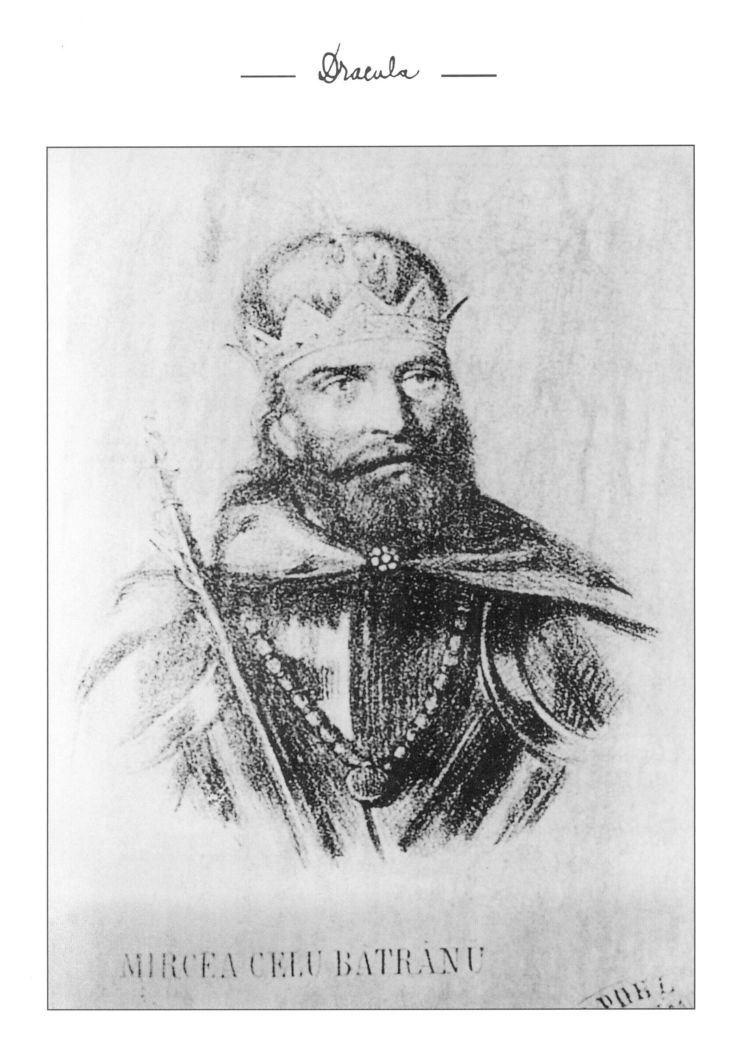

MIRCEA CELU BATRÂNU

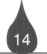

MIRCEA CEL BATRIN AND VLAD DRACUL

The most famous of the early rulers of Wallachia was Vlad Dracula's grandfather, Mircea cel Batrin. (The ruler of Wallachia was known as "voivode," a word of Slavic origin, used in Romania for the leader of a principality, a warlord, or a supreme chief.) Mircea succeeded in consolidating an extensive Wallachian state which roughly comprises that part of present-day Romania between the southern range of the Carpathian Mountains and the Danube River. But his entire reign was dominated by struggles against the Ottoman Empire. In spite of a number of remarkable successes, eventually he was forced to recognize Turkish control and agreed to pay a tribute to the sultan. But he succeeded in achieving what none of his Balkan neighbours did, the continuation of a degree of autonomy for Wallachia: an independent church, retention of land by the boyars and the exclusion of permanent Turkish settlement on Wallachian lands. Mircea died in 1418 and was buried at the monastery at Cozia, located in the valley of the Olt River, where his tomb can be seen to this day. A stained glass window shows him with his only legitimate son, Mihail, who for several years shared power with his father. Referred to by one Greek historian as "the profligate voevod of Wallachia," Mircea left behind a number of illegitimate children, a fact that was to have significant consequences in the absence of any clear rules of succession. The council of "boyars" (nobility) had the power to select as voivode any son of a ruling prince. Consequently, factional disputes were common, as branches of the family fought incessantly for the Wallachian throne. Not surprisingly, Mircea's death led to a major struggle for power. Mihail's death two years after his father's initiated rival claims not only from his illegitimate brood (including Vlad, the father of Vlad Dracula) but by Dan, the son of one of Mircea's brothers. This was the beginning of what historians refer to the Dracula-Dane ti feud, a struggle that was to play a major role in the history of fifteenth-century Wallachia.

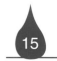

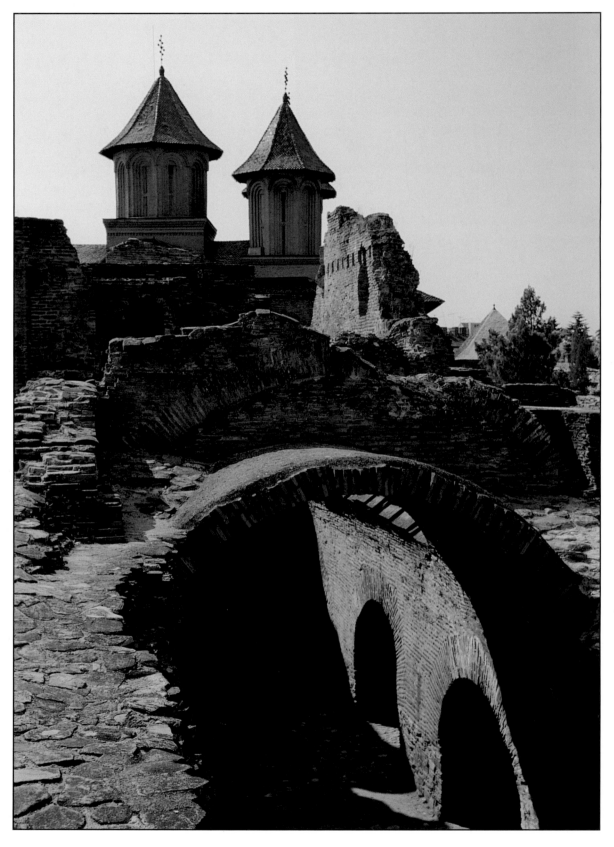

8 View of Târgoviste, capital of Wallachia.

9 The House of Vlad Dracul in Sighisoara in which he took up residence
 when he was frontier commander,
 guarding the mountain passes from Transylvania into Wallachia.

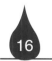

The senior Vlad had spent much of his youth in the court of King Sigismund in Buda and Nuremberg where he would have been exposed to education and culture befitting a royal personage. After the death of his father and his brother Mihail, his eye was on the throne. He was not immediately successful, as he was competing against his cousin Dan and his half-brother Alexandru.

But Vlad's ambitions received a tremendous boost in 1431, when

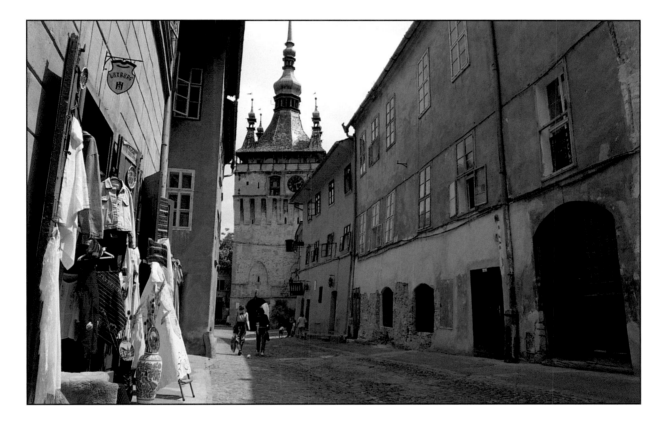

Sigismund (the Holy Roman Emperor) granted him a singular honor. At the time, Vlad was serving in the military capacity of frontier commander with responsibility for guarding the mountain passes from Transylvania into Wallachia from enemy incursion. His residence was in Sighisoara, a Transylvanian town that was a former seat of Saxon power.

With its streets, thick citadel walls and defensive towers, it remains one of the best preserved medieval towns in all of Europe. Near its central landmark, a clock tower in the main square, stands the house in which Vlad took up residence, as well as a small museum of artifacts from the fifteenth century. Today, the house is marked by a small plaque which reads:

Casa Vlad Dracul
In aceasta casa a locuit între ani 1431-1435 domnitorul Tara Romane ti
VLAD DRACUL fiul lui Mircea cel Batrin("In this house lived between the
years 1431-1435 the ruler of Wallachia Vlad Dracul son of Mircea the Old.")

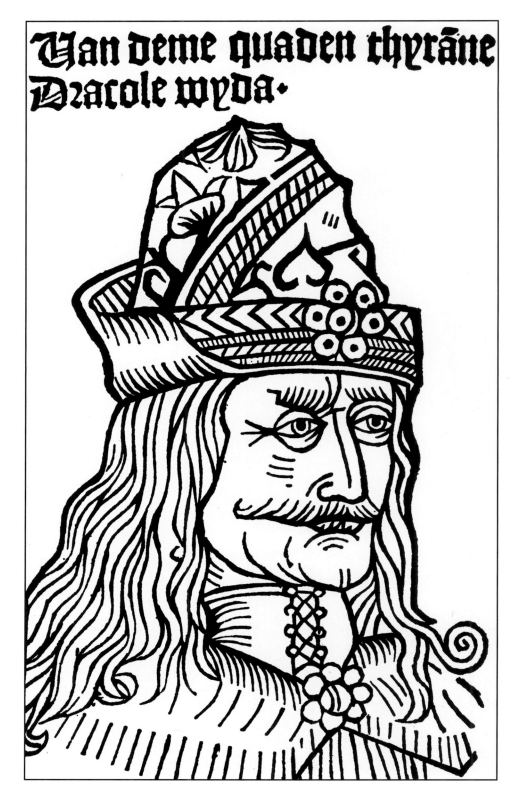

10 *Vlad Tepes,*
engraving printed in Dracole Wayda,
Barth. Ghotan Edition, Lübeck, 1485.

During a restoration in the 1970s a mural was discovered depicting a figure that historians believe may well be Vlad Dracul; if this is so, it is the only extant portrait of Vlad Dracula's father. In 1431, Sigismund summoned to Nuremberg a number of princes and vassals that he considered useful for both political and military alliances. His primary objective was to initiate the group into the Order of the Dragon.

One of these was Vlad. Thanks to recent research conducted by Romanian historian Constantin Rezachevici, much is now known about the origins, nature and iconography of this Order (German name "Drachenordens" and the Latin "Societatis draconistrarum"). It was in fact an institution, similar to other chivalric orders of the time, modelled on the Order of St George (1318).

It was created in 1408 by Sigismund (while he was still king of Hungary) and his queen Barbara Cilli, mainly for the purpose of gaining protection for the royal family.

The statute which survives in a copy dated 1707 states that the Order also required its initiates to defend the Cross and to do battle against its enemies, principally the Turks. The original Order comprised twenty-four members of the nobility, including such notable figures as King Alfonso of Aragon and Naples, and Stefan Lazarevic of Serbia.

It adopted as its symbol in 1408 the image of a circular dragon with its tail coiled around its neck. On its back, from the base of its neck to its tail, was the red cross of St George on the background of a silver field.

With the expansion of the Order, other symbols were adopted, all variations on the theme of dragon and cross.

For example, one class of the Order used a dragon being strangled with a cross draped across its back; another presents a cross perpendicular to a coiled-up dragon with an inscription "*O quam misericors est Deus*" (vertical) and "*Justus et paciens*" (horizontal). Other emblems of the Order included a necklace and a seal, each with a variant form of the dragon motif.

Vlad was obviously proud of this achievement. Later he had coins minted which show on one side a winged dragon, similar to the Paolo Uccello painting "St George and the Dragon" (Italy). His personal coat-of-arms also incorporated a dragon.

It is important to note that in all of these cases, the dragon was intended to convey a favourable image drawn from medieval iconography in which the dragon represents the Beast of Revelation (Satan) who is slain by the forces of good (Christianity).

Most important for our story, Vlad took on the nickname "Dracul" in reference to his induction into the order. As a sobriquet adopted by Vlad (and later by his son), the original association was positive.

After the death of Sigismund in 1437, the Order lost much of its prominence, though its iconography was retained on the coats-of-arms of several noble families.

While at Nuremberg, Vlad also received Sigismund's pledge to support his claim to the throne of Wallachia, provided that on accession he support Catholic institutions in the Orthodox principality. But it would be another five years before his ambition could be realized.

Between him and his goal stood the current voivode, his half-brother Alexandru Aldea.

In 1436, learning that Alexandru lay deathly ill, Vlad gathered an army, marched on Târgoviste and gained the throne.

His wife and two sons (a third would be born two years later) joined him and took up residence in the princely palace.

Vlad Dracul remained voivode, with a brief interruption in 1442-1443, until 1447.

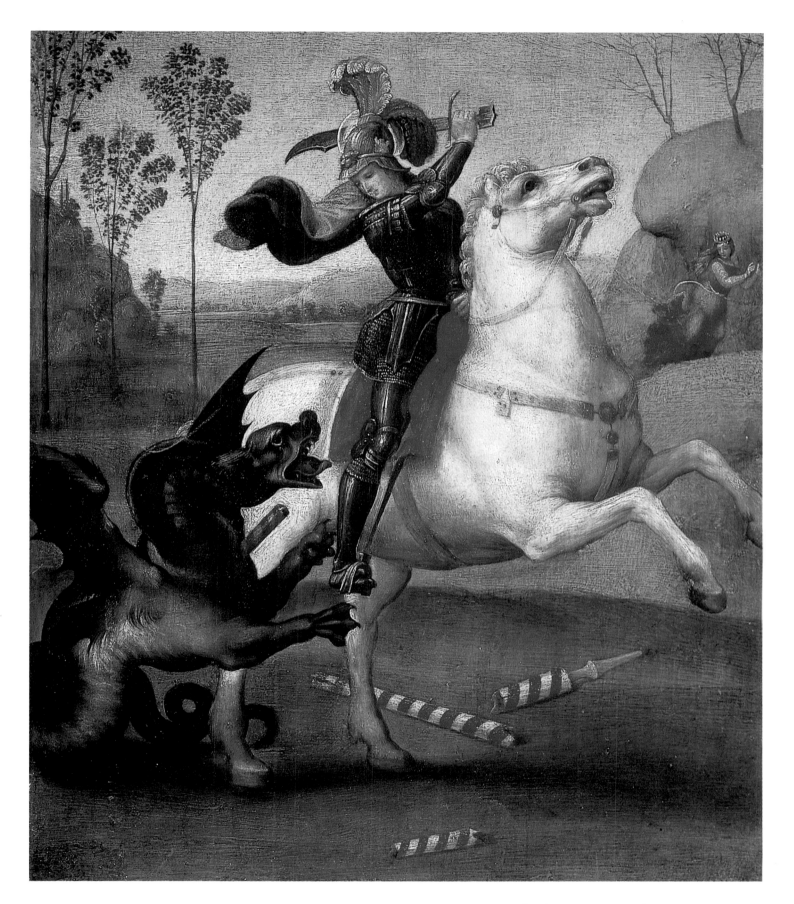

11 Raphaël, *St. George Fighting the Dragon*,
1505. Wood, 30 x 26 cm.
Musée du Louvre (Paris).

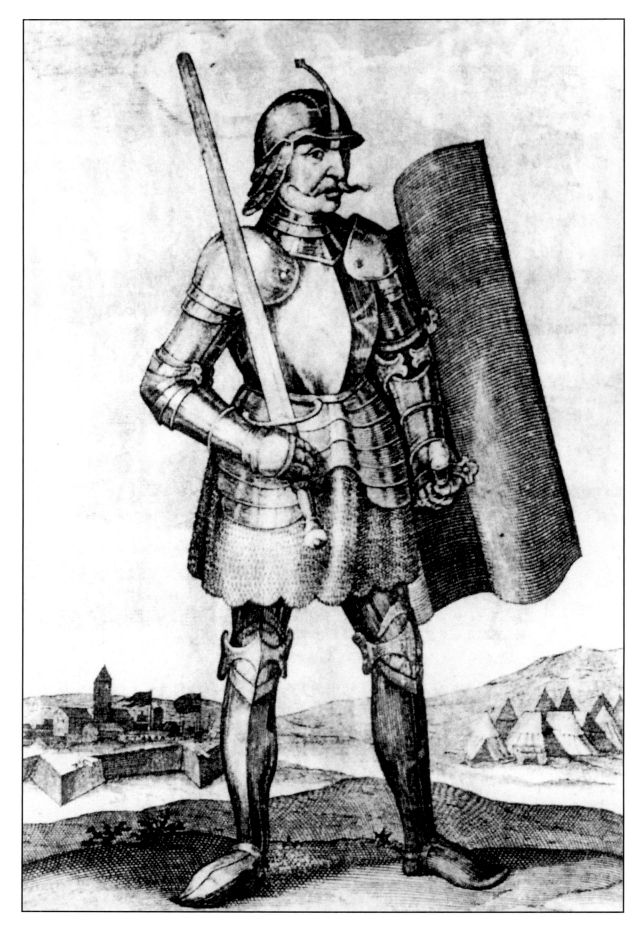

12 Portrait of John Hunyadi, Prince of Transylvania (1441-1456)
and Governor of Hungary (1446-1453).

13 Representation of *the Order of the Dragon* created in 1408.
Vlad Dracul was initiated into the Order of Dragon in 1431
by Sigismund the Holy Roman Emperor.

VLAD THE IMPALER (DRACULA)

The same year that saw Vlad's initiation into the Order of the Dragon appears also to have been the year of young Vlad's birth. The second of three legitimate sons (the others were Mircea and Radu), his mother was likely Princess Cneajna, of the Moldavian princely Musat family. After the move to Târgoviste, young Vlad was educated at court, with training that was appropriate for knighthood. But his political wiliness was to have major consequences for Vlad and his younger brother Radu.

On the death of his patron, Sigismund, Vlad Dracul ranged from pro-Turkish policies to neutrality, to protect his own country's interests.

The Turkish sultan was so unsure of the reliability of Dracul's support (or even his neutrality) that he required of Vlad that two of his sons - Vlad and Radu - be held in Turkey as tangible guarantees that he would actively support Turkish interests. It is estimated that the two boys spent up to six years under this precarious arrangement.

Young Vlad would have been about eleven at the time of the internment, while Radu would have been about seven. According to Turkish account, the two boys were held for part of the time at the fortress of Egregoz, located in western Anatolia, and later moved to Sultan Murad's court at Adrianople. At times, the situation became quite tense.

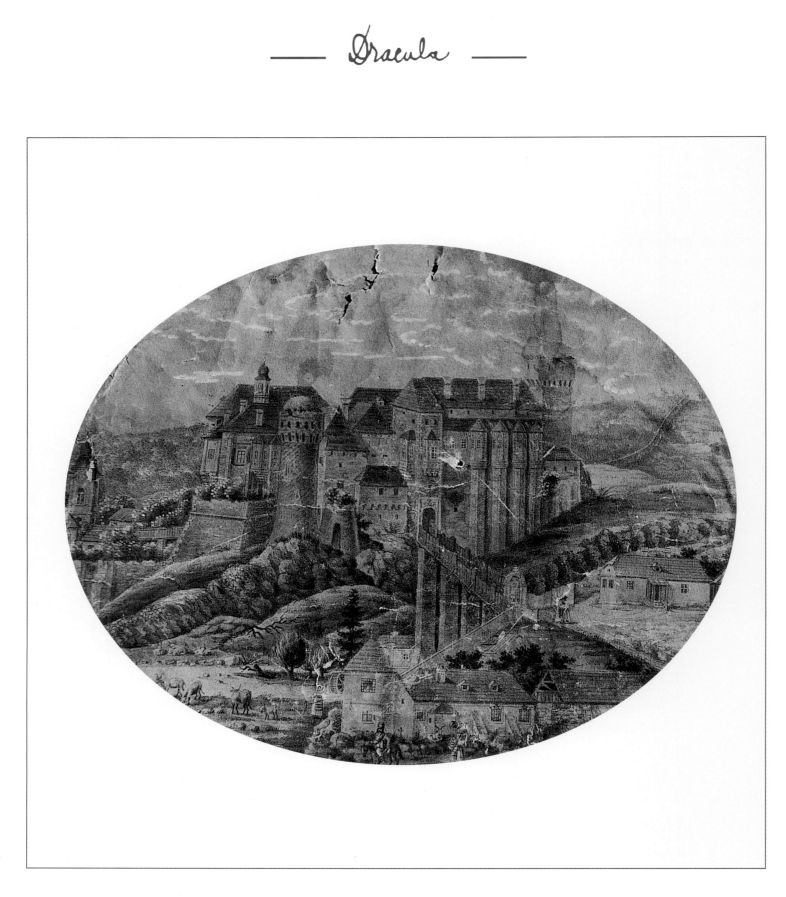

14 Castle of Hunedoara, engraving.

On one occasion, Vlad Dracul actually allowed his older son Mircea to cooperate with Christian forces at the battle of Varma, thus risking the lives of his two hostage sons.

What effect this might have had on young Vlad and his concept of trust we cannot ascertain. Some historians claim that Vlad's later sadistic tendencies were due at least in part to these formative years spent in captivity.

The younger brother Radu, a handsome lad who attracted the attention of the future sultan, fared better than Vlad, a factor that helps explain the bitter hatred and rivalry that developed between the brothers later. Apparently, no serious physical harm came to the boys during these years of captivity, though the psychological impact on Vlad is difficult to assess. After their subsequent release in 1448, Radu chose to remain in Turkey. Not so Vlad.

Dracul was assassinated in 1447 by the boyars of Târgoviste on the orders of John Hunyadi, who had decided to support a member of the rival Dane ti branch of the family (Vladislav II). Also murdered was the eldest son Mircea (reportedly buried alive), thus eliminating any threat, as Dracul's other two sons were still in Turkish captivity. Hunyadi placed his protégé, Vladislav II, on the Wallachian throne.

When news of Dracul's death reached Turkey, Vlad not only was released from his imprisonment in Turkey, but was given the sultan's support to supplant Vladislav. Taking advantage of Vladislav's absence (he had led a contingent of troops to support Hunyadi in the ill-fated second Battle of Kosovo), he was successful in gaining the throne, albeit for a short time.

Little is known of this initial period of Vlad's rule, except that by the end of 1448 the former voivode was back in control and Vlad had left the principality. He spent the next several years contriving to regain power in Wallachia. Much of the time was spent in Moldavia, in the company of his cousin Stephen (later known as Stephen the Great). In 1456 he was finally successful and held power for the next six years, the period about which most is known.

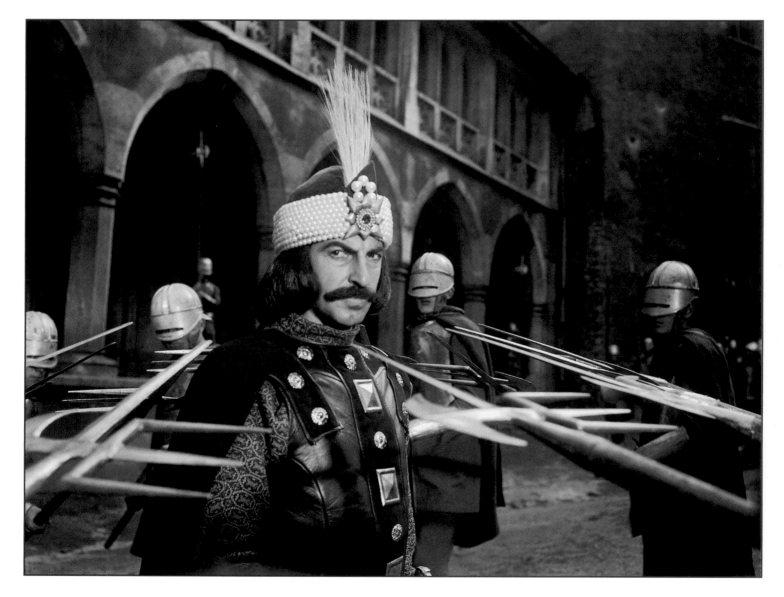

15 Movie still from a Romanian film (Doru Nastase), 1978,
The Arrest of Vlad Tepes by Hungarian soldiers .

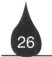

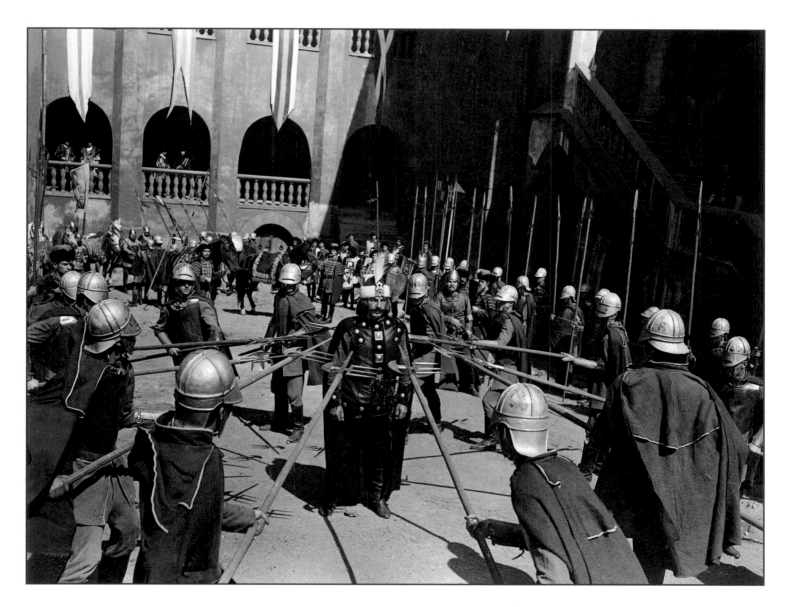

16 Movie still from a Romanian film (Doru Nastase),
The Arrest of Vlad Tepes by Hungarian soldiers,.
He was held as a prisoner until the mid-1470s.

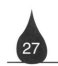

After major battles against the Turks in 1462, he escaped across the mountains into Transylvania and was held as a prisoner by the Hungarian king Mathias Corvinus until the mid-1470s.

His recovery of the throne for a third time in 1476 was short-lived, for he was killed in battle during the coming winter.

Vlad is known by two separate names: Vlad Tepes (the Impaler) and Vlad Dracula. As with much concerning this voivode, there is controversy over which sobriquet carries the greater validity.

As surnames were rarely used in the nomenclature of the voivodes, chroniclers found it useful to append epithets to distinguish one Vlad or Dan from another. So we find "Mircea the Old," "Stephen the Great," "Peter the Lame," "Vlad the Monk," and so forth.

Vlad is much better known in Romanian history as " epe " (the Impaler), derived from the Turkish nickname "kaziklu bey" used by Ottoman chroniclers of the late fifteenth and early sixteenth centuries because of his predilection for impalement as a means of execution.

That the epithet echoed the fear that he instilled in his enemies may account for why it has been embraced to such an extent in his native country.

No evidence exists to suggest that Vlad ever used this term in reference to himself.

By contrast, the appellation "Dracula" (or linguistic variations thereof) was widely employed in fifteenth- and sixteenth-century manuscripts and printed texts: by Pope Pius II; by Antonio Bonfini, official court historian of Corvinus; and by the great humanist Nicolae Olahus, an indirect descendant of Dracula who referred to himself as *"ex sanguine Draculae."*

In fact, it was even used on occasion by Vlad himself, for example in two separate letters written to citizens in Sibiu and Brasov in 1475.

Yet the term "Dracula" has met (and still meets) with some opposition among his countrymen.
The explanation lies in the fact that the designation was made popular by late fifteenth-century German pamphlets which, as we shall see, emphasized the negative aspects of his rule and thus contributed to his notorious reputation.

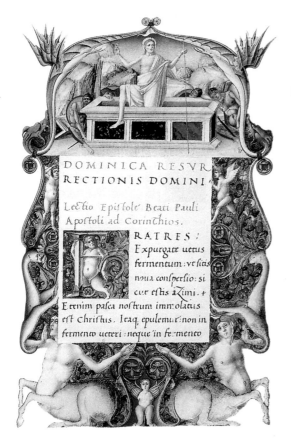

The issue is further complicated by the fact that "dracul" has acquired a second and more familiar meaning, "the devil". Though it is doubtful that Vlad himself used it with that in mind. For him, "Dracula" identified him as the son of Dracul, the son of the one who belonged to the Order of the Dragon.

The name would have been used as a badge of honour, without the negative connotations that have since accrued to it, especially as a result of Bram Stoker's decision to appropriate the nick-name for the vampire in his novel Dracula.

Though Romanian historians have been reluctant to use the term (and in some cases have even challenged its authenticity), it is being more widely acknowledged.

17 *Missal of Cardinal Domenico della Rovere,* 1490s. New York, The Pierpont Morgan Library, M. 306.

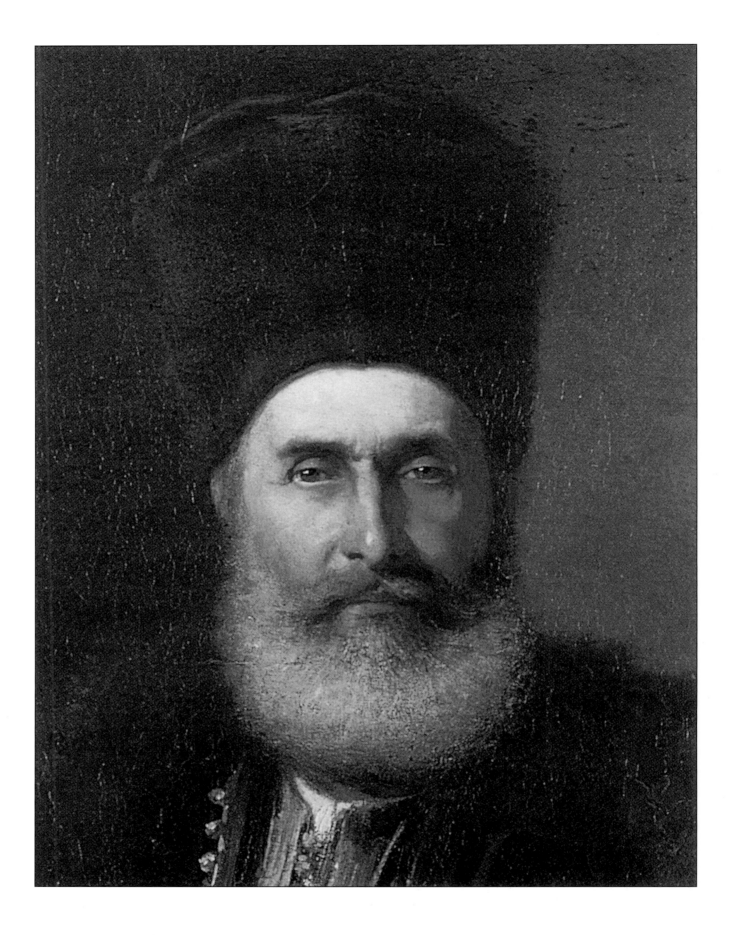

18 Nicolae Grigorescu,
Portrait of the Great Boyar Nasturel Herescu, 1870
Oil on canvas, 119 x 90 cm
National Art Museum of Romania, Bucharest

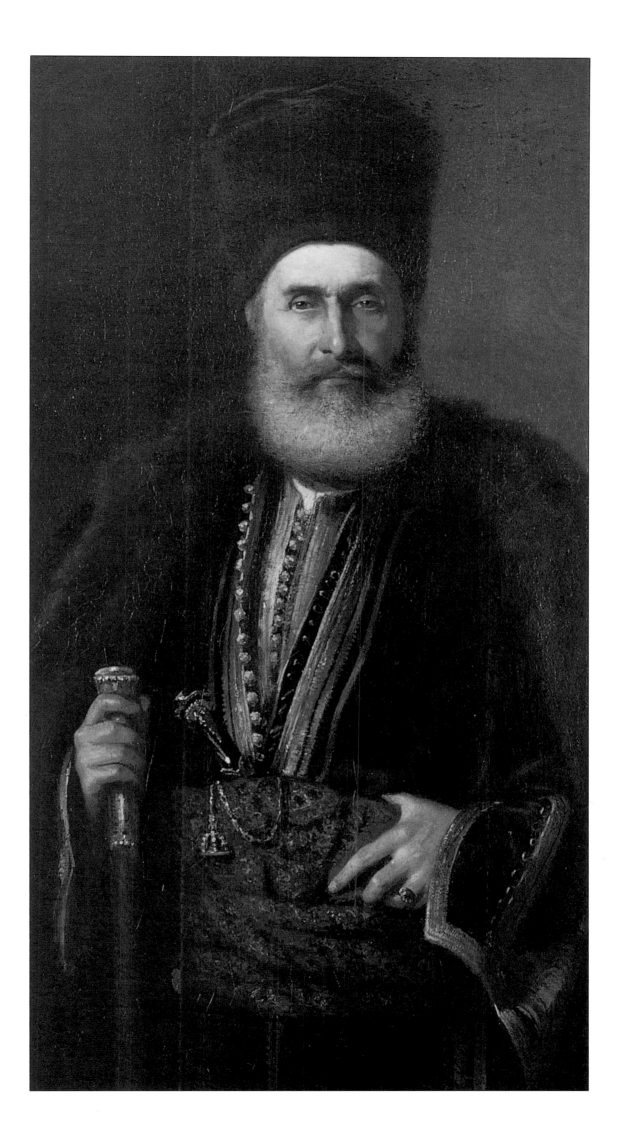

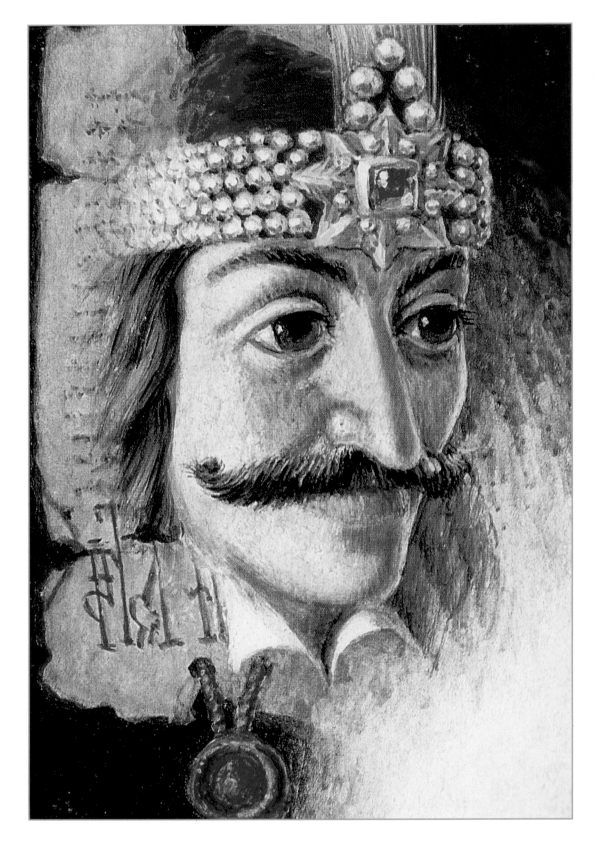

19 Contemporary postcard.

Dracula

SOURCES OF INFORMATION

Though Vlad was to reign for only six years, his reputation throughout Europe was considerable. The major sources of information exist in a variety of forms: manuscripts written while he was still alive (including a narrative poem), several accounts of his military campaign against Turkey in 1462, Slavic manuscripts found in Russian archives, a series of German pamphlets printed from 1488 to 1530, a chronicle by Italian humanist Antonius Bonfini and Romanian oral narratives collected and transcribed by chroniclers and folklorists. What emerges from these texts is a spectrum of representations, from Vlad as a cruel, even psychopathic tyrant to Vlad as a hero who put the needs of his country above all else. An examination of some of these documents is an excellent exercise in the difficulties involved in historical reconstruction [1].

First and foremost, and certainly the most influential in establishing his notoriety throughout Europe, were the German sources. The earliest of these are from the period 1462-63, including the St Gall manuscript and a narrative poem by German meistersinger Michel Beheim, both of which played vital roles in establishing Vlad's negative image.

The manuscript (so named because it was discovered in the Monastery Library of St Gall, Switzerland) contains thirty-two short anecdotes in no particular sequence which present him as a bloodthirsty tyrant of such cruelty that his deeds are noted as worse than those of such persecutors as Herod and Nero.

Beheim's poem is similarly denigrating, a fact that can be explained by its source. Beheim, the court poet of Emperor Frederick III, based his lengthy narrative on the accounts of German Catholic monks from Transylvania who had encountered Vlad's wrath at first hand and had succeeded in fleeing the country following the impalement of one of their number. Their story forms the core of the narrative poem *Story of a Bloodthirsty Madman Called Dracula of Wallachia*, which was read in court during the winter of 1463.

Like the St Gall episodes, the focus was on Vlad's atrocities. Another negative account of Vlad was *Chronicorum regum romanorum*, by an Austrian academic Thomas Ebendorfer, a source that was disseminated throughout the scholarly communities of Europe. Equally damning was the report of the legate to Pope Pius II, who claimed that up to 1462 Vlad had killed 40,000 of his political opponents by the most ferocious of methods, including impalement and skinning alive.

But by far the most popular of the stories, and the ones that ensured a lasting reputation for Vlad, were several pamphlets that began to appear late in the century and which were widely disseminated because of the recent invention of the printing press.

Indeed, some of the earliest secular texts to roll off the presses were horror stories about Vlad Dracula. Written in German and published at major centres such as Nuremburg, Bamberg and Strassburg, these had such unsavoury titles as *The Frightening and Truly Extraordinary Story of a Wicked Blood-drinking Tyrant Called Prince Dracula*. Researchers have discovered at least thirteen of these pamphlets dating from 1488 to 1521 [2]. The printers of the Dracula tales also included woodcut portraits of the prince and, in some cases, illustrations of his atrocities.

Other historical documents include Russian sources, notably a record supplied by a Russian diplomat, Fedor Kuritzyn, who visited Hungary, Moldavia and Transylvania a few years after Vlad's death to investigate rumours of his atrocities. His report, *The Story of Prince Dracula*, while presenting the cruel side of Vlad's behaviour, focuses more on his sense of justice and his determination to restore order in his kingdom. Turkish chronicles, not surprisingly, emphasize the horrors that Dracula inflicted on his enemies, especially during the battles of 1461-62.

By contrast there are the Romanian oral narratives, still preserved in the villages near the ruins of Vlad Dracula's fortress on the Arge River. Here we find a very different Dracula: a prince who repeatedly defended his homeland against the Turks at a time when just about every other principality in the Balkans had been subjected to Ottoman rule; and a leader who succeeded in maintaining law and order in what were indeed lawless and disorderly times.

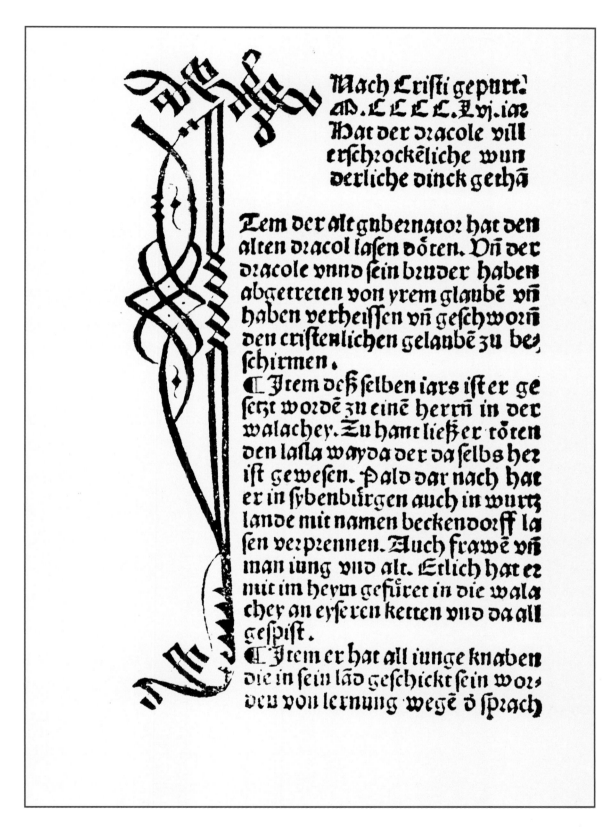

20 A page of the German pamphlet of 1488.

One can detect an element of bias in all of these sources.

In the case of the German reports, the monks, for example, who supplied the narratives for Beheim's poem, were refugees with stories to tell - possibly with embellishment. And Beheim was a performer (music even accompanied his reading) and might well have distorted or exaggerated the accounts for the benefit of the audience.

The German Saxons of Transylvania were among the targets of Dracula's harsh economic measures, hence hardly to be considered objective informants. Some historians go further and suggest that the Hungarian king, Matthias Corvinus, played a role in instigating insidious anti-Dracula propaganda to justify his own decision to switch his support to Radu and have Dracula arrested in 1462.

Whatever the motivations, these tracts had a clear consequence: the blackening of Vlad's reputation throughout Europe.

The Turkish chroniclers are hardly more objective, downplaying Vlad's military successes and waxing eloquent about their own demonstrations of bravery and cunning.

Russian narratives, though more objective, could have been prejudiced by resentment that, while in Hungary, Vlad had abandoned his Orthodox faith and embraced Catholicism.

Standing in stark contrast, the Romanian narratives present him as a folk hero who endeavoured to save his people not only from the invading Turks but from the treacherous boyars.

We have some evidence of Vlad's physical appearance. One written description survives, that of Modrussa, a papal legate to Buda, who met him during the period of his Hungarian captivity:

He was not very tall but very stocky and strong with a cold and terrible appearance, a strong and aquiline nose, swollen nostrils, a thin and reddish face in which the very long eye lashes framed large wide-open green eyes;

the bushy black eyebrows made them appear threatening. His face and chin were shaven, but for a moustache. The swollen temples increased the bulk of his head. A bull's neck connected his head (to the body) from which black, curly locks hung on his wide-shouldered person.

Several visual representations of Vlad exist in the form of portraits, woodcuts and paintings. The best known is a portrait located at the Ambras Museum near Innsbruck. The close proximity to the legate's description suggests that the portrait was painted from a living model, though its date is uncertain. Other portraits appear in the various woodcuts that emerged from the German printing presses in the last two decades of the fifteenth century. The image of Vlad is also included on a fifteenth-century Austrian painting "Saint Andrew's Martyrdom."

Until recently, no full-length portrait of Vlad was known to have existed. But that changed during the 1990s with the revelation that one such work has been located in Austria. The "discovery" was made by Canadian doctoral student Benjamin Leblanc who, while touring Forchtenstein Berg (a fortress near Wiener Neustadt in Burgenland), happened to notice a familiar portrait on the wall. With his interest in the historical Dracula, he recognized it immediately as Vlad.

The portrait shows the voivode in his pearl-encrusted cap but without the star in the middle. It bears the familiar long hair, aquiline nose and slanting eyes, though the moustache is thinner and sharper. The stocky build seems to fit the Modrussa description. Vlad carries a sceptre in one hand while the other rests on his sword.

In the upper left corner of the painting is the following Latin inscription: *"Dracula Waida Princeps et Waivoda Walachia Transalpina hostis Turcarum intensissimus - 1466"* (*"Dracula, Voevod and Prince of Transalpine Wallachia, the most hostile foe of the Turks - 1466"*). *Of unknown date, it was commissioned by a Hungarian nobleman, Nicholas Esterhazy (1582-1645).*

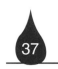

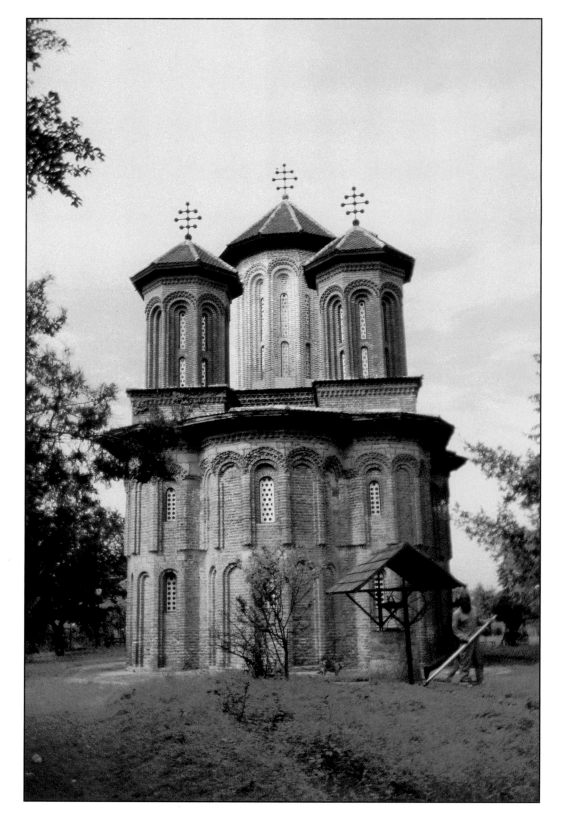

21 External view of the Snagov Monastery,
founded by Vlad Tepes in the XVth century.

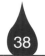

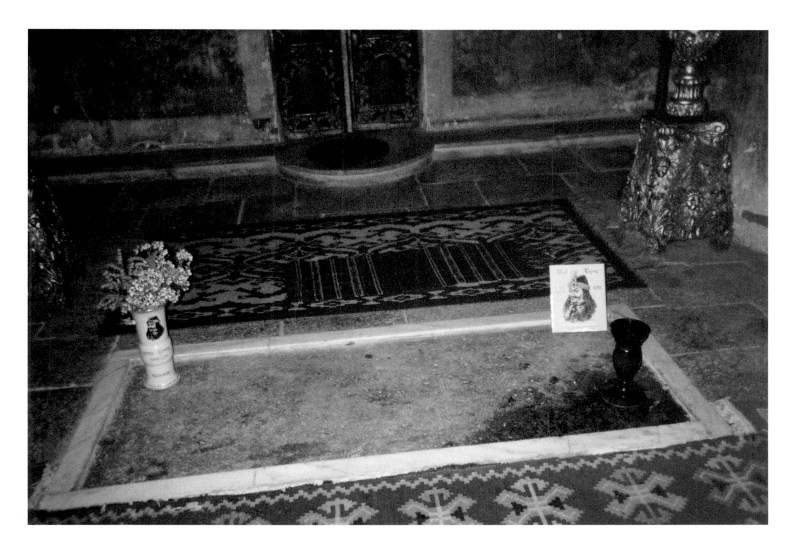

22 Traditional site of Vlad Tepes' grave in the Snagov Monastery.
Vlad would have been buried close to the altar.

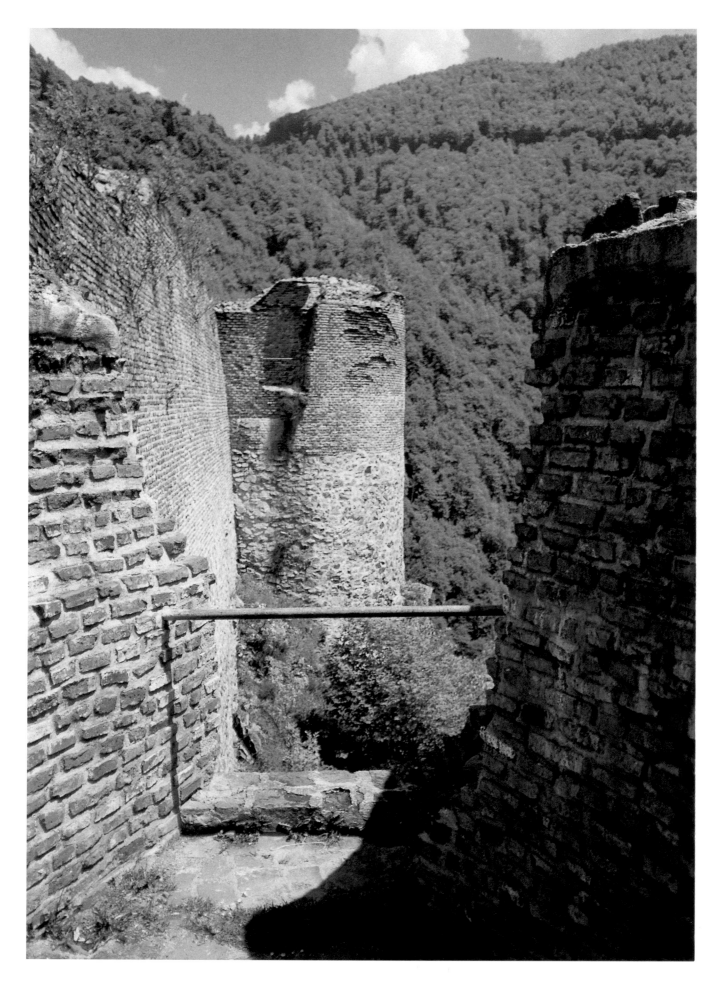

23 Vlad Tepes' Fortress, Poenari.

POLICIES AND ATROCITIES

Vlad regained the Wallachian voivodate in 1456, just three years after the fall of Constantinople. Again, his princely court was in the capital city of Târgoviste. Bucharest, the present capital of Romania, was at that time a nameless citadel on the banks of the Dimbovita River.

In fact, the name "Bucharest" first appeared in a document signed by Vlad in 1459; Vlad built a citadel there to bolster up the protection of the settlement, exposed as it was in the middle of the Wallachian plain. Today a few modest ruins of Vlad's princely palace (Curtea Veche) can be seen in the older section of the city.

Although a clash between Vlad and the Turks was only a matter of time, such a confrontation was not his immediate priority.

Rather, he focused his energies on consolidating his position in Wallachia.

His first objective was to break the hold that the boyars, as the body that selected the voivode, had on political power.

The nobles, because of their tendency to support puppet leaders who would protect their interests, often deliberately selected as voivode the weakest of the available candidates.

Such a policy worked against the development of a strong nation state, not only in Wallachia but in many of the post-feudalist principalities throughout Europe.

Furthermore, the nobles themselves were often divided into factions, supporting rival claimants to the throne. Vlad was determined to make the position of voivode free of such vagaries. Vlad's domestic policy can be best seen in a letter he wrote to the civic officials at Brasov, shortly after he ascended the throne in 1456: "When a man or a prince is strong and powerful, he can make peace as he wants; but when he is weak, a stronger one will come and do what he wants to him."

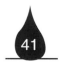

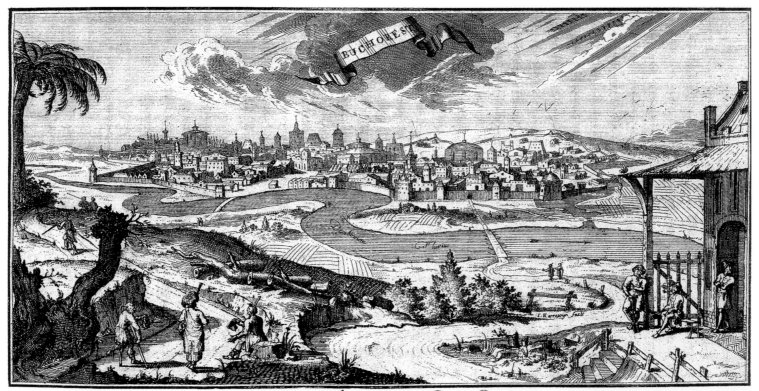

BUCHOREST *in Moldavia aan de Revier Dembowicen.*

24 Bucarest, engraving printed in a publication
of the XVIIIth century. Romanian Academy Library.

A related internal problem that faced Vlad was the continuous threat from rival claimants to the throne, all of whom were descendants of Mircea cel Batrin.

One story goes that when Vlad questioned his boyars about how many princes the state had seen in their living memory, the answers ranged from seven to thirty. Clearly, occupation of the Wallachian throne was tenuous at best. Vlad was determined to put a stop to this, though ironically, his tenure would be brief as well.

The method was simple: To purge the existing boyar class of any potential opposition and to replace them with hand-picked men whose loyalty would be unflinching. The boyars of his capital city, Târgoviste, were selected for specific treatment, as Vlad suspected them of having participated in the murders of his father and brother in 1447.

An early Romanian historical chronicle (transcribed in the seventeenth century) provides an account of how he exacted his revenge. In the spring of 1457, the voivode invited the boyars and their families to an Easter feast. After his guests had finished their meal, Vlad's soldiers surrounded them, rounded up the able-bodied and marched them fifty miles up the Arges River to Poenari, where they were forced to build his mountain fortress. His prisoners laboured under very difficult conditions for many months.

Those who survived the gruelling ordeal were impaled. Coupled with his determination to consolidate his own power was his extreme view of law and order. He did not hesitate to inflict the punishment of impalement on anyone who committed a crime, large or small. Impalement was an especially sadistic means of execution, made even more so by Vlad's determination to administer it in ways that would ensure the longest possible period of suffering for the victim. While impalement was his punishment of choice, Vlad did employ other equally excruciating ways of dispensing with opponents. The Nuremberg pamphlet of 1488 notes the following episodes:

He had some of his people buried naked up to the navel and had them shot at. He also had some roasted and flayed.

He captured the young Dan (of the rival Dane ti clan) and had a grave dug for him and had a funeral service held according to Christian custom and beheaded him beside the grave.

He had a large pot made and boards with holes fastened over it and had people's heads shoved through there and imprisoned them in this. And he had the pot filled with water and a big fire made under the pot and thus let the people cry out pitiably until they were boiled quite to death.

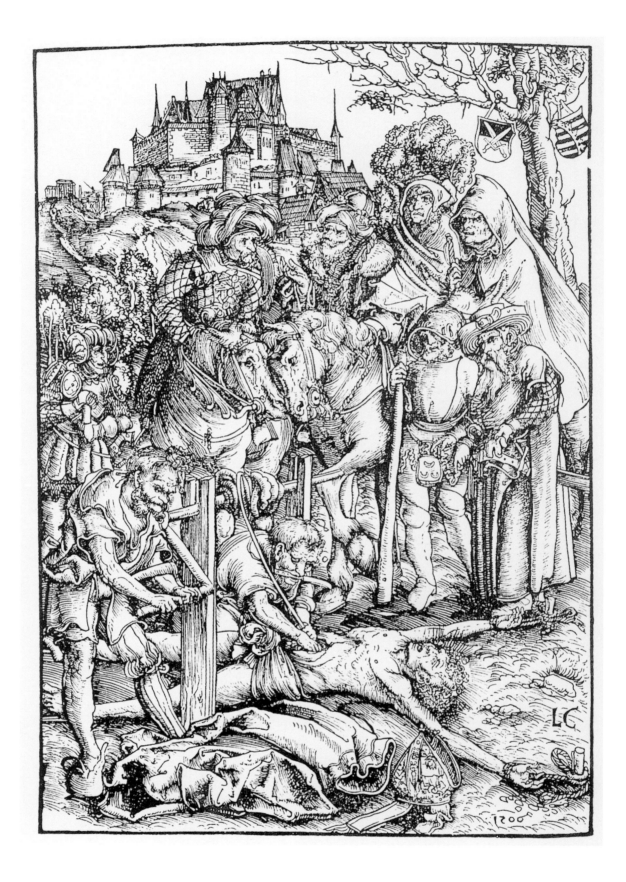

25 Lucas Cranach the Elder,
Martyrdom of St. Erasmus.
1500-1550, woodcut. Aschffenburg.

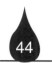

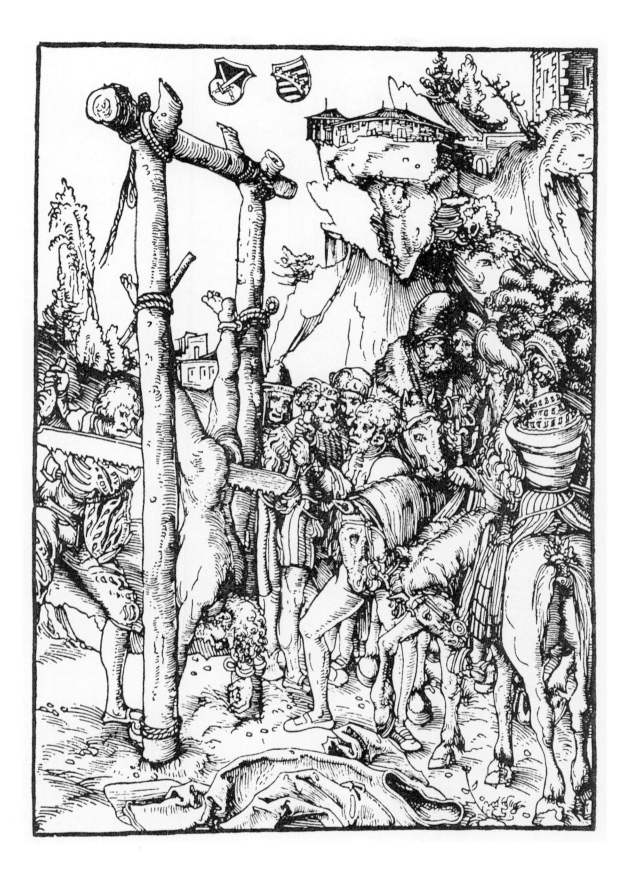

26 Lucas Cranach the Elder,
Martyrdom of St. Simon.
1500-1550, woodcut. Berlin.

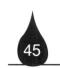

Wie facht sich an gar ein grauffem
liche erschröckenliche Hyftorien. von dem wilden wü-
trich Dracole weyde Wie er die leüt gespist hot vnd
gepraten vñ mit den häubtern yn einē keffel gefotten

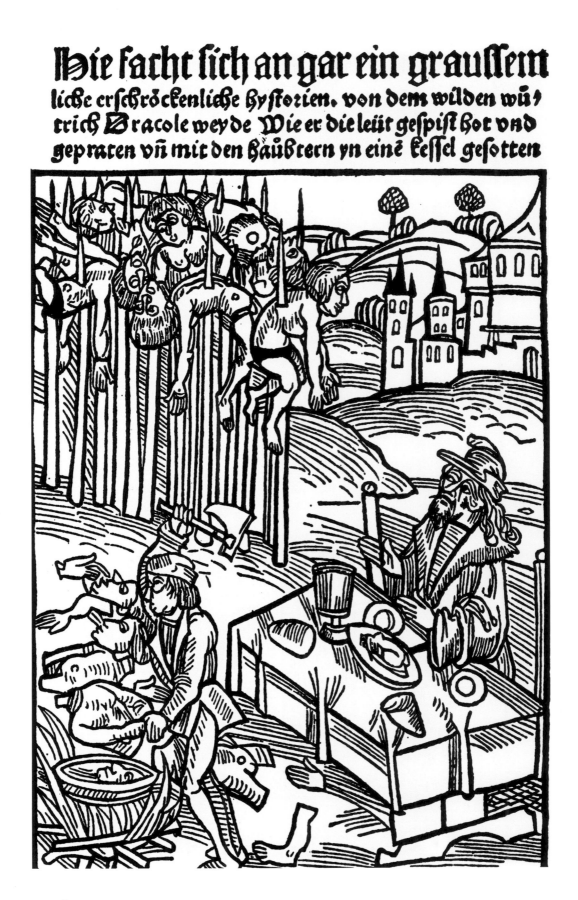

27 *Impale Forest,*
engraving printed in *Dracole Wayda*,
Matth. Hupfuff Edition, Strassburg, 1500.

He devised dreadful, frightful, unspeakable torments, such as impaling together mothers and children nursing at their breasts so that the children kicked convulsively at their mothers' breasts until dead. In like manner he cut open mothers' breasts and stuffed their children's heads through and thus impaled both.

He had all kinds of people impaled sideways: Christians, Jews, heathens, so that they moved and twitched and whimpered in confusion a long time like frogs.

About three hundred gypsies came into his country. Then he selected the best three of them and had them roasted; these the others had to eat.

While it is impossible to verify that each of these incidents took place exactly as related, there is no doubt that Vlad meted out his punishments with unusual cruelty.

Several of the tales of his atrocities occur in three or more separate and independent accounts, indicating a large measure of veracity. One is this story of how he dispensed with the sick and the poor:

Dracula was very concerned that all his subjects work and contribute to the common welfare. He once noticed that the poor, vagrants, beggars and cripples had become very numerous in his land. Consequently, he issued an invitation to all the poor and sick in Wallachia to come to Târgoviste for a great feast, claiming that no one should go hungry in his land. As the poor and crippled arrived in the city they were ushered into a great hall where a fabulous feast was prepared for them.

The prince's guests ate and drank late into the night, when Dracula himself made an appearance. "What else do you desire? Do you want to be without cares, lacking nothing in this world," asked the prince. When they responded positively Dracula ordered the hall boarded up and set on fire. None escaped the flames. Dracula explained his action to the boyars by claiming that he did this, "in order that they represent no further burden to others so that no one will be poor in my realm."

Nobody was immune from his cruelty. Another widely disseminated tale involves the arrival in his court of two foreign ambassadors:
Some Italian ambassadors were sent to him. When they came to him they bowed and removed their hats and they kept on the berets beneath them. Then he asked them why they did not take their caps off, too. They said it was their custom, and they did not even remove them for the Emperor.
Dracula said, "I wish to reinforce this for you." He immediately had their caps nailed firmly on their heads so that their caps would not fall off and their custom would remain. Thus he reinforced it.

In other versions, the ambassadors are Turkish and the caps are turbans. But the essence of the story remains the same.
Vlad also used impalement among his own citizenry as a deterrent to even the most petty of offences:
Once he had seen a worker in a short shirt and said to him: "Have you a wife at home?" He said: "Yes." Dracula said: "Bring her to me." Then he said to her: "What do you do?" She said: "I wash, cook, spin, etc." He immediately had her impaled, because she had not made her man a long shirt, so that one could not see the seam. Dracula at once gave him another wife and ordered that she should make a long shirt for her man, or he would also have her impaled.

Impalement also proved to be a powerful deterrent to would-be criminals. Consider the following story, found in both Russian and Romanian narratives:
Dracula so hated evil in his land that if someone stole, lied or committed some injustice, he was not likely to stay alive.
Whether he was a nobleman, or a priest or a monk or a common man, and even if he had great wealth, he could not escape death if he were dishonest.
And he was so feared that the peasants say that in a certain place, near the source of the river, there was a fountain; at this fountain at the source of this river, there came many travelers from many lands and all these people came to drink at the fountain because the water was cool and sweet.

28 Pinturicchio, Pope Pius II opening the Congress in the Cathedral of Mantua on September 26 1459 to launch a crusade against the Turks, fresco, 15th century. Cathedral of Siena (Libreria Piccolomini).

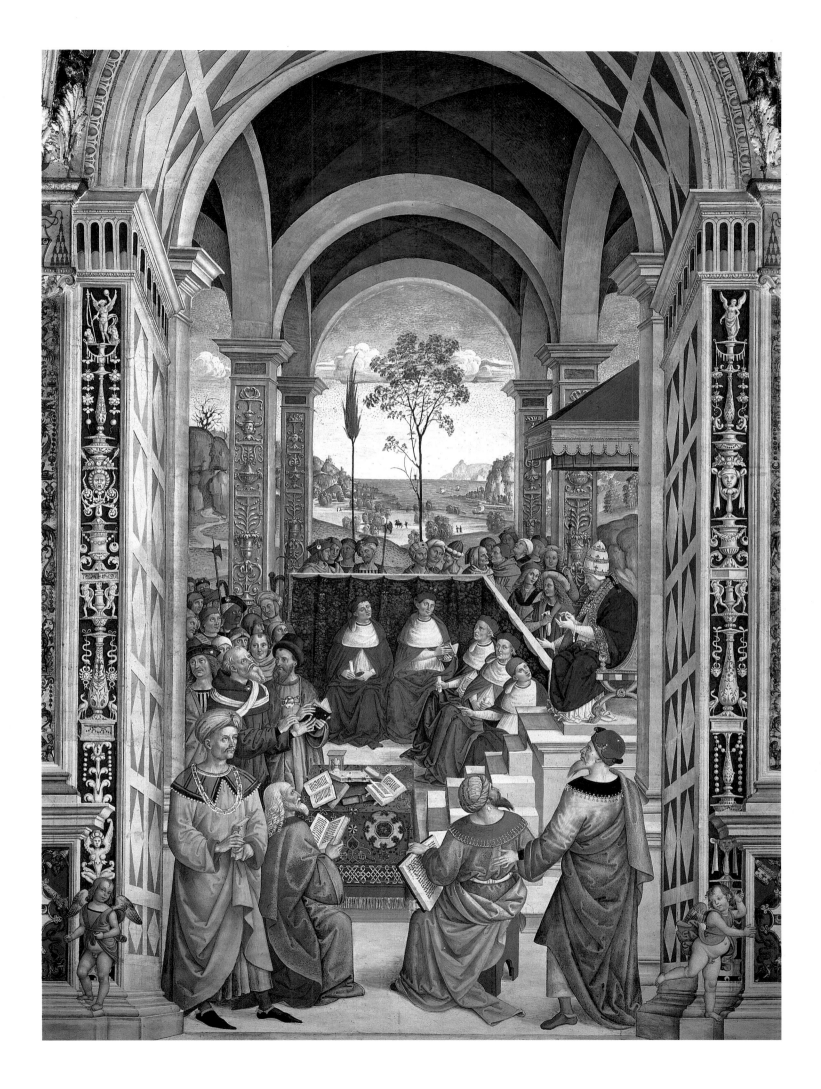

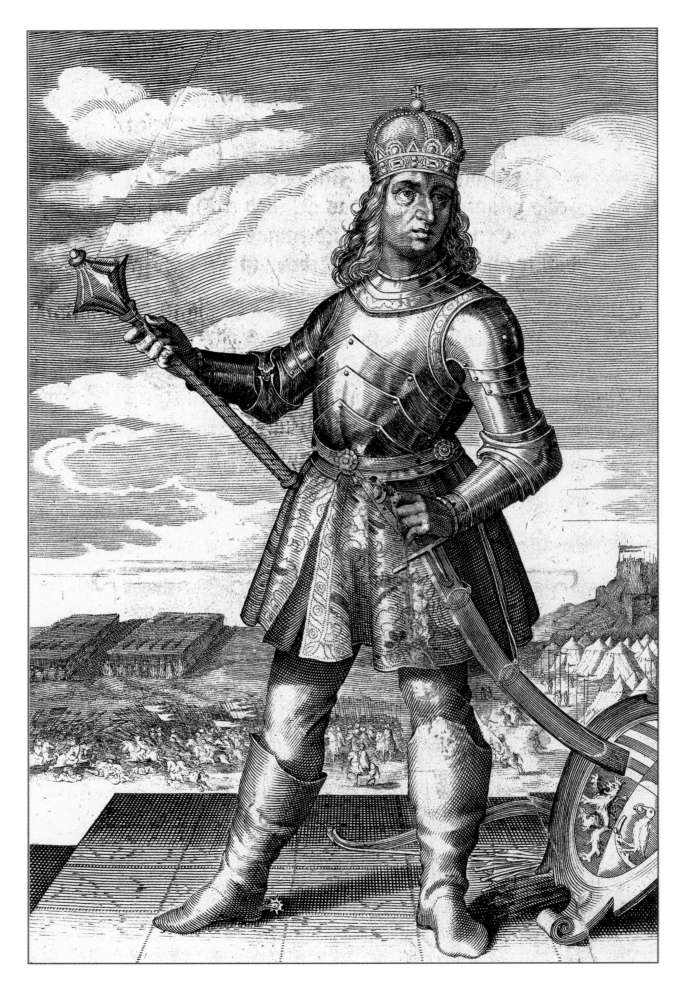

29 Portrait of Mathias Corvin, son of John Hunyadi
and King of Hungary (1458-1490), engraving.

Dracula had purposely put this fountain in a deserted place, and set a cup wonderfully wrought in gold and whoever wished to drink from this gold cup had to put it back in its place. And so long as this cup was there no one dared steal it.

Romanian oral narratives, while not denying the cruelty, place more emphasis on Dracula's determination to restore law and order:

When Dracula ruled Wallachia, an important Florentine merchant travelled throughout the land, and he had a great deal of merchandise and money. As he reached Târgoviste, the capital of the country at the time, the merchant immediately went to the princely palace and asked Dracula for servants who might watch over him, his merchandise and his money. Dracula ordered him to leave the merchandise and the money in the public square and to come and sleep in the palace.

The merchant, having no alternative, submitted to the princely command. However, during the night someone passing by his carriage stole 160 ducats. On the next day, early in the morning, the merchant went to his carriage, found his merchandise intact, but 160 ducats were missing. He immediately went to Dracula and told him about the missing money. Dracula told him not to worry and promised that both the thief and the gold would be found. He ordered his servants to replace the gold ducats from his own treasury, but to add an extra ducat. To the citizens of Târgoviste he ordered that they immediately seek out the thief and if the thief were not found, he would destroy his capital.

In the meantime, the merchant went back to his carriage, counted the money once, counted it a second time and yet again a third time, and was amazed to find all the money there with an extra ducat. He then returned to Dracula and told him: "Lord, I have found all my money, only with an extra ducat." The thief was brought to the palace at that very moment. Dracula told the merchant: "Go in peace. Had you not admitted to the extra ducat, I would have ordered you impaled together with this thief." This is the way that Dracula conducted himself with his subjects, both believers and heretics.

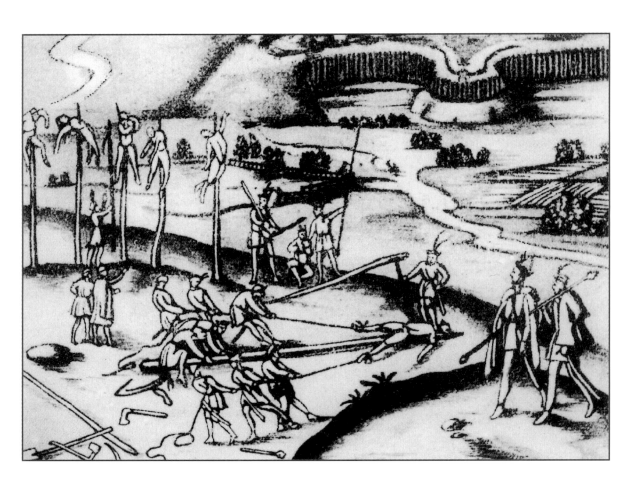

30 The Sovereign of Transylvania's Highwaymen
Executing by Impale Turkish Prisoners ,
engraving by Gabriel Bethlen, 1617.

Perhaps his most horrifying atrocities were committed against the
Germans (Saxons) of Transylvania, beginning with raids on a number
of Transylvanian towns where residents were suspected of
supporting a rival:

In the year 1460, on the morning of St Bartholomew's Day, Dracula
came through the forest with his servants and had all the Wallachians
of both sexes tracked down, as people say outside the village of
Humilasch (Amla), and he was able to bring so many together that he
let them get piled up in a bunch and he cut them up like cabbage with
swords, sabers and knives; as for their chaplain and the others whom
he did not kill there, he led them back home and had them impaled.

And he had the village completely burned up with their goods and it is said that there were more than 30,000 men. But the incident that was to cause the greatest damage to his reputation took place in Brasov. His quarrels with this city were both political and economic. Not only were the German merchants championing rival claimants to the Wallachian throne, they were ignoring customs duties being levied on goods entering Wallachia. Repeated warnings went unheeded.

Finally in 1459, Dracula led an assault on Brasov, burned an entire suburb and impaled numerous captives on Tîmpa Hill. The scene has been immortalized in an especially gruesome woodcut which appeared as the frontispiece in a pamphlet printed in Nuremberg in 1499. It depicts Vlad having a meal while impaled victims are dying around him. As he eats, his henchmen are hacking off limbs of other victims right next to his table.

The narrative begins as follows: "Here begins a very cruel frightening story about a wild bloodthirsty man Prince Dracula. How he impaled people and roasted them and boiled their heads in a kettle and skinned people and hacked them to pieces like cabbage.
He also roasted the children of mothers and they had to eat the children themselves. And many other horrible things are written in this tract and in the land he ruled."
A similar woodcut appeared the following year (Strasbourg) with the caption, "Here occurred a frightening and shocking history about the wild berserker Prince Dracula."
Vlad's evil reputation was assured.

It was inevitable that Vlad Dracula would finally confront the Turks, as Wallachia lay between Turkish controlled Bulgaria and the rest of central and eastern Europe. It was a classic case of David facing Goliath: the small principality of Wallachia against the might of Sultan Mehmed II, the conqueror of Constantinople. Pope Pius II had summoned a council of the church at Mantua to raise the possibility of a new crusade against the Ottomans.

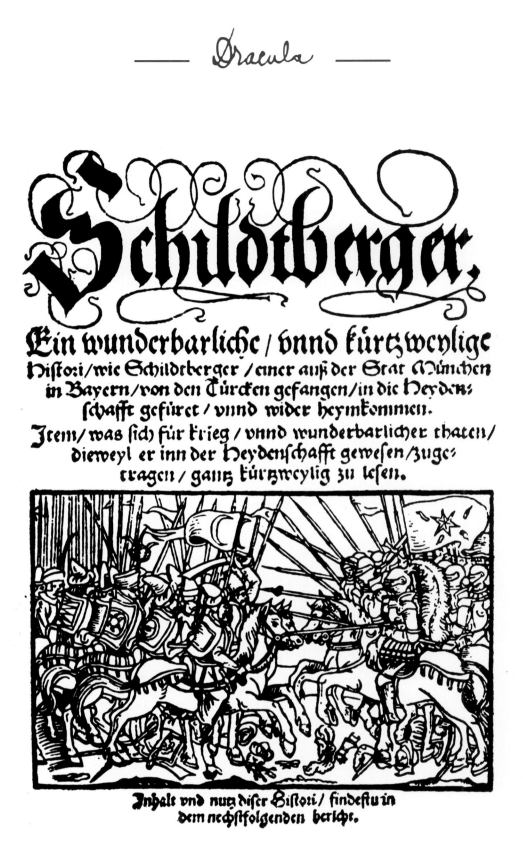

31 *Battle near Nicopoli.*
Engraving printed in 1540 (Nuremberg).

Support was limited, with the notable exception of Vlad Dracula who, having succeeded in his domestic policies, was now ready to turn his attention to his longstanding enemy.

Vlad took his own initiative and precipitated the ire of the Sultan by refusing to continue honouring an earlier arrangement to pay an annual tribute and to supply young Wallachian men for the Turkish army.
After a period of raiding and pillaging along the Danube border, full-fledged war broke out during the winter of 1461-62.

Initially, Dracula met with remarkable success. Early in the campaign he wrote a letter to Hungarian king Mathias Corvinus, claiming to have killed nearly 24,000 enemies.
His exploits drew the attention of several European rulers, including the Pope himself.

The Turks launched a full counter-offensive. Badly outnumbered, Vlad employed every possible means to gain an advantage: drawing the enemy deep into his own territory through a strategic retreat, he burned villages and poisoned wells along the route; he employed guerilla tactics, using the local terrain to advantage; he even initiated a form of germ warfare, deliberately sending victims of infectious diseases into the Turkish camps.

On 17 June 1462, he led a raid known in Romanian history as the "Night Attack." But the sultan's army continued onwards and reached the outskirts of Vlad's capital city.
There Vlad used his most potent weapon - terror. The following is an account from the Greek historian Chalkondyles of what greeted the invaders:
He (the sultan) marched on for about five kilometers when he saw his men impaled; the sultan's army came across a field with stakes, about three kilometres long and one kilometre wide.

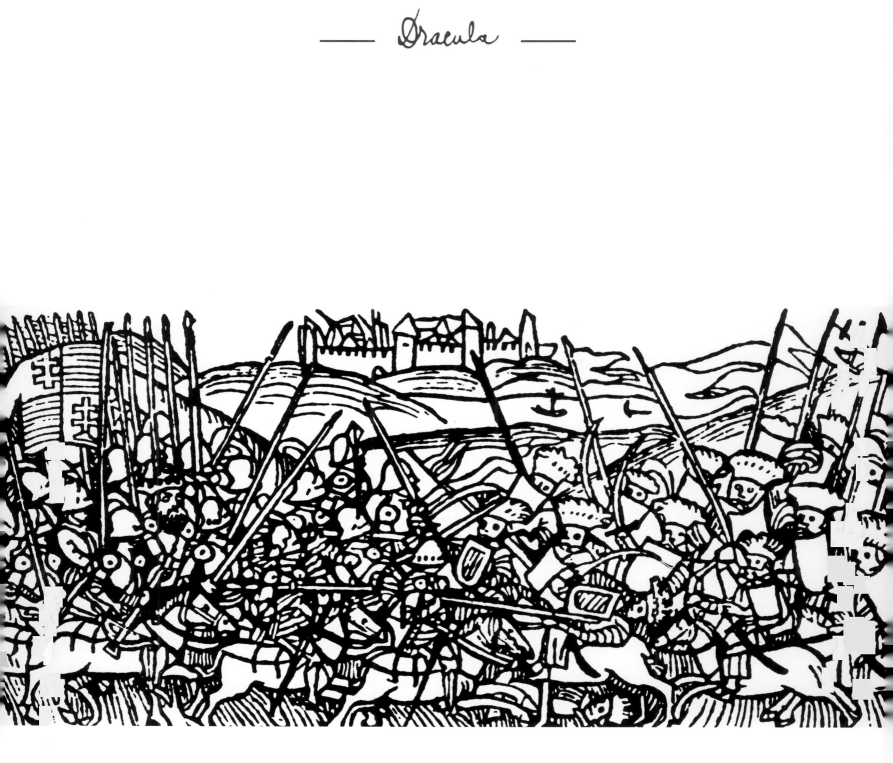

32 Battle in Târgoviste to regain the Princely Seat for
Vlad Tepes, 1476, engraving printed after *Cronica
Hungarorum* by Joh. de Thurocz, Radolt Edition,
Augsburg, 1488.

And there were large stakes on which they could see the impaled bodies of men, women and children, about twenty thousand of them, as they said; quite a spectacle for the Turks and the sultan himself!

The sultan, in wonder, kept saying that he could not conquer the country of a man who could do such terrible and unnatural things, and put his power and his subjects to such use. He also used to say that this man who did such things would be worthy of more. And the other Turks, seeing so many people impaled, were scared out of their wits.

There were babies clinging to their mothers on the stakes, and birds had made nests in their breasts.

The sultan withdrew. But the war was not over. Mehmed threw his support behind Vlad's brother Radu, who with the support of defecting boyars and Turkish soldiers, pursued Vlad all the way to his mountain fortress at Poenari.

According to oral legends that survive to this day in the village of Arefu, near the fortress, Vlad was able to escape with the help of the villagers:

My grandfather used to tell me that during the reign of Vlad the Impaler, Romanians paid tribute to the Turks in exchange for peace.

This tax included one to two hundred young people a year to serve in the mercenary corps of the Turkish army. Some of these lads came from the village of Arefu. Vlad the Impaler decided to put a stop to it. The mighty Sultan, on hearing that Vlad refused to pay tribute, sent an army to capture him alive and bring him to Turkey.

When the Turkish army crossed the Danube, Vlad retreated through this village to his fortress. When he arrived at Castle Poenari, he sent word to the village asking the elders for advice. Vlad told the elders, "The Turks have surrounded this fortress and I want you to take me across the border into Transylvania, by morning."

One of the elders who was an ironsmith said, "I have a plan. Let us reverse the shoes of the horses so that when we leave the fortress and the Turks come, they will think we have entered when we have actually gone away."

So they reversed the shoes and escaped through a secret passage, and crossed the Carpathian Mountains into Transylvania. When they reached the border, Vlad asked how he could compensate them for their loyalty.
The elders of Arefu replied, "Your Highness, give us not gold or silver because these can be spent. Give us land because the land is fertile and will keep us alive for all time."
So he asked for a rabbit skin and wrote on it, "I give you, the elders of Arefu, fourteen mountains and nine sheepfolds which you will have forever."
We still have a couple of the mountains from that time. And as children, listening to our grandfather, we rejoiced at how Vlad fooled the Turks.

Another well-known legend from Arefu is the tale about the suicide of Vlad's wife:
It is said that Vlad the Impaler had a kind and humble wife with a heart of gold. Whenever Vlad took his sword and led his army into battle, his wife's heart grew sad.
One night a strange thing happened. An arrow entered through one of the windows of the fortress and put out a candle in their bedroom. Striking a light, she discovered a letter in the point of the arrow which said that the fortress was surrounded by the Turks.
Approaching the window she saw many flickering fires in the valley. Thinking that all was lost, and without waiting for her husband's decision, she climbed up on the wall of the fortress and threw herself into the Arges River.

This cannot be verified through historical documents.

33 *Portrait of Sultan Mehmed II* by Nakkas Sinan Bey.
Istanbul, Topkapi Palace Museum.

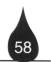

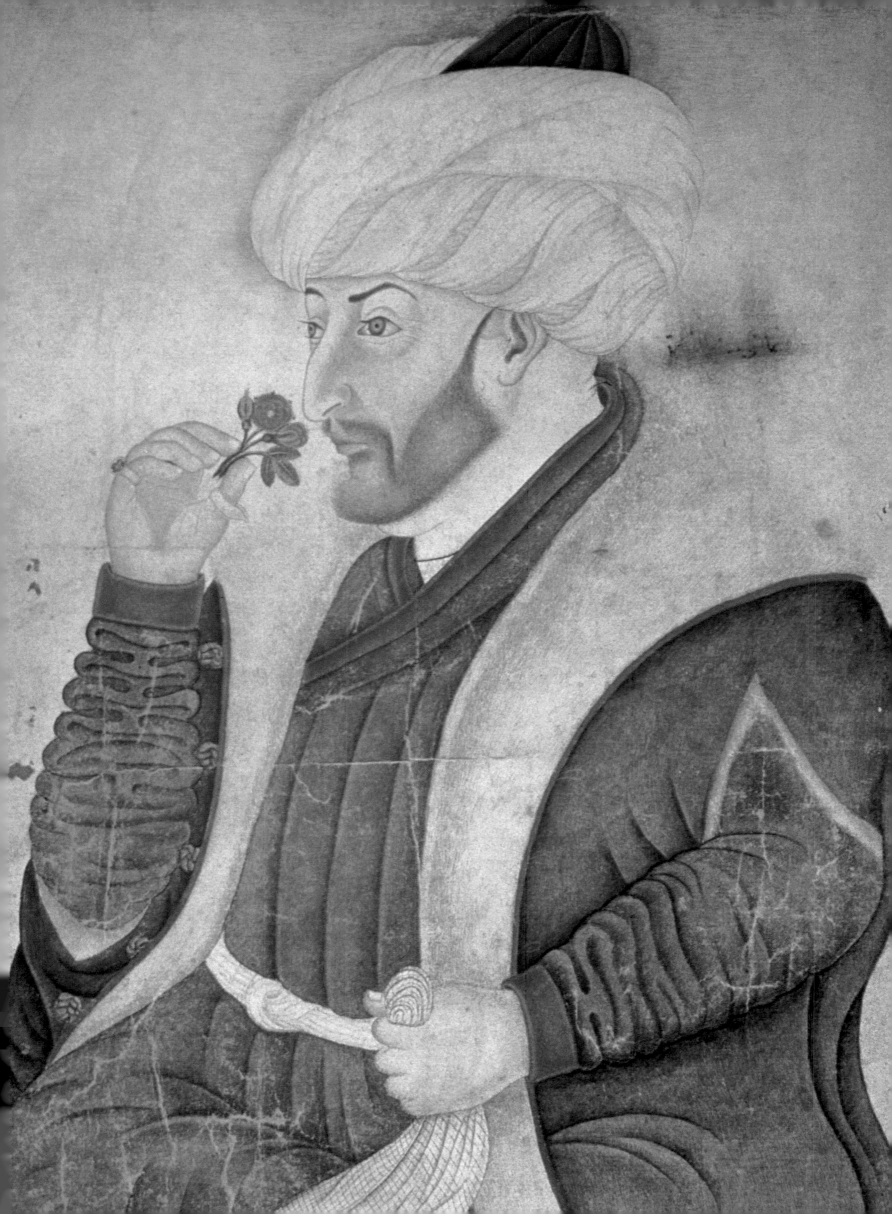

34 Movie still from a Romanian film (Doru Nastase),
1978, Soldiers Set Some Houses on Fire.

We do know that in 1462, Vlad escaped into Transylvania. But he was soon arrested near Brasov by Mathias Corvinus, King of Hungary, who had chosen to throw his support behind Radu, Vlad's successor.

Corvinus used as evidence letters supposedly written by Vlad that indicated he was a traitor to the Christian cause and was plotting to support the Turks; most historians concur that these letters were forgeries and part of a larger campaign to discredit Vlad and justify Corvinus's actions.

The earliest manuscript accounts of Vlad's atrocities appeared during this same period.
While there is no doubt that many of the atrocities noted earlier did occur, there is also reason to suspect political motivation on the part of the Hungarian king.

Dracula was held under a form of house arrest, first in a fortress in Buda and later at Visegrad, on the banks of the Danube.
Among the scant accounts of Vlad's activities at that time is one from Fedor Kurytsin, a Russian diplomat at the Hungarian court during the 1480s.
According to his manuscript, Vlad did not abandon his nasty habits even while in jail: _"He caught mice and bought birds in the market._
And he tortured them in this way: some he impaled, others he cut their heads off, and others he plucked their feathers out and let them go."

The account also records that Dracula "abandoned Orthodoxy and forsook the truth and light and received the darkness." That is, he converted to Catholicism.

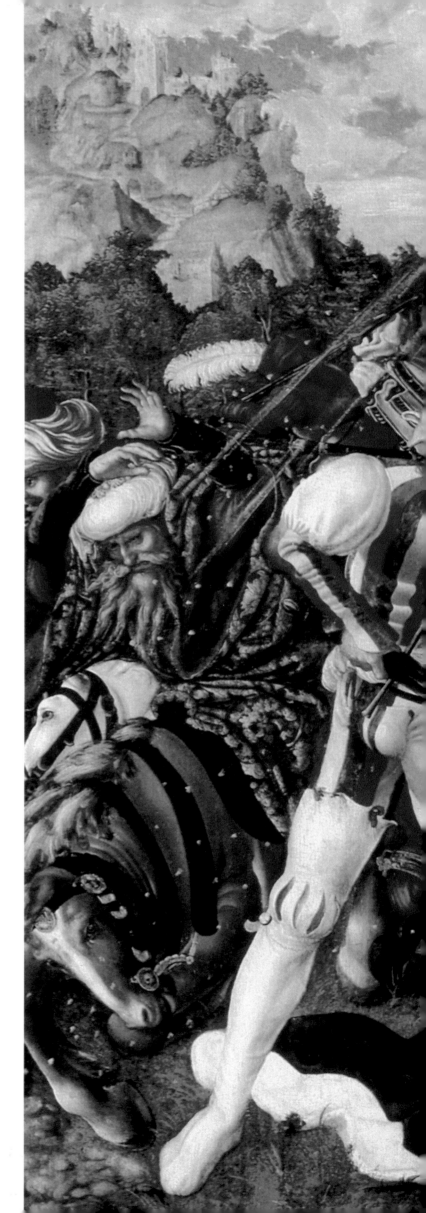

35 Lucas Cranach the Elder,
Martyrdom of St. Catherine, 1510.
Oil on panel, 112 x 95 cm. Budapest.

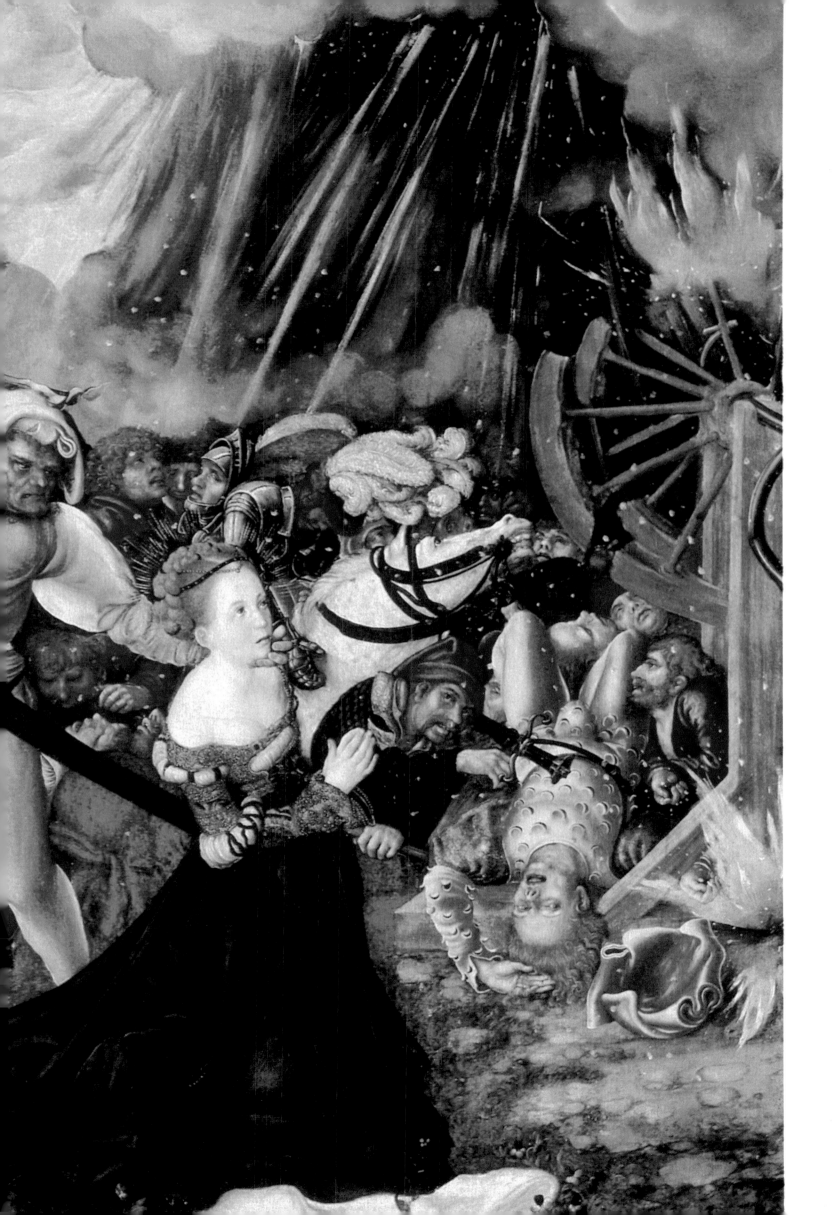

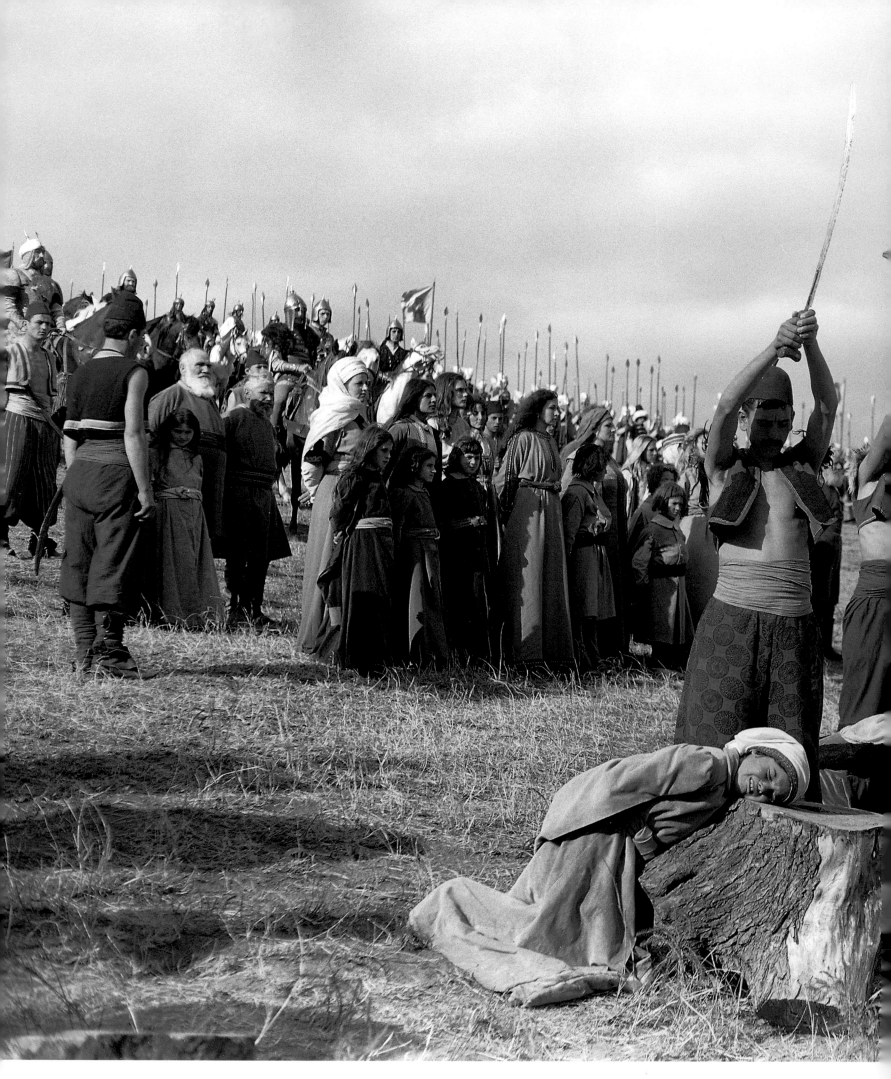

36 Movie still from a Romanian film
(Doru Nastase), 1978,
The Beheading of Some Prisoners (in color).

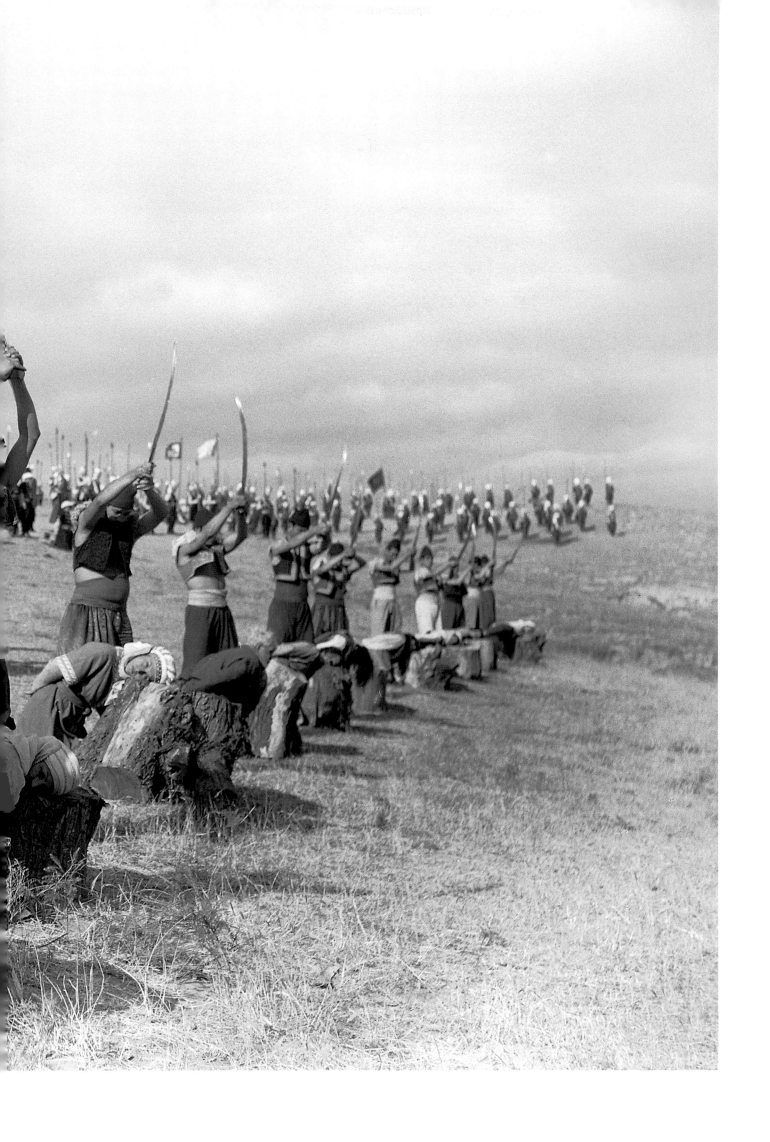

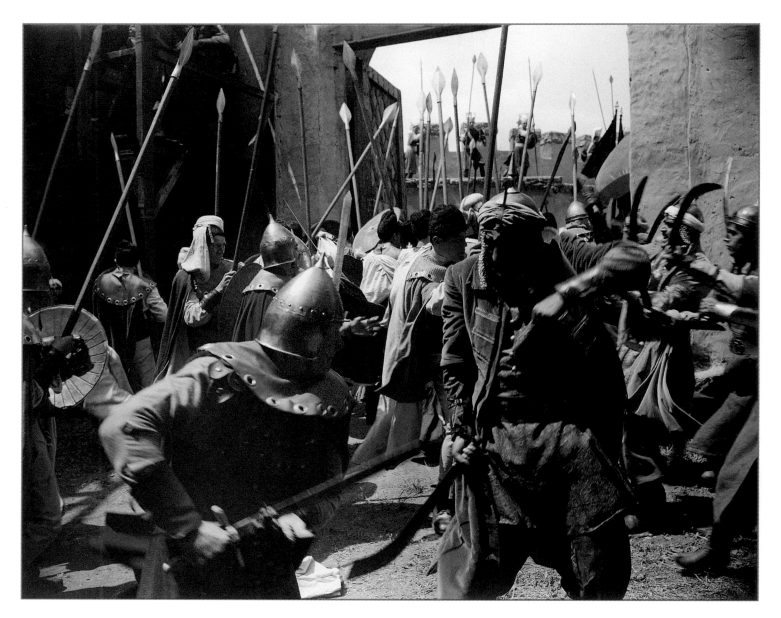

37 Movie still from a Romanian film (Doru Nastase),
1978, A Battle Scene.

This was done on the insistence of Matthias Corvinus to clear the way for Vlad to marry a member of the Hungarian royal family.

After the death of Radu in 1475, Corvinus agreed to support Vlad's reinstatement on the Wallachian throne.

Dracula quickly resumed his former practices, supporting Corvinus's attack on the Bosnian city of Srebrenica which had been occupied by the Turks, and meting out his usual means of punishment on the Moslem inhabitants. Within months, he re-entered Wallachia and was reinstated as voivode in November.

Dracula's last period of rule was short lived. In less than two months (probably near the end of December) he was killed in battle near a forest just north of Bucharest. The circumstances of his death are unclear.

A Russian source claims that he was mistaken by one of his own men for a Turk and consequently killed.

More likely is that he was attacked by a rival claimant, Basarab Laiota (who succeeded him as voivode), and killed by a hired assassin. One story goes that he was beheaded, and his head was taken back to the sultan in Constantinople and displayed as a trophy.

Even more shrouded in mystery is the location of his resting place.

Tradition has it that his body was taken by monks to the Snagov Monastery and buried there close to the altar, in recognition of the fact that he had supplied funds for the rebuilding of the monastery years earlier.

However, excavations on the site during the early 1930s failed to uncover a burial site. Where are his remains?

Some suggest that he was buried elsewhere on the monastery site where indeed remains were found but have since disappeared.
Others contend he is buried near the altar, but at a greater depth than was excavated. Yet others suggest he may have been interred in a different area altogether, such as in Targsor, in a church he had built himself. To date, the mystery remains unsolved.

Vlad left behind three sons: the eldest, Mihnea, from his union with the Transylvanian noblewoman who, according to legend, committed suicide in 1462; and two sons by his Hungarian wife - Vlad, and a second whose name is unknown. Only Mihnea succeeded in gaining the throne. During his brief rule from 1508-1509, he showed signs that he could be as atrocious as his infamous father; nicknamed "Mihnea the Bad," he is reputed to have cut off the noses and lips of his political enemies. He was assassinated in 1510 on the steps of a church in Sibiu.

38 Hans Holbein the Younger,
Bat. Black and coloured chalks,
16.8 x 28.1 cm. Art Museum, Basel.

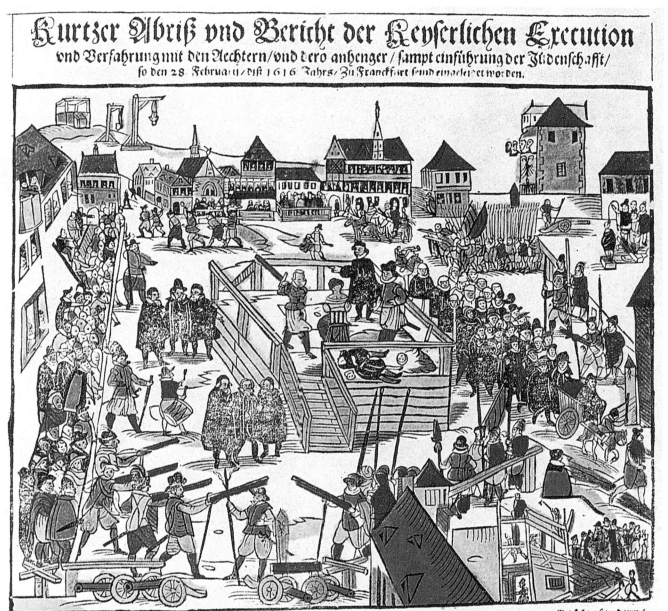

39 *Execution of rebels,* 1616.
Engraving. Frankfurt.

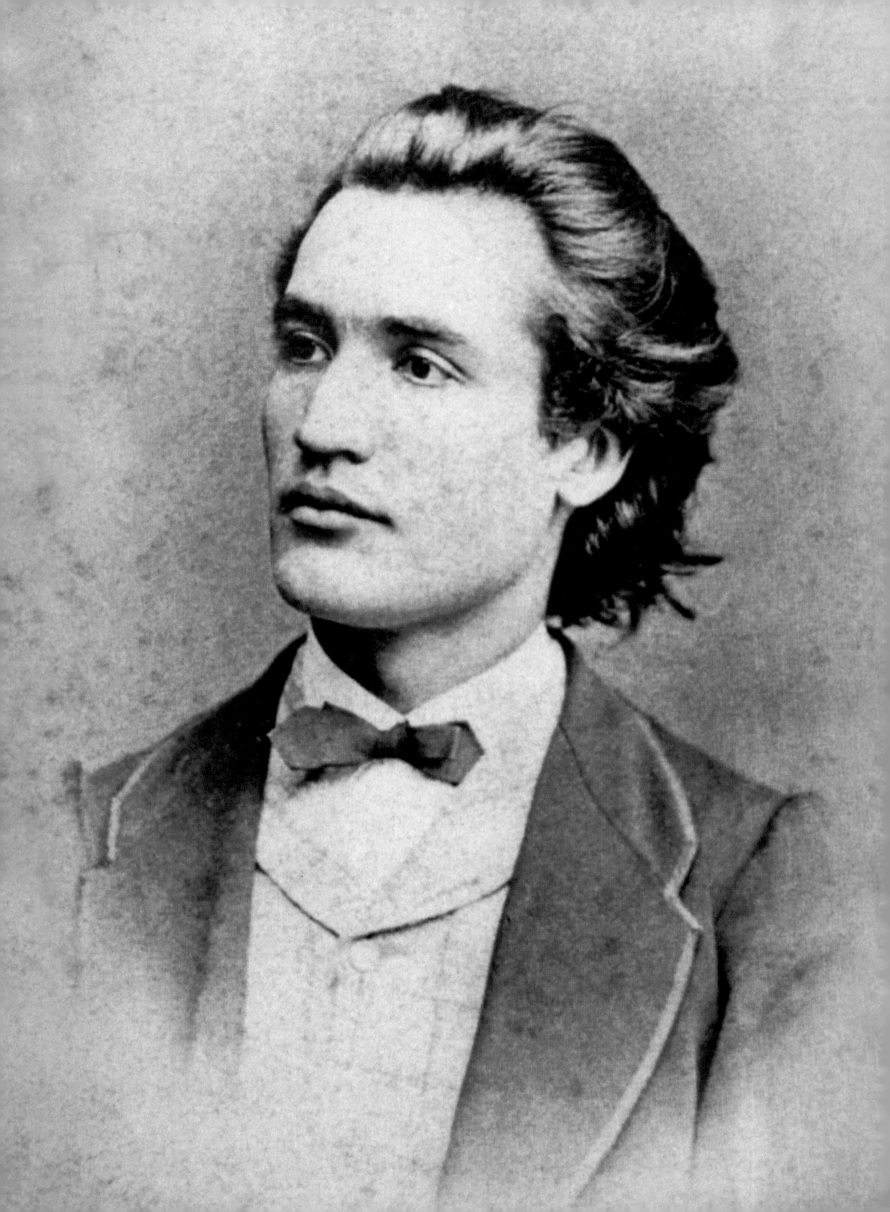

VLAD DRACULA IN THE NINETEENTH CENTURY

Following the initial flurry of interest in the late fifteenth and early sixteenth centuries, provoked in particular by the German printed pamphlets, Vlad Dracula faded into relative obscurity.

His re-emergence as a national hero coincided with the revolutionary fervour that swept through Europe in 1848 and which culminated in the formation of a Romanian state in 1859 (the union of two of the three principalities - Transylvania would not join the union until the realignment of Europe after the First World War).

Vlad made several appearances in the nationalistic literature of the period, as a number of writers, swept up in the fervor of a revolutionary movement that culminated in the formation of a Romanian state in 1859, looked back to him as a symbol of independence and nationhood.

Ion Budai-Deleanu's epic poem i*ganiada* (though actually written in the last decade of the eighteenth century) was published in 1875: here, Vlad Tepes is presented as one of Romania's first great national heroes, fighting against the Turks, the boyars and the legions of evil.

Poet Dimitrie Bolintineanu, in his "Battles of the Romanians," also praised Dracula's military exploits.

But the most famous is the oft-quoted *The Third Letter* (1881), by the late nineteenth-century poet Mihai Eminescu, who called on the Impaler to come once again and save his country:

40 Mihai Eminescu (1850-1889),
Romanian poet,
author of *The Third Letter* (1881).

You must come, O dread Impaler, confound them to your care.
Split them in two partitions, here the fools, the rascals there;
Shove them into two enclosures from the broad daylight enisle 'em,
Then set fire to the prison and the lunatic asylum."

But another picture was also emerging. In 1874, Romanian poet Vasile Alecsandri wrote a narrative entitled "Vlad Tepes and the Oaktree," which reprimands the harshness of Vlad, particularly with respect to the impalements at Târgoviste.

However, the chief challenge to the "Vlad as hero" concept came from renowned historian Ion Bogdan, whose treatise Vlad Tepes (1896) questioned the traditional image of Vlad by presenting him as a bloodthirsty tyrant whose cruelty could only be accounted for in terms of mental aberration, a sick man who killed and tortured out of sadistic pleasure.

Bogdan even went so far as to depict Vlad as a politically weak leader. Needless to say, the publication sparked a vigorous debate. That book appeared just one year before Bram Stoker's novel Dracula, which would immortalize Vlad's sobriquet in a completely different way.

This raises a fundamental question: to what extent is Stoker's vampire a literary reincarnation of the voivode? Were Vlad and his reported atrocities the inspiration for the horror tale that haunted the collective imagination of the twentieth century?

How much did Bram Stoker know about Vlad?

Before considering these questions, we need to backtrack and discover the roots of the legend of the vampire and the literary ancestors of Count Dracula.

41 *The Third Letter,* poem by Mihail Eminescu, who presents Vlad the Impaler as a national hero.

La steaua care-a răsărit
E-o cale-atât de lungă
Că mii de ani i-au trebuit
Luminei să ne-ajungă

Poate de mult s-au stins în drum
În depărtări albastre
Iar raza ei abia acum
Luci vederii noastre

Icoana stelei ce-a murit
Încet pe cer se sue,
Era, când *——————*, nu să *——* zărit.
Azi o vedem și nu e.

Tot astfel când al nostru dor
Pieri în noaptea adâncă
Lumina stinsului amor
Ne urmărește încă.

5371.

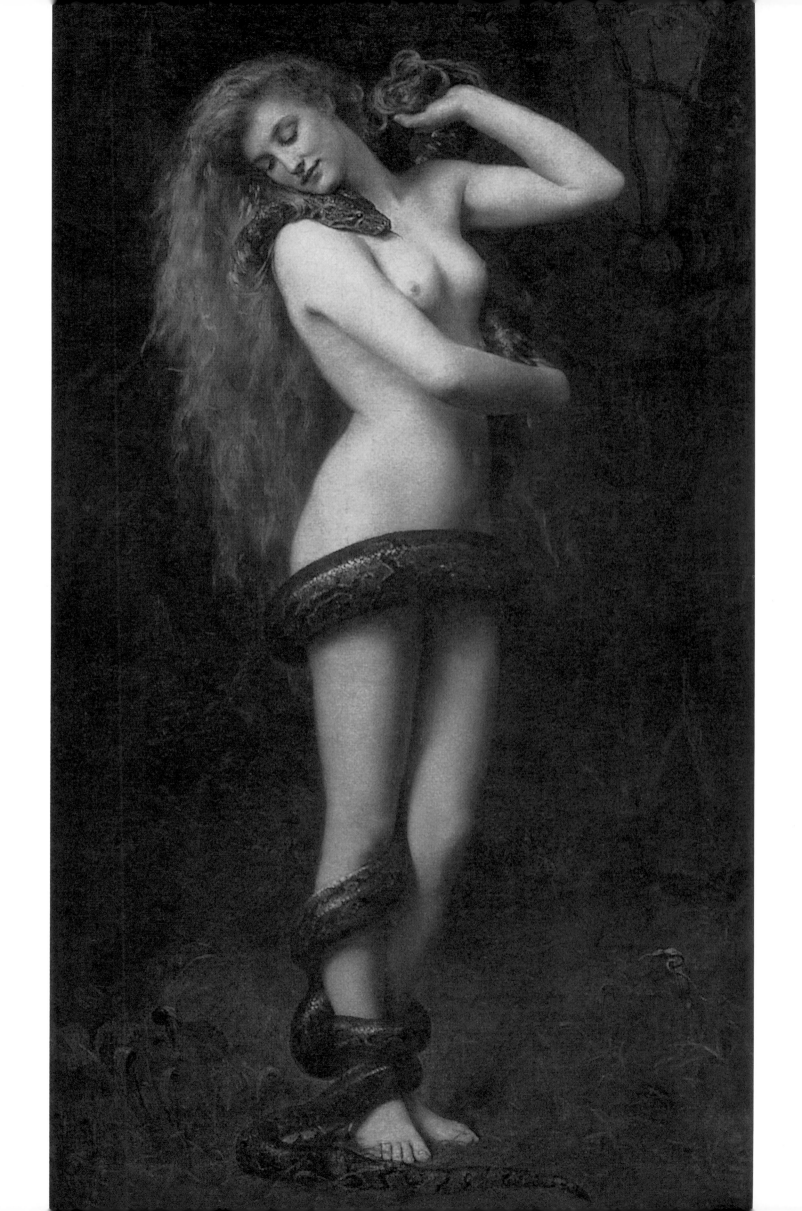

CHAPTER II

"THE BLOOD IS THE LIFE"

ORIGIN OF THE VAMPIRE

Vampires did not originate with Count Dracula. A revenant who returns from the grave to suck the blood of its victims in order to sustain its existence, the vampire has its origins in the folk legends of many countries, most specifically in central and eastern Europe.

From these roots it metamorphosed into the more familiar image that has dominated literature and popular culture for the past one hundred years. Attempts to identify the genesis of the vampire legend are fraught with difficulty.

Inquiry is further complicated by what folklorist Jan Perkowski refers to as "contamination," the process by which the vampire has been merged with other supernatural beings such as the mora, strigoi, incubus, werewolf and poltergeist.

If one confines the search to legends associated with the word "vampire" or its many variants, the trail leads to the Slavic countries of Europe.

Most folklorists concur that the word "vampire" has Slavic roots, first appearing as a proper name ("Upir") in an Old Russian manuscript of the eleventh century and as a generic term in a Serbian manuscript two hundred years later. The form "vampir" has been found in a fifteenth-century South Slavic source.

42 John Collier, *Lilith*, 1887.
Oil on canvas, 237 x 141 cm.
Southport, The Atkinson Art Gallery.

Perkowski defines the Slavic folkloric vampire as a half-human, half-supernatural being, a reanimated corpse that emerges from its grave to prey on the living, and asserts that it arose as a consequence of the clash of orthodox Christianity with dualist heterodoxy. Other scholars contend that belief in vampires existed in southern and eastern Europe before the advent of Christianity and later spread among the Slavic people who apparently passed it to their non-Slavic neighbours. Some suggest that gypsies may have brought some of the legends with them from India.

Explanations for what causes some individuals to become vampires after death differ from one folk culture to another. Some unfortunate persons are predisposed at birth: those born on certain holy days, or on the new moon; those born with a defect such as a caul, an extra nipple, or teeth; anyone who is the seventh son of a seventh son.

Others are doomed to return as vampires because of transgressions committed against acceptable codes of behaviour during their lifetime, such as practising sorcery or engaging in acts of violence.

Still others return from the dead because of the circumstances surrounding their death or burial: they died without baptism, they died in a state of excommunication, they committed suicide, they were in life attacked by another vampire, or their bodies were not buried in accordance with appropriate rituals.

We also find in the folk legends a variety of ways by which a vampire can be detected: a disturbed grave, a strange reaction by animals around a grave, tell-tale signs in a victim (anaemia, bite marks, nightmares, sleepwalking, weight loss, aversion from garlic), the appearance of the exhumed corpse of a suspected vampire (ruddy, and/or bloated appearance, new nails or hair, lack of decomposition, presence of blood).

Not surprisingly, ways were devised to cure the community of such visitations. The most widespread was to drive a wooden stake through the heart of the vampire; other techniques included decapitation, drenching the body in garlic or holy water, extracting and burning the heart or burning the entire corpse.

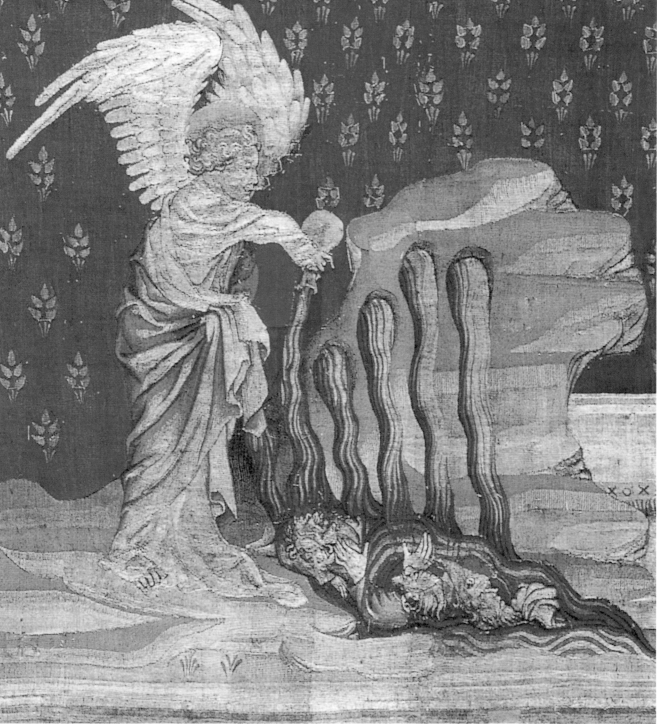

43 Nicolas Bataille, detail from
the Apocalypse of St John, 1377.
Tapestry. Museum of the Tapestries,
Angers (France).

Though the term "vampire" is of comparatively recent vintage, the image goes back much further in time. If one applies a more liberal definition (including either the return from the dead or the blood drinking), one can identify "vampires" in various cultures around the world, including a wide range of revenants, ghosts and restless spirits.

Thus we find evidence of "vampirism" in diverse places: for example, in drawings from ancient Babylonia and representations of the goddess Kali of India. Also identified by some scholars as archetypal sources for vampire legends are the lamia of Greek mythology and the Jewish Lilith. Vampire-like creatures appear in the folk tales of Malaysia, China, Australian aboriginals, Romania, Germany, Ireland and Greece.

The two powerful components of the legend - blood and death - have firm roots in ancient myth and practice. Since early times, human beings have been aware of the link between blood and life. Blood has been perceived as both a literal and a figurative representation of family, race, culture and power. A loss of blood results in weakness and often loss of life itself. Not surprisingly, pre-scientific societies attached magical and supernatural properties to this body fluid. Some warriors, for example, believed that drinking the blood of an enemy would permit them to absorb some of their opponents' strength.

Ritualistic use of blood flourished in many ancient religions, primarily as part of animal (or even human) sacrifices. Most significantly, blood sacrifice is an inextricable part of the Judeo-Christian tradition. Mosaic law required of the ancient Israelites that they sprinkle the blood of sacrificial animals on the altars of the Most High as a form of atonement for the sins of the people. That blood was considered sacrosanct was reflected in the proscriptions against its consumption. God commanded Noah: "But flesh with the life thereof, which is the blood thereof, shall ye not eat" (Gen. 9:4).

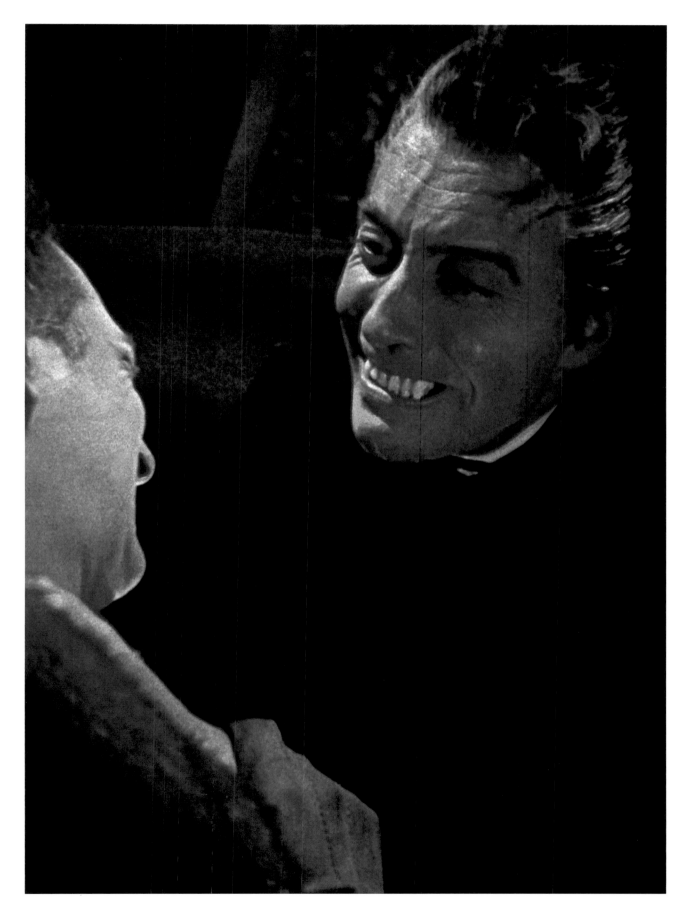

44 The vampire needs the blood
of its victim to sustain its existence.
Horror of Dracula, 1958.

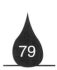

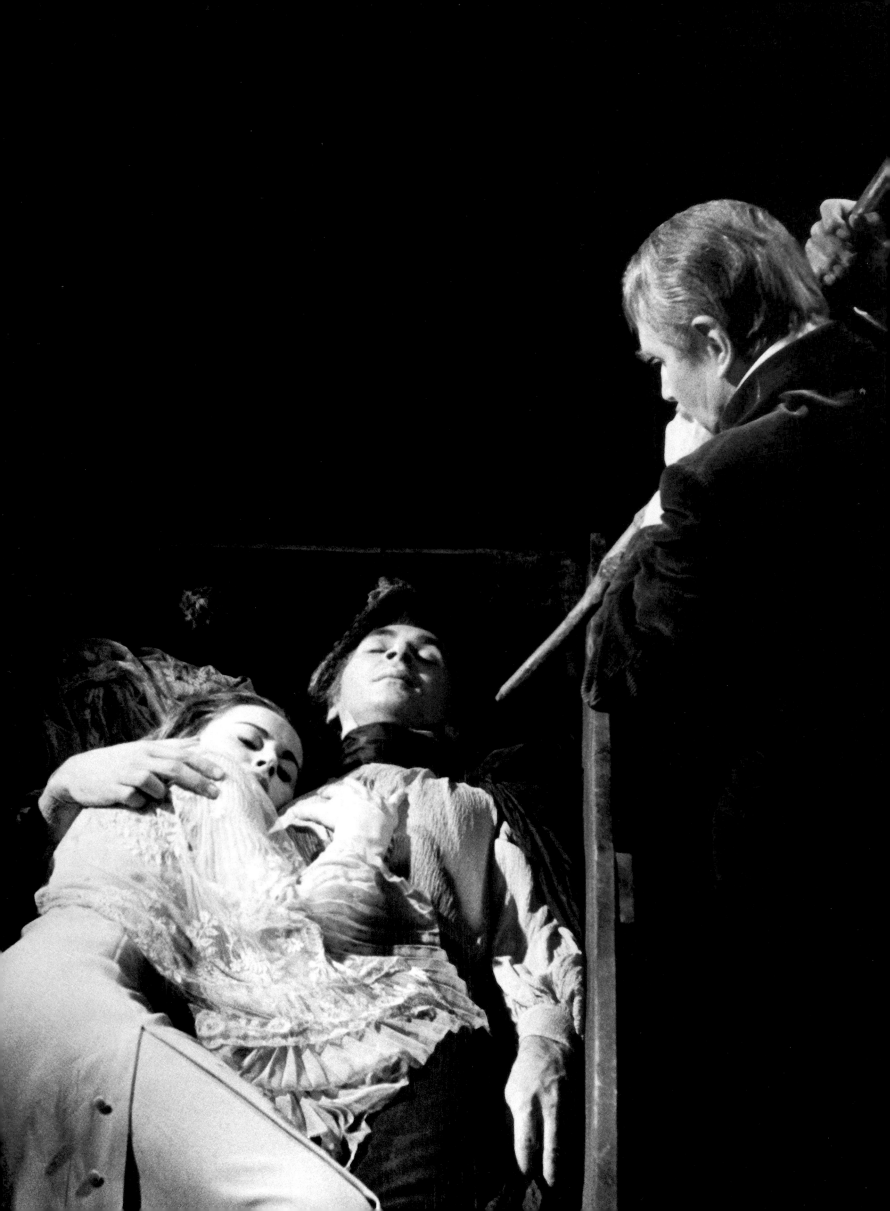

Again, God's law to Moses required "Only be sure that thou eat not the blood, for the blood is the life" (Deut. 12:23) and "Ye shall eat the blood of no manner of flesh; for the life of all flesh is the blood thereof; whosoever eateth it shall be cut off" (Lev. 17:14).

The Christian Church revitalized this ancient practice, giving it new meaning and significance. Christ was presented as the Lamb who was sacrificed for the sins of the world. Jesus instituted the Lord's Supper during which he took a cup of wine and told his disciples, "Drink from it, all of you. For this is my blood, the blood of the covenant, shed for many for the forgiveness of sins" (Matt. 27:24-26). In the Book of Revelation, John spoke of Jesus as the one who "freed us from our sins with his life's blood" (Rev. 1:5). Blood became even more central to the Christian Church in the practice of the Eucharist, in which the red wine that the priest would drink was declared to be the very blood of Christ. The forbidding of blood-drinking combined with the sacredness of the precious blood of Christ gave new significance to vampirism: not only was the vampire consuming blood in direct defiance of the biblical command, it was defiling the very blood of Christ. The second common denominator in vampire folk legends is death. The combination of the fear of death and the terror at the prospect that the dead might return to take us with them to the grave lies behind the many legends and folktales about various forms of revenants. Again we find an intersection with a central doctrine of Christianity: that of a corpse rising from the tomb.

After the split of the Christian Church into Eastern Orthodox (Greek) and Roman Catholic (Latin) branches in 1054, the two churches were in competition in central and eastern Europe, those areas where vampire legends were most predominant. Gordon Melton observes the following connection:

Meanwhile, quite apart from the major doctrinal issues which had separated them in the eleventh century, the theology in the two churches began to develop numerous lesser differences.

45 One of the ways to get rid of vampires :
Professor Van Helsing is about to drive a stake
into Count Dracula's heart. *Dracula*, 1979.

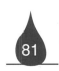

46 Vampires' taste for blood.
Bram Stoker's Dracula by Francis Ford Coppola, 1992.

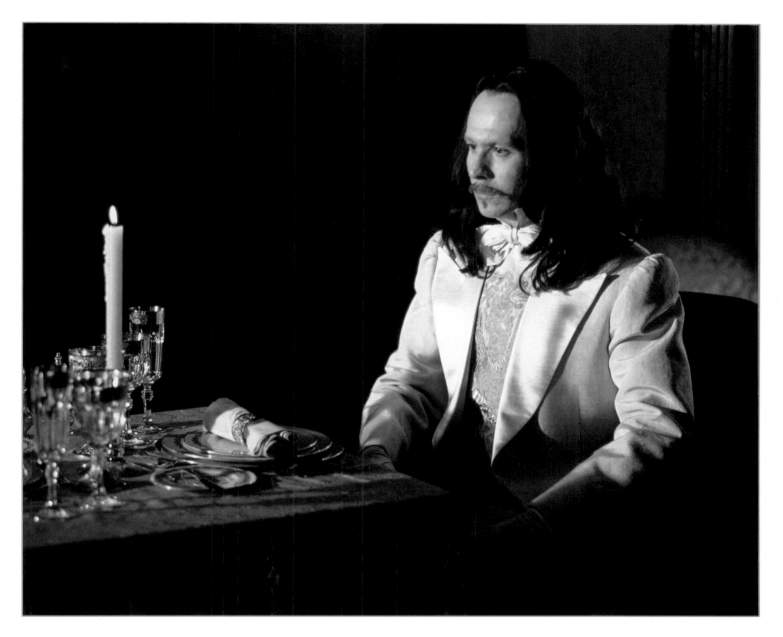

47 The "Satanic Lord".
Bram Stoker's Dracula, 1992.

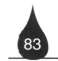

These would become important especially in those areas where the boundaries of the two churches met and wars brought people of one church under the control of political leaders of the other. Such a situation arose, for example, in the twelfth century when the predominantly Roman Catholic Hungarians conquered Transylvania, then populated by Romanians, the majority of whom were Eastern Orthodox. Slavic but Roman Catholic Poland was bounded on the east by Orthodox Russian states. In the Balkans, Roman Catholic Croatia existed beside predominantly Orthodox Serbia.

One doctrinal difference that was to influence the vampire legend was the contrasting position on the non-corruptibility of dead bodies. In the East, the failure of the soft tissue of a body to decay quickly once buried was interpreted as a sign of evil. That the body refused to disintegrate meant that the earth would, for some reason, not receive it. A non-corrupting body was thus added, in some Orthodox countries, to the list of causes of vampirism. In the West, quite the opposite was true. The body of a dead saint often did not experience corruption like that of an ordinary body. These contrasting interpretations could help to explain why belief in vampires was more pronounced in Orthodox than in Catholic countries.

By the mid-seventeenth century, however, a change in attitude towards vampire legends had taken place in the Catholic Church, in line with already accepted positions on witchcraft. The official statement on witches had been published in the 1480s in the Malleus Maleficarum, prepared by two Dominican monks, both of whom had been appointed Inquisitors by Pope Innocent VIII. Following the Pope's admonition in a papal Bull of 1484 to the effect that many had strayed from their Catholic faith and had abandoned themselves to devils, incubi and succubi, the two set forth to prove the existence of witches, to establish methods of identification and to prescribe examination and punishment. The underlying premise was that rather than products of superstitious minds, witches were very real manifestations of the devil.

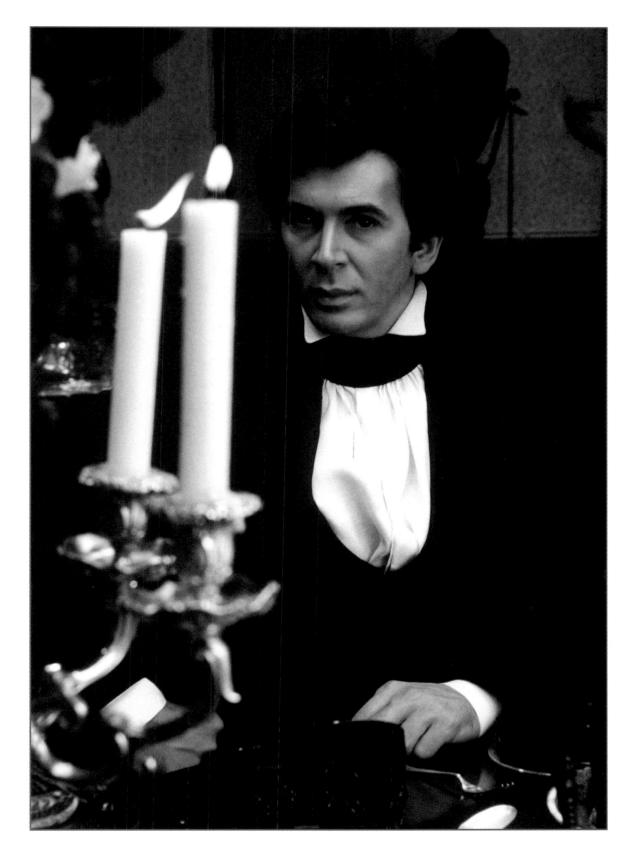

48 The «Demon Lover»
who aroused forbidden desires.
Dracula, 1979.

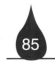

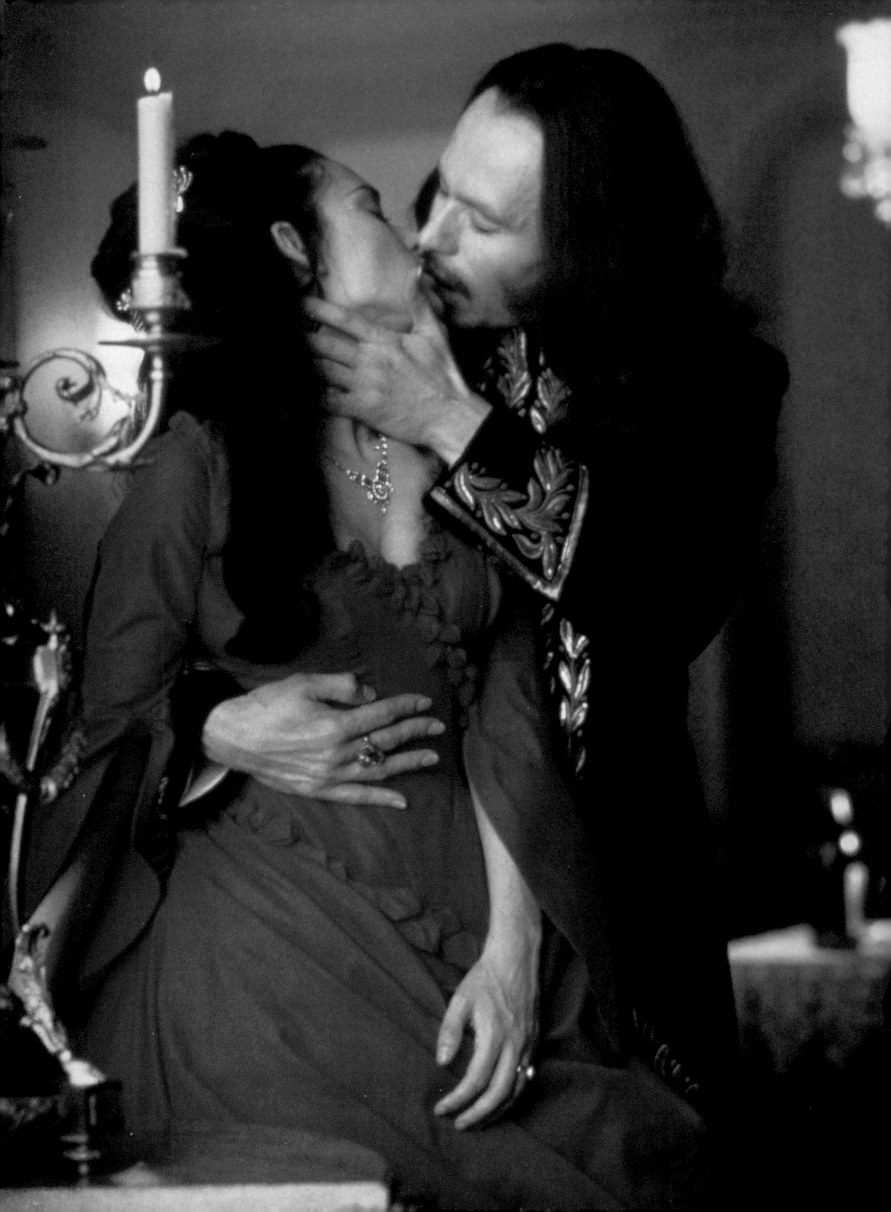

In 1645 there appeared the first serious treatise of the subject of vampires. *De Graecorum hodie quorundam opinationibus.*

Its author, Leo Allatius, a Greek Roman Catholic, chose to focus primarily on the vrykolakas, the Greek vampire, a dead man who remained whole and incorrupt, thus not following the expected pattern of rapid disintegration in a time before embalming.

Allatius asserted that these vampires were real and were the work of the devil; that they were bodies reanimated by the devil and his minions. Melton suggests that this tying of vampirism to the devil by Allatius and his colleagues brought Satan into the vampire equation:

Vampirism became another form of Satanism and the vampire the instrument of the devil. Also, his victims were tainted by evil. Like the demons, vampires were alienated from the things of God.

They could not exist in the realms of the sacred and would flee from the effective symbols of the true God, such as the crucifix, or from holy things, such as holy water and the eucharistic wafer, which both Orthodox and Roman Catholics believed to be the very body of Christ.

In like measure, the offices of the church through the priest were an effective means of stopping the vampire. In the Eastern Orthodox church, the people always invited the priest to participate in their antivampire efforts.

In its attempt to counter the superstitious belief in vampires, the Orthodox church ordered its priests not to participate in such activities, even threatening excommunication.

49 The Image of the vampire as a seductive aristocrat who lure attractive young women. *Bram Stoker's Dracula, 1992.*

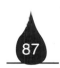

50 Richard Westall, *Lord Byron*, 1813.
Oil on canvas, 91.4 x 71.1 cm.
London, The National Portrait Gallery.

EIGHTEENTH-CENTURY VAMPIRE SIGHTINGS

It was the folkloric vampire of central and eastern Europe that penetrated western culture and to make "vampire" a household word in the English language.

The triggering mechanism was a rash of vampire sightings reported throughout the eighteenth century primarily in Hungary, Moravia, Silesia, Poland and Serbia. These incidents prompted a number of reports [3].

In 1706, a treatise entitled Magia Posthuma appeared in Moravia. Its author, Charles Ferdinand de Schertz, recorded several attacks attributed to vampires as who were targeting former neighbours and livestock. Those people who were attacked grew pale and fatigued. In one specific case, that of a Bohemian villager, "whomever he visited died within eight days.
The villagers finally dug up the man's body and drove a stake through it.... After several more attacks occurred, his body was burned. Only then did the visitations end".

Schertz's main concern was for the legal process involved in such responses: he urged that the bodies of suspected vampires be examined by both medical and church representatives, and that the destruction be carried out as an official act. Schertz's treatise evoked a number of responses, including Johann Heinrich Zedler who, in his *Universal Lexicon* (published in Leipzig between 1732 and 1754), argued that such sightings were to be attributed to dreams and mental illness. Even more sceptical was Giuseppe Davanzati, whose *Dissertazione sopra I vampiri* (1743) disavowed the existence of vampires, a position that was supported by the current pope, Benedict XIV.

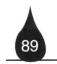

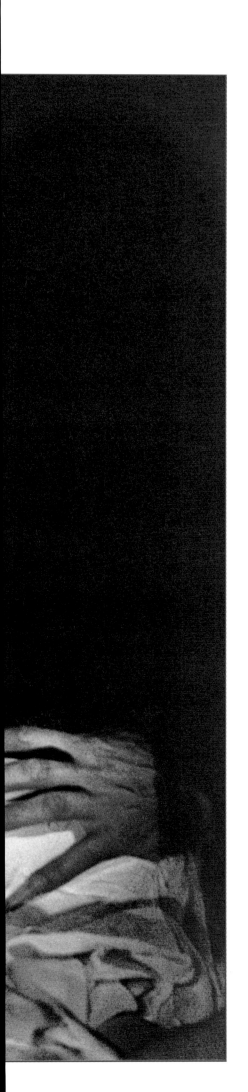

By far the most influential of all the treatises on these vampire sightings was that of a French Benedictine abbot, Dom Augustin Calmet (1672-1757) whose work was first published in 1746 [4].

Determined to keep an open mind, Calmet posited that "If the return of vampires is real, it is of import to defend it, and prove it; and if it is illusory, it is of consequence to the interests of religion to undeceive those who believe in its truth, and destroy an error which may produce dangerous effects".

The most famous of the cases cited by Calmet was that of Arnold Paul:

About five years ago, an inhabitant of Madreiga (in Austrian Serbia) named Arnold Paul was crushed to death by the fall of a wagon-load of hay.

Thirty days after his death, four persons died suddenly, and in the same manner in which, according to the traditions of the country, those die who are molested by vampires.

They then remembered that this Arnold Paul had often related that in the environs of Cassovia and on the frontiers of Turkish Serbia he had often been tormented by a Turkish vampire; for they believe also that those who have been passive vampires during life become active ones after their death, that is to say, that those who have been sucked, suck also in their turn; but that he had found means to cure himself by eating earth from the grave of the vampire, and smearing himself with his blood; a precaution which, however, did not prevent him from becoming so after his death, since, on being exhumed forty days after his interment, they found on his corpse all the indications of an archvampire.

51 Nosferatu the vampire sucking the blood of his victim. *Nosferatu the Vampyre,* 1979.

His body was red, his hair, nails and beard had all grown again and his veins were replete with fluid blood, which flowed from all parts of his body upon the winding sheet which encompassed him.

The Hadnagi of the village, in whose presence the exhumation took place, and who was skilled in vampirism, had, according to custom, a very sharp stake driven into the heart of the defunct Arnold Paul, and which pierced his body through and through, which made him, as they say, utter a frightful shriek, as if he had been alive: that done, they cut off his head, and burnt the whole body.
After that they performed the same on the corpses of the four other persons who died of vampirism, fearing that they in turn might cause the death of others.

In another report, the body of Peter Plogojovitz of the Hungarian village of Kesolova, was said to have been exhumed by an officer of the emperor who asserted that "in his mouth (was) some fresh blood, which these people believed that this vampire had sucked from the men whose death he had occasioned".
As a consequence, a sharp pointed stake was driven into the corpse "whence there issued a quantity of fresh and crimson blood" which served only to confirm local convictions concerning vampirism.

Dozens of similar reports of horrifying encounters with the dead emanating from many regions evoked an electrifying reaction. For example, a popular version of the Arnold Paul case was a bestseller at the Leipzig book fair in 1732.
In some areas, government and religious officials felt obliged to carry out official investigations. Some of these sensational stories were picked up by British publications, including the _London Journal_ and _Gentleman's Magazine_, both of which carried accounts during 1732.

52 *A Vampire rises from the grave,*
illustration for an early
eighteenth century treatise on the living.

53 Title page for
Heinrich Marschner's opera
Der Vampyr.

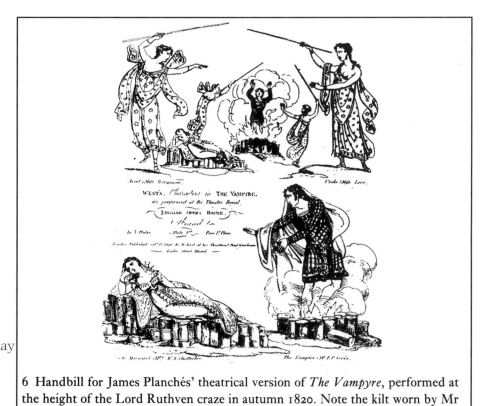

54 Engraving by J. Findlay from J. R. Planché's *The Vampire or The Bride of The Isles.*

6 Handbill for James Planchés' theatrical version of *The Vampyre*, performed at the height of the Lord Ruthven craze in autumn 1820. Note the kilt worn by Mr T. P. Cooke in the role of Lord Ruthven.

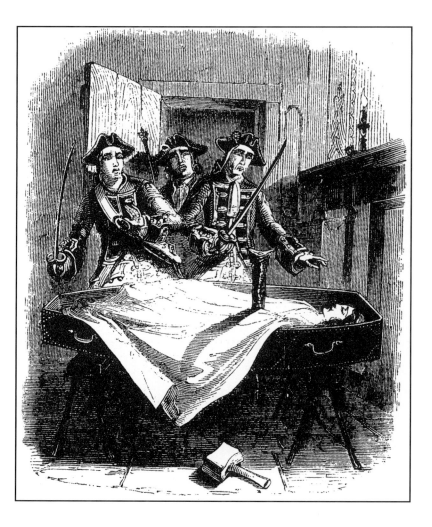

55 Illustration for *Varney the vampire* by James Malcolm Rymer, 1847.

Thus the word "vampire/vampyre" officially entered the English language.

Though he condemned the hysteria which had followed reported incidents of vampirism and the mutilation of exhumed bodies, Calmet was unable to reach a definitive conclusion.

On the one hand, he did concede the possibility of the existence of vampires by noting that "such particulars are related of them, so singular, so detailed and attended by such probable circumstances and such judicial information, that one can hardly refuse to credit the belief".

Yet elsewhere he asserts that he requires "unprejudiced witnesses" and is persuaded that "no such witness will be found". The hysteria continued as a result of the publication of Calmet's book. Austria's Empress Maria Theresa even stepped in after a new outbreak of vampirism had been reported in Silesia.

The physician that she sent to investigate the case declared the incident false, leading the empress to pass decrees aimed at stopping the spread of the vampire hysteria and ensuring that all investigations were conducted by civil rather than religious authorities.

Even the leading scholars of the eighteenth century, including Diderot, Rousseau and Voltaire, were drawn into the debate. The latter, the greatest of the Enlightenment philosophers, exclaimed in the supplement to his Dictionnaire Philosophique: "What! Vampires in our Eighteenth Century? Yes, in Poland, Hungary, Silesia, Moravia ... (but) there was no talk of vampires in London, or even Paris.

I admit that in these two cities there were speculators, officials and businessmen who sucked the blood of the people in broad daylight, but they were not dead (though they were corrupted enough).... The true vampires are the churchmen who eat at the expense of both the king and the people".

Several explanations have been offered to account for the significant number of cases.

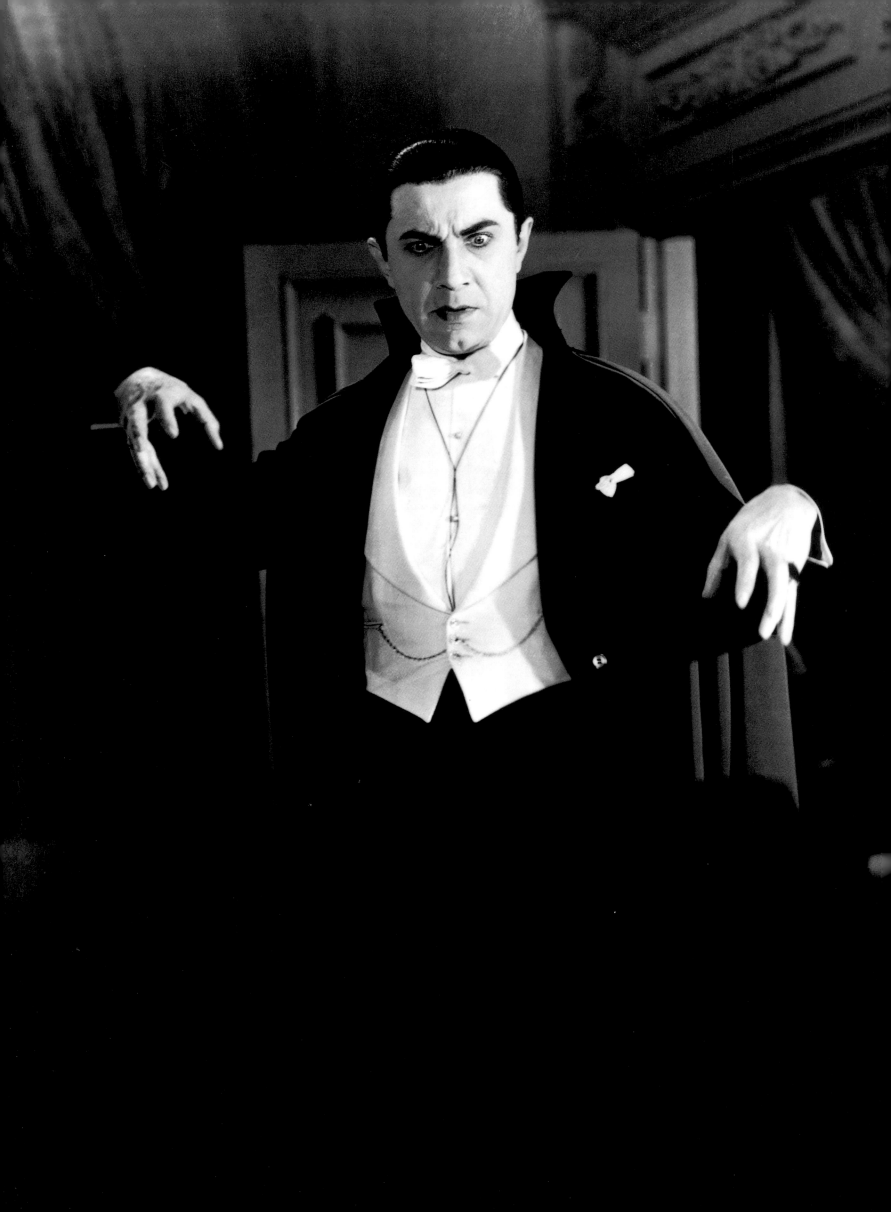

Calmet himself proposed premature burial as a possible factor in some of the reports:
"We have an infinite number of instances of persons supposed to be dead, who have come to life again, even after they have been put in the ground", noting even cases where an exhumed body showed life and was promptly dispatched with a stake through the heart.

In the Europe of the early 1700s, science was in its infancy, and superstition was still rampant. Infectious diseases (such as the plague) were often blamed on supernatural causes (or on religious fanatics, on the devil himself).
Other explanations include the frequent occurrence of premature burial and of unnaturally well-preserved corpses.
Also suggested are outbreaks of rabies, the symptoms of which might have been explained as the result of an attack by a vampire.

Theological confusion, as the result of Greek Orthodox Church making inroads on Roman Catholicism over the question of the corruption of the body after death, as well as concern that the vampire was a hellish imitation of Christ and the doctrine of transubstantiation may also have played a part.

Voltaire had singled out the Greeks and their Orthodox faith, which insisted that the bodies of Christians of the Latin church, buried in Greece, do not decay, because they are excommunicated. Some even suggest that priests deliberately gave credence to the vampire in order to keep the common folk under their sway.

Modern anthropologists, most notably Paul Barber, have proposed more scientific explanations for at least some of the reported sightings.

56 Bela Lugosi as a theatrical vampire.
Movie still from *Dracula* by Tod Browning, 1931.

Foremost was a lack of understanding of the process of decomposition of the human body after death and burial coupled with the conviction that disease was spread by the dead.

When a corpse was exhumed, the investigators would find signs which today we understand, but which to them would have confirmed their folkloric beliefs.

For example, we now know that bodies which are buried decompose more slowly, that rigor mortis is a temporary condition and that corpses can actually emit a "groan" due to built-up gases.

Other "vampires" might well have been victims of consumption (tuberculosis), whose symptoms (increasing pallor and loss of energy, pressure on the chest, coughing up of blood) were interpreted as evidence of vampire attacks [5].

Premature burial was no doubt a factor in some cases; indeed, in the nineteenth century, one ingenious inventor patented a product that would ensure a "deceased" the means of alerting those above should he awaken in his coffin.

57 Hans Holbein the Younger, *Two Death's-heads on the Embrasure of a Window*, 33 x 25 cm. Bâle.

58 Bela Lugosi as a theatrical vampire. Movie still from *Dracula* by Tod Browning, 1931.

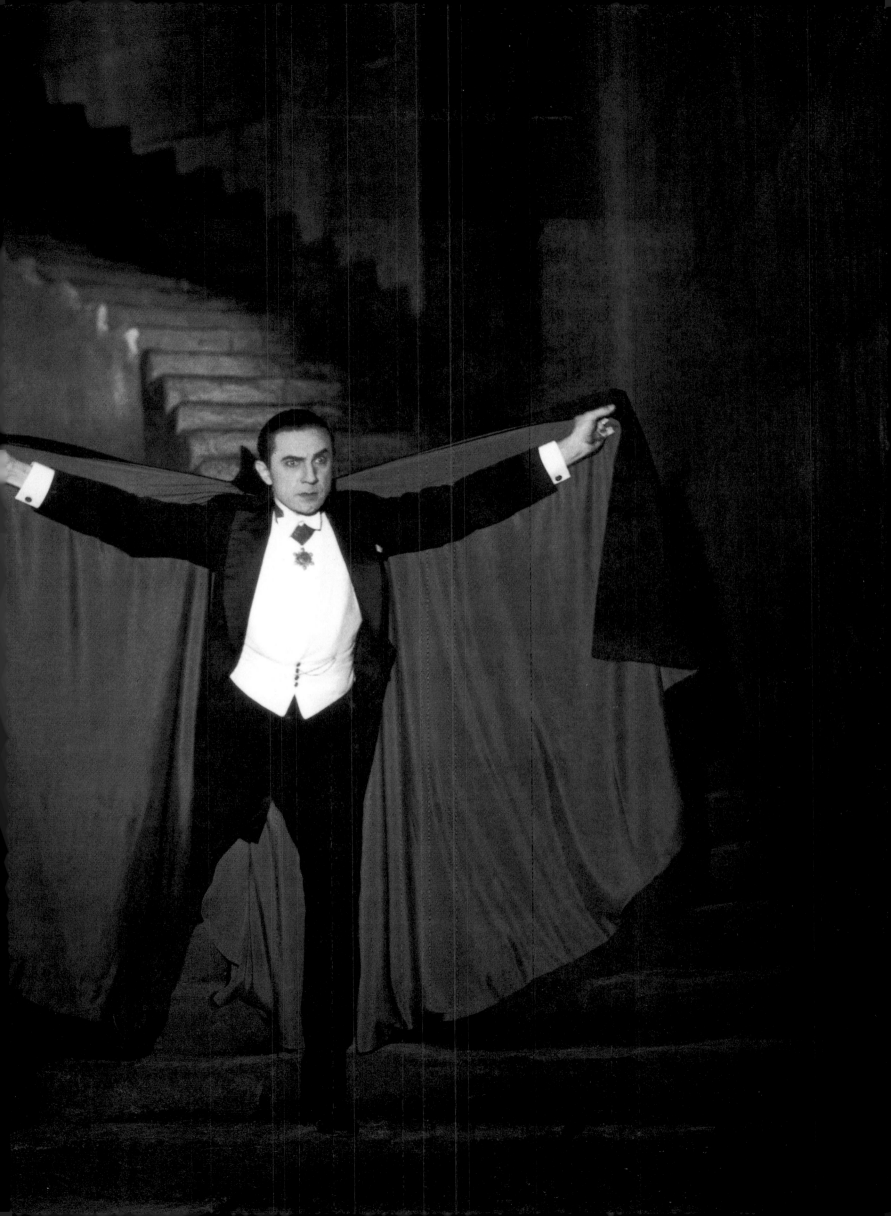

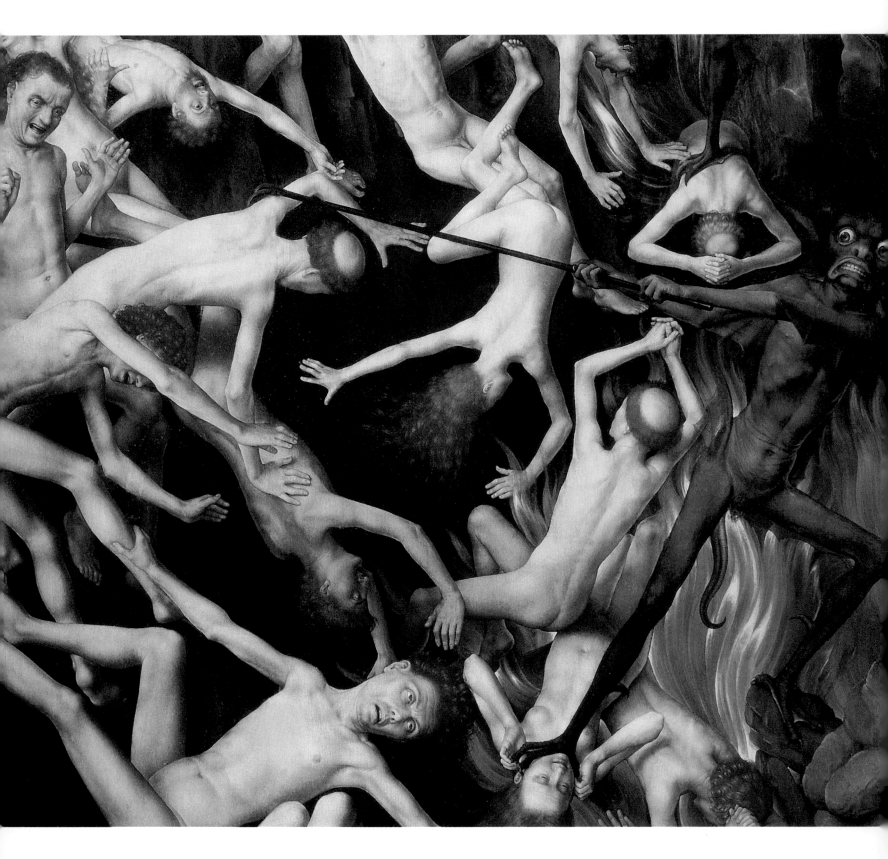

59 Hans Memling, Triptych of _The Last Judgment_ (detail: _The Damned_),
1472. Oil on panel, Muzeum Narodowe, Gdansk.

THE SATANIC LORD

Though the Age of Reason may have succeeded in relegating the vampire back to the realm of superstition, the bloodsucking monster would re-emerge through an even more powerful and enduring medium - the literary imagination.

Over the next one hundred years, the vampire would be transformed from the walking corpse who returned to his village to prey on his loved ones to the suave, seductive aristocrat who lured virginal maidens to his medieval castle.

The attention given to vampirism coincided with (and maybe contributed to) a rising interest in Gothic literature, first in Germany and later (during the last decades of the eighteenth century) in England.

The Gothic movement developed from the same impulses that shaped the Romantic Age: the focus on subjective experience, the emphasis on the imagination as the central human faculty, the revival of interest in medievalism and, most essentially, the reaction against rationalism and empirical science.

Gothic literature, the dark side of Romanticism, explored the nonrational, intuitive and chaotic aspects of the self.

The term "Gothic" owes its etymology to the Goths, one of the many tribes that invaded the Roman Empire.

The term came to signify "medieval" as in a style of architecture, but later it was applied to a new type of fiction that used medieval settings with castles, dungeons and the supernatural, with the added connotations of barbaric, wild and lacking in literary decorum. The movement in England was fed by several factors: *"Sturm und Drang"* in Germany, especially *Goethe's The Sorrows of Young Werther* (1774) with its heightened subjectivity, a powerful motif in the Gothic novel.

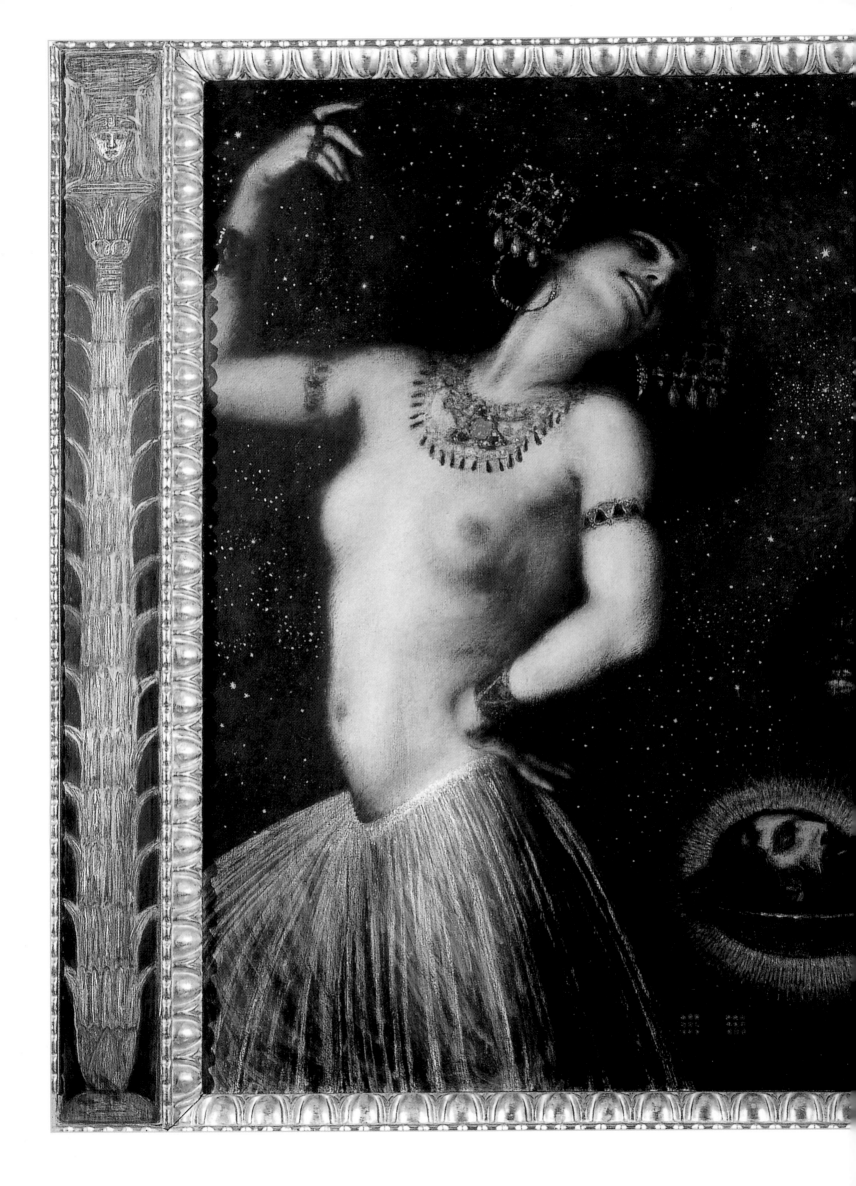

Other influences included the English "Graveyard Poets" whose works drew attention to the more physical and hence morbid aspects of death and human mortality; Edmund Burke's essay on the sublime, the German literary concept of the "doppelganger" and interest in nightmares, all of which pointed to the fragility of the rational, ordered world.

As with the Romantics in general, the Gothic authors went back to the myths of Prometheus, the Wandering Jew, Faust and, of course, Satan as filtered through John Milton in *Paradise Lost*.

By the time the nineteenth century began, the major conventions that we now associate with the genre were in place. Drawing on the patterns of chivalric romance, these novels re-enacted the medieval tales of knights in shining armour rescuing delicate maidens from monstrous antagonists.

Invariably set in foreign (usually Catholic) countries, British Gothic novels firmly established the convention of the Gothic villain, first introduced in Walpole's *The Castle of Otranto* (1764), and further refined by Ann Radcliffe in *The Mysteries of Udolpho* (1794) and *The Italian* (1797) and Matthew Lewis in *The Monk* (1796).

The prototypical villain, in whom the threat of evil was combined with the mysterious and often the supernatural, was an aristocrat whose appearance verified his true nature.

Radcliffe, for example, describes Schedoni, the villain of *The Italian* as tall, extremely thin and clad in black garments.

60 Franz von Stuck, *Salomé*, 1906,
oil on canvas, 115.5 x 62.5 cm. Munich,
Städtische Galerie im Lenbachhaus.

Lewis's evil monk, Ambrosio, was even more striking in appearance, with his aquiline nose, large penetrating eyes and dark brows almost joined together.

Anatomical features such as aquiline noses and bushy eyebrows would be employed regularly by Gothic writers as signifiers of degenerate and predatory humanity.

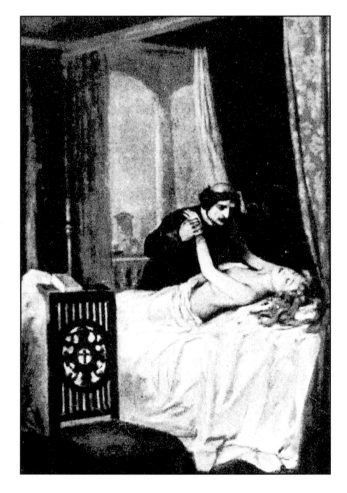

61 Illustration for Théophile Gautier's *The Vampire.*

The Gothic villain incorporated the "demon lover" whose appearance aroused forbidden desires. His most frequent abode was a faraway medieval castle, which, with its broken battlements against a backdrop of rolling clouds, steep precipices and tumultuous streams, quickly became part of the common stock of Gothic motifs. Even the approach would present a threat, with roads winding through mountainous terrain amidst the gloom and vastness of precipices and roaring water.

Not surprisingly, vampires drew the attention of the Gothic authors. Literary vampires made their debut in German literature in the second half of the eighteenth century, in works such as Heinrich Ossenfelder's *"Der Vampir"* (1748), *Goethe's "Die Braut von Korinth"* (1797) and Ludwig Tieck's short story *"Wake Not the Dead"* (1800).

While vampiric imagery abounds in much British Romantic poetry and art (Coleridge's _"The Rime of the Ancient Mariner,"_ Keats's _"Lamia"_ and Fuseli's _"The Nightmare,"_ for example), the first specific appearance of the vampire in English literature was in Robert Southey's Thalaba, the Destroyer (composed 1797-1800). Southey was a prolific poet best known today as the target of Lord Byron's great satirical poem _The Vision of Judgment_ (1822). During the course of his elaborate Gothic tale, Southey's hero encounters his deceased lover who returns from her tomb as "a vampire corpse." Of greater

significance than the fleeting reference in the poem was a copious gloss provided by the poet which outlined vampire beliefs and practices in Hungary, Greece and Turkey. Southey included Calmet's account of the Arnold Paul incident, as well as excerpts from Tournefort's _A Voyage into the Levant_ (1718) which included an account of vampires on the Greek island of Mykonos. But the poet who was to put his own indelible imprint on the embryonic image of the literary vampire was Lord Byron. Several years after the appearance of Southey's poem, Byron had

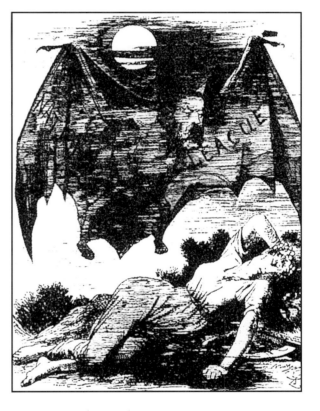

62 The Irish vampire , drawing by John Tenniel, Punch, 24 october, 1885.

published a narrative tale in verse entitled _"The Giaour"_ (1812) which contains this distinctively vampiric curse:

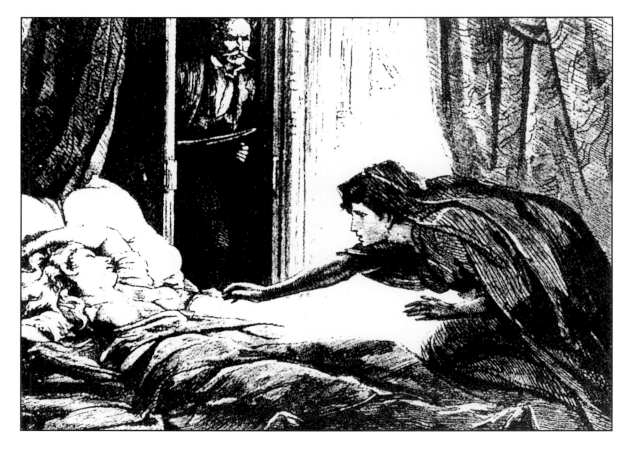

63 D. M. Friston, *Carmilla* ,
illustration for the novel of J. Sheridan Le Fanu,
Dark Blue Magazine, 1871.

> *But first, on earth as Vampire sent*
> *Thy corpse shall from its tomb be rent:*
> *Then ghastly haunt thy native place,*
> *And suck the blood of all thy race;*
> *There from thy daughter, sister, wife,*
> *At midnight drain the stream of life;*
> *Yet loathe the banquet which perforce*
> *Must feed thy livid living corse,*
> *Thy victims, ere they yet expire,*
> *Shall know the demon for their sire.*

While the image evoked is of the horrid creature of folklore who
attacks those closest to him to sustain his own existence, there is just
a hint of that self-loathing that would become associated with the
Byronic hero.

But Byron entered vampire literature in a much more pronounced way, as the prototype for the first vampire in British fiction.

It began in mid-June of 1816, at a gathering of friends at Villa Diodati on the shores of Lake Geneva.

Byron had taken up temporary residence at the villa, having recently left England under the dark shadow of scandal (brought on by a reputation for philandering, a bitter separation from his wife and a likely sexual liaison with his half-sister).

Accompanying Byron to Geneva was his personal physician - John Polidori - who had just graduated, at the age of nineteen, with an M.D. from Edinburgh University.

Frequent visitors at the Villa were three neighbours: Percy Shelley, a rebellious youth who had previously been expelled from Oxford, his mistress Mary Godwin (with whom he had run away, leaving a wife and two children back in England) and Mary's step-sister, Claire Claremont. The group entertained themselves during rainy evenings by reading German ghost stories.

One evening (most likely 16 June), Byron reportedly challenged each of the group to compose their own stories. Percy Shelley and Claire Clairmont contributed nothing, but each of the other three did. By far the most famous product of this literary contest was Mary Shelley's classic novel Frankenstein; but it was not the only result. Byron wrote a short fragment which he soon discarded.

It was picked up and expanded on later in the summer by Polidori and eventually was published (in 1819) as *"The Vampyre."*

While his preface shows the influence of the writings of both Tournefort and Calmet, Polidori introduces a vampire who differs greatly from the eighteenth-century prototypes.

Unlike its counterparts who were mostly peasants who preyed on their loved ones in the village, Lord Ruthven is an aristocrat who travels throughout Europe, seducing women at will.

This switch in emphasis, which would set the course for future vampire fiction, can be explained by the fact that the model for Lord Ruthven was Byron himself.

By the time Polidori wrote the tale, his relationship with Byron had deteriorated considerably: a constant object of Byron's merciless jokes, the young doctor was dismissed by the arrogant poet late in the summer of 1816. The vampire in his story is named Lord Ruthven, the very name used in Glenarvon, a novel written just months earlier by one of Byron's former mistresses, Lady Caroline Lamb, who had clearly modelled her villain on Byron. In _"The Vampyre,"_ the relationship between Lord Ruthven and his travelling companion, Aubrey, is similar to how Polidori perceived his relationship with Byron - that of domineering master and submissive slave.

"The Vampyre" holds a unique position in literary history, as it was the first story successfully to fuse the various elements of vampirism into a coherent literary genre. Combining clinical realism with supernatural events (as Bram Stoker would so successfully do eighty years later), Polidori gives us in Lord Ruthven many of the features that would become parts of the vampire of present-day popular culture: unlike the re-animated corpse of folklore, Polidori's vampire is a tall, gaunt and pale aristocrat dressed in black, whose distinguishing feature is his seductive power; his "dead grey eye" fixes upon the victim's face and pierces "through to the inward workings of the heart."

64 _Nosferatu the Vampyre, 1979._

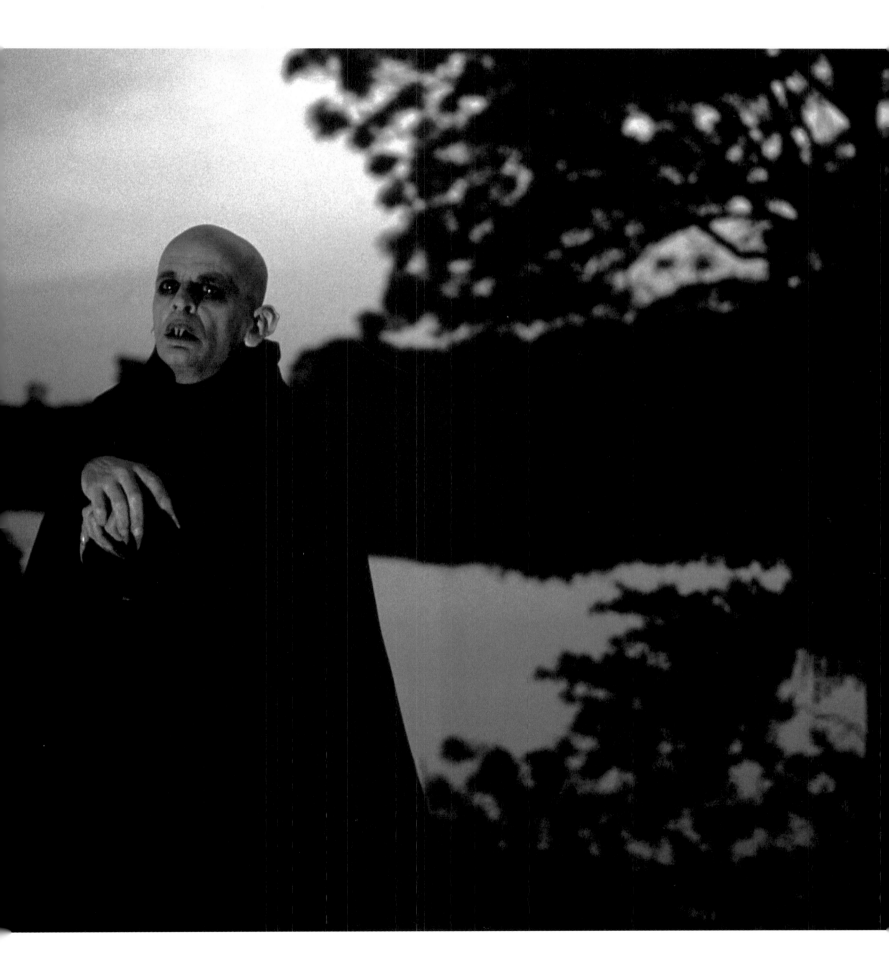

Ruthven victimizes young innocent women and his method of attack is now commonplace: "Upon her throat were the marks of teeth having opened the vein." Polidori's story focuses on the seductive powers of his vampire rather than the attempts to destroy him, as no remedies are presented. What Polidori does is give us a Byronic hero endowed with supernatural powers.

"The Vampyre" was an immediate and phenomenal success. Its popularity was due less to its intrinsic literary merit than to the fact that when it first appeared in print, it was attributed to Lord Byron. Though the evidence shows that Byron had no part in this (it appears to have been a deliberate move by the publisher to boost sales) and though Byron continued to deny his involvement, the assumption guaranteed the story's wide-spread popularity throughout Europe. Even Goethe praised it as the finest of all of Byron's work.

In fact, within a year, vampires became the rage in both London and Paris, with the appearance of several stage versions and adaptations of Polidori's tale. Within months, a novel - *Lord Ruthven ou les Vampires* by Cyprien Berard (1820) - offered a sequel to the original tale.

But it was the stage that ensured the durability of *"The Vampyre,"* as it would for Stoker's Dracula a century later. The figure of the vampire was ideal for melodrama, with its reaction to neoclassical rules and its appeal to a more popular audience. Within a year, the first of many dramatizations appeared on the Paris stage, beginning with Charles Nodier's *"Le Vampire"* which spawned several imitations and parodies [6]. Nor was London immune from the flurry. The year 1820 also saw the appearance of James Robinson Planché's adaptation of Nodier, entitled The Vampire; or the Bride of the Isles (1820). This time the setting was Scotland and the lead vampire appeared in a kilt! The vampire craze continued, even after the true authorship of *"The Vampyre"* became known. In 1828, the bloodsucker became the central figure in an opera.

The German production of Heinrich Marschner's opera *Der Vampyr*, with libretto by Wilhelm August Wohlbriech who used an adaptation of the Nodier stage play, opened in Leipzig in March, with an English performance the following year. By 1849, the vampire makes his first appearance as co-star in a production with Frankenstein's monster in Frankenstein; or The Vampire's Victim. Thus John Polidori's short tale initiated a trend that survives to this present day.

While the flurry of stage productions did subside somewhat after 1830, the vampire retained a steady interest for writers of fiction, both in England and on the Continent: for example, Theodor Hildebrandt, *Der Vampyr oder die Todtenbraut* (1828); an anonymous German tale *"The Mysterious Stranger"* (1860), Franco Mistrali, *Il Vampiro* (1869) and Richard Burton's translation of the *Arabic tale Vikram and the Vampire* (1870).

One of the most popular, Varney the Vampyre, appeared in serial form in London between 1845 and 1847.

Until recently this sensational pot-boiler was considered to have been written by Thomas Preskett Prest, but recent scholarship gives the nod to James Malcolm Rymer. *Varney the Vampyre* has the distinction of being the first full-length vampire novel - perhaps its only distinction.

Lengthy (868 double-columned pages, 220 chapters), it is distinguished by its repetitive storyline. It was published as a popular "penny dreadful," a term coined to refer to numerous booklets (many of which were gothic tales) cheaply printed, with lurid titles and sensational illustrations.

If the novel succeeds at all, it is in its uncanny ability to extend a single situation though an endless number of variations. Rymer builds on some of the traits of Lord Ruthven (Varney is also an aristocrat, tall, gaunt and spectral, with a fondness for young ladies); however, he adds a number of significant ingredients to the growing stereotype.

Notably, this vampire has fangs: "The eyes look like polished tin; the lips are drawn back, and the principal feature next to those dreadful eyes is the teeth - the fearful-looking teeth - projecting like those of some wild animal, hideously, glaringly white, and fang-like". And this vampire is despatched in a method that has since become all too familiar:

The blacksmith shuddered as he held the stake in an attitude to pierce the body, and even up to that moment it seemed to be a doubtful case, whether he would be able to accomplish his purpose or not; at length, when they all thought he was upon the point of abandoning his design and casting the stake away, he thrust it with tremendous force through the body and the back of the coffin. The eyes of the corpse opened wide - the hands were clenched, and a shrill, piercing shriek came from the lips.

There are also references to the vampire's appearance after feeding - the lips "dabbled in blood" and the face "flushed with colour." And of course, on the neck of his victim - in this case Flora - is the tell-tale sign, the "two bloody bite marks." There are numerous other excerpts in *Varney the Vampyre* that ring familiar to any reader of vampire fiction: mixed reactions of desire and fear on the part of the victims, the massive vampire hunt, sleepwalking scenes, the use of science to defeat the monster, a midnight vigil at the tomb of a suspected vampire and a vampire transforming himself into a wolf.
Not surprisingly, the vampire as metaphor found its way into several mainstream works, both fiction and non-fiction.
Charlotte Brontë evokes the image in *Jane Eyre* as Bertha Rochester reminds young Jane of that "foul German spectre - the Vampyre." Nelly Dean in *Emily Brontë's Wuthering Heights* (1847) asks whether Heathcliff is "a ghoul or a vampire." The metaphor appears in political cartoons, as well as in Karl Marx's *Das Kapital* (1867) where he defines Capital as "dead labour, that, vampire-like, only lives by sucking living labour."

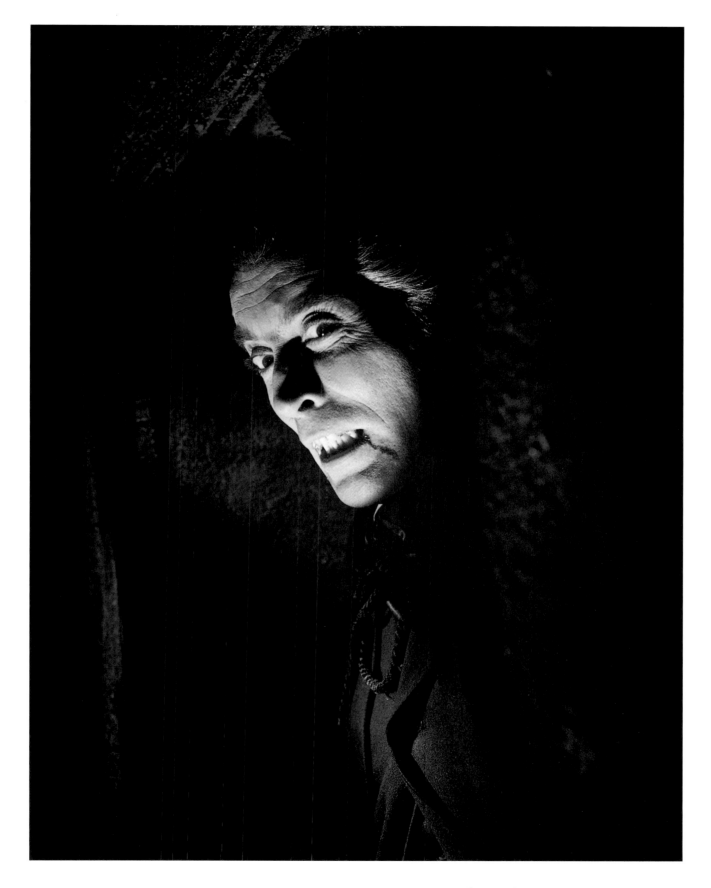

65 Christopher Lee, *Horror of Dracula*, 1958.

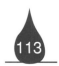

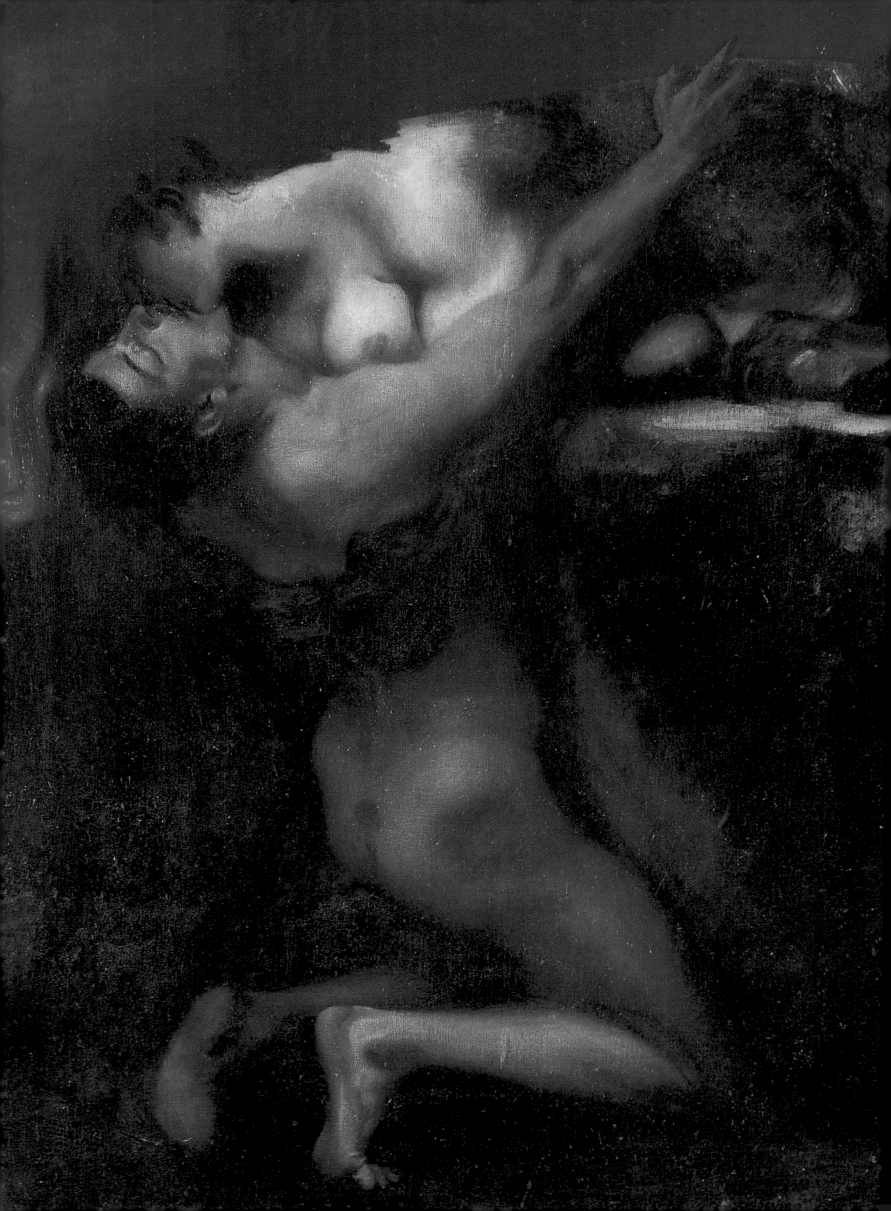

THE FEMME FATALE

Not all nineteenth-century literary vampires were male. Once the vampire was rescued from the cemetery and brought into polite society, it became an apt representation of the "femme fatale" in new adaptations of the mythological archetypes of the Sirens, Medusa, the Harpies, Pandora, Delilah, Salome, Eve and Lilith.

The motif of the "femme fatale" had been well established in literature by the British Romantic poets; one need think only, for example, of Coleridge's *"Christabel"* and John Keats's *"La Belle Dame Sans Merci."*
As early as 1836 we find Theophile Gautier's short story "La Morte Amoureuse" (1836), the story of the female vampire Clarimonde who seduces and takes possession of a young priest.

The French poet Baudelaire (1821-1867) who had a significant influence on the Decadent Movement, included in his Les Fleurs du Mal (1857) a poem entitled *"The Vampire's Metamorphosis"* which celebrated the union of sex and death.

The best known and most influential female vampire in nineteenth-century literature was created by the Irish writer, Sheridan Le Fanu, whose collection of stories - In a *Glass Darkly* (1872) - contained the tale of Carmilla, the prototypical female vampire [7]. In *"Carmilla,"* Le Fanu not only adds a strong psychological element absent in the earlier fiction, but provides us with British fiction's first female vampire.

The prototype is clearly Geraldine from Coleridge's poem *"Christabel"* about the strange woman with the mysterious past who must be helped over the threshold.

66 Franz von Stuck, *The Kiss of the Sphinx.*
Budapest, Szépmüészeti Museum.

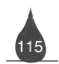

The story also draws on eastern European vampire folklore. The vampire is destroyed in the manner prescribed so often: the stake through the heart "in accordance with the ancient practice"; she is decapitated, body and head are burned and the ashes are scattered. *"Carmilla"* has much of the vampire lore that we have come to associate with Bram Stoker: the sharply pointed canines, as well as the vampire gliding through cracks, entering in the form of mist, producing a languor, maintaining its existence in sunlight and appearing in the form of a beast.

Le Fanu was apparently familiar with the eighteenth-century reports, as his description of destruction of the Carmilla vampire closely resembles several of the accounts in Calmet's treatise. What is unique about *"Carmilla,"* however, is not only that the sexual attraction of victim for vampire is more pronounced, but that Carmilla preys solely on other women. Carmilla is the eternal animal embodied within the female, the bestial counterpart if the virginal ideal.

She is Laura's doppelganger, the dark self which struggles against the restrictions rightfully imposed by the patriarchal world.

As the century progressed, the female literary vampire became more frequently appropriated as an image of the misogynist demonization of women who deviated from the idealized norms of chastity, docility and propriety.

68 Edvard Munch, *The Perseus series*:
The Death of Medusa, 1882. Gouache,
124.5 x 116.9 cm.
Southampton City art Gallery.

67 Philip Burne-Jones,
The Vampire, 1897.

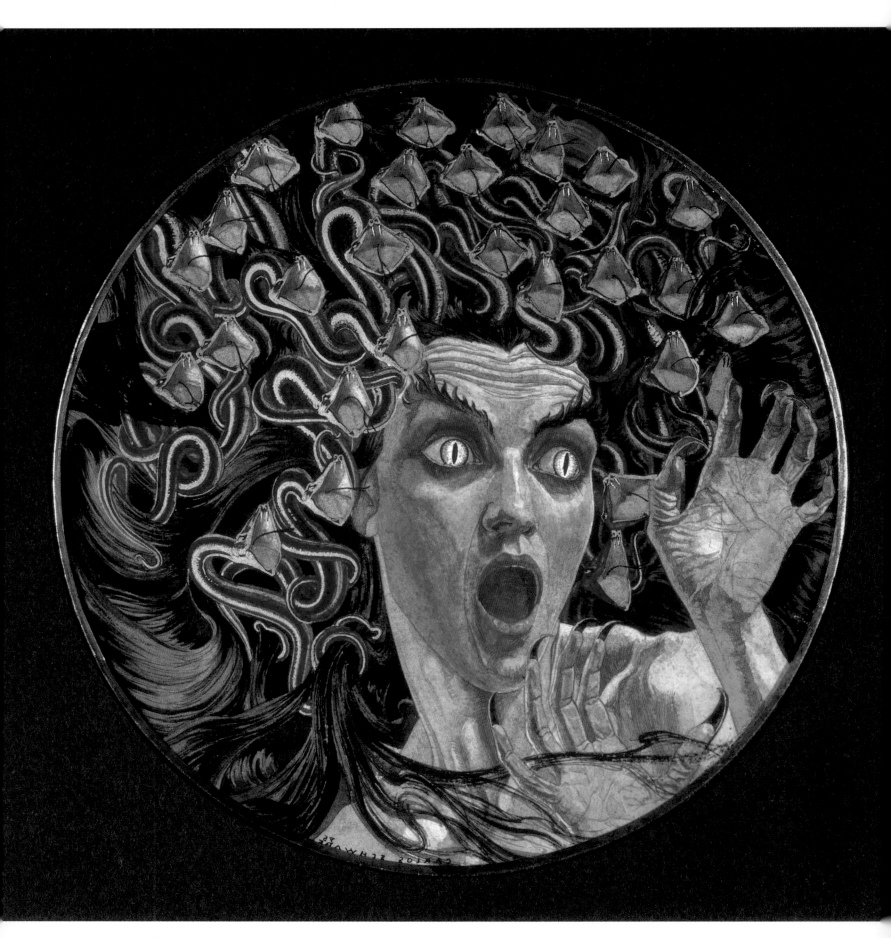

69 Carlos Schwabe, *Medusa*, 1895,
watercolor on paper. New York,
Barry Friedman Gallery.

In 1896, Arthur Symons ("*The Vampire*" in Lesbia) makes a clear association between sexually aggressive women and sinful bloodlust: "intolerable woman, where's the name/For your insane complexity of shame?/Vampire!"

The "white bloodless creature of the night" who "may not rest/Till she have sucked a man's heart from his breast,/And drained his life-blood from him, vein by vein."

The vampire as female became a familiar motif in works of art, especially during the 1890s, in works by Albert Pénot, Edvard Munch, Max Kahn and Philip Burne-Jones.

By the time Bram Stoker started to write *Dracula*, the vampire was a well-established artistic trope.

A number of literary conventions were already in place: the vampire is of an old, aristocratic (and usually foreign) family; the vampire is tall, dark, spectral and dressed in black; the vampire possesses sharp fangs which leave two bite marks on the victim; the vampire is a creature of unusual physical strength; the vampire has a strong seductive power over women; the victim's response to the vampire is ambivalent, revealing both attraction and repulsion; the vampire has the ability to shape-shift into animal form, to enter as mist, to glide through a crack; and the most effective way to destroy a vampire is to drive a wooden stake through its heart.

As the nineteenth century drew to a close, the vampire began to take on new metaphorical characteristics, drawn from social and cultural conditioning of late-Victorian England.

In the midst of continuing debates over *Darwin's theory of evolution*, treatises on physiological traits associated with degeneracy, the age of Decadent art and literature, the age of Oscar Wilde, xenophobic tendencies in the wake of mass immigration from eastern Europe and male anxieties about the *"New Woman,"* Bram Stoker wrote *Dracula*, the novel that would define the vampire for the twentieth century and beyond.

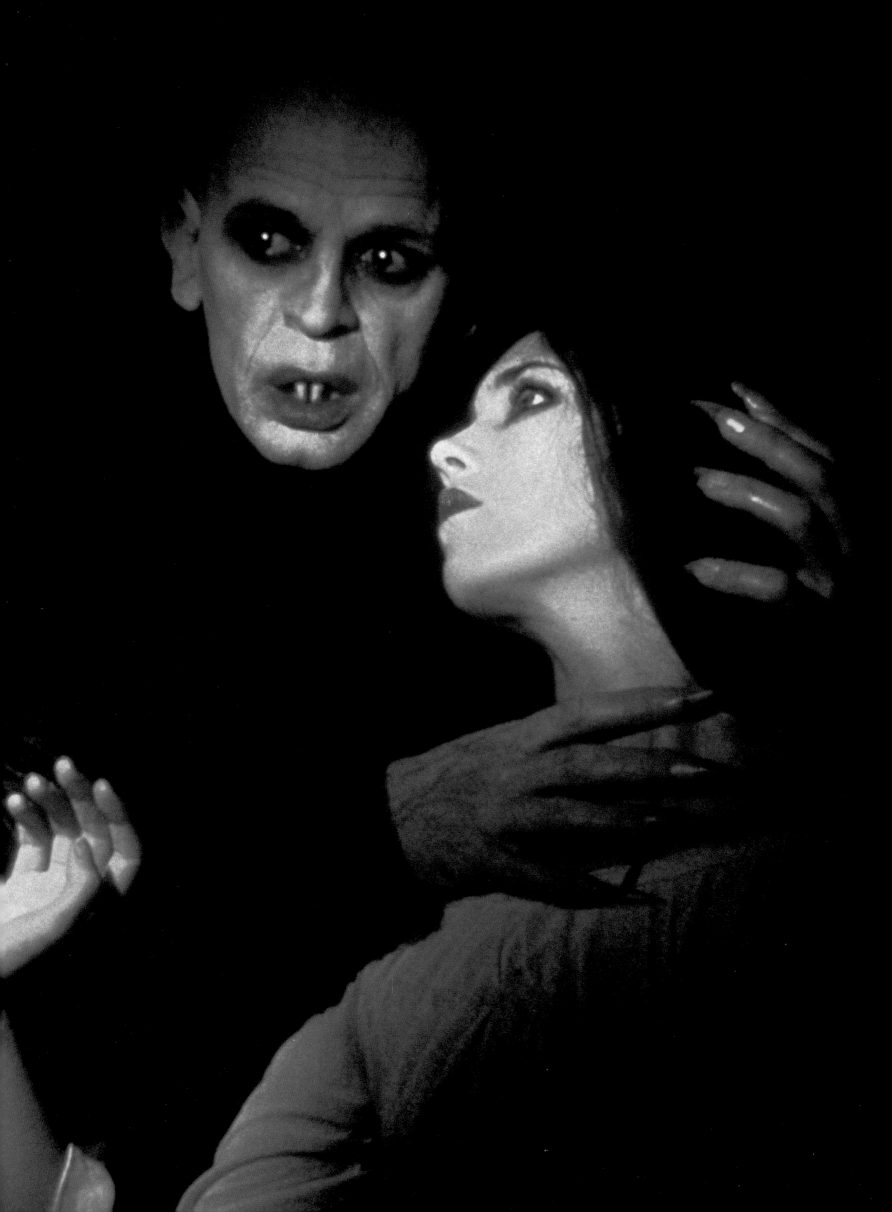

CHAPTER III

DRACULA THE VAMPIRE

First published in London in 1897, Dracula is the quintessential vampire novel. It tells the story of a mysterious Count Dracula who, having purchased properties in London from Jonathan Harker, an English solicitor, sets out from his castle in the remote Carpathian mountains to take up residence in England.

The ship on which he travels, the Demeter, runs aground in Whitby, where the Count hunts his first prey, the young Lucy Westenra.

In spite of the efforts of Lucy's friends (including two former suitors and her betrothed) led by a specialist in obscure diseases of the blood, Professor Abraham Van Helsing, Lucy grows weaker and eventually dies.

But Dracula's bite has ensured that she will join the ranks of the "undead," returning from her crypt to feast on the young children of Hampstead Heath.

Van Helsing leads the other men into her tomb where they end her vampiric existence by driving a wooden stake through her heart.

The Count, with the reluctant assistance of the lunatic Renfield, begins to track his second victim, Mina Harker, who married Jonathan after his miraculous escape from Castle Dracula.

70 Klaus Kinski in the role of Nosferatu.
Nosferatu The Vampyre, 1979,
20th Century-Fox Film Corporation.

She, too, begins to show the tell-tale signs, but this time Van Helsing knows for certain what is happening.

The vampire hunters, including Mina, track Dracula back to his homeland in Transylvania, and finally destroy him near the entrance to his castle.

Symmetrically constructed, the main narrative is set in England and focuses in turn on Dracula's victimization of Lucy and Mina.
This is framed by two journeys to Transylvania:
one that releases the monster
and one that tracks him down and destroys him.

In many respects, the novel fits the template of the detective story - a genre that was gaining respectability in the late nineteenth century due to the Sherlock Holmes stories of Arthur Conan Doyle - with its tripartite structure:
mystery, investigation and resolution.

Borrowing his technique from Wilkie Collins, Stoker narrates Dracula through a series of documents ranging from journals and diaries to newspaper reports, phonograph recordings and a ship's log.

The effect is not only to present a supernatural tale through realistic means, but to bring to the forefront the role of contemporary science and technology. This grounds the novel firmly in the Victorian age.

71 Dracula

72 Louis Jourdan as *Count Dracula* in the BBC's series, 1978.

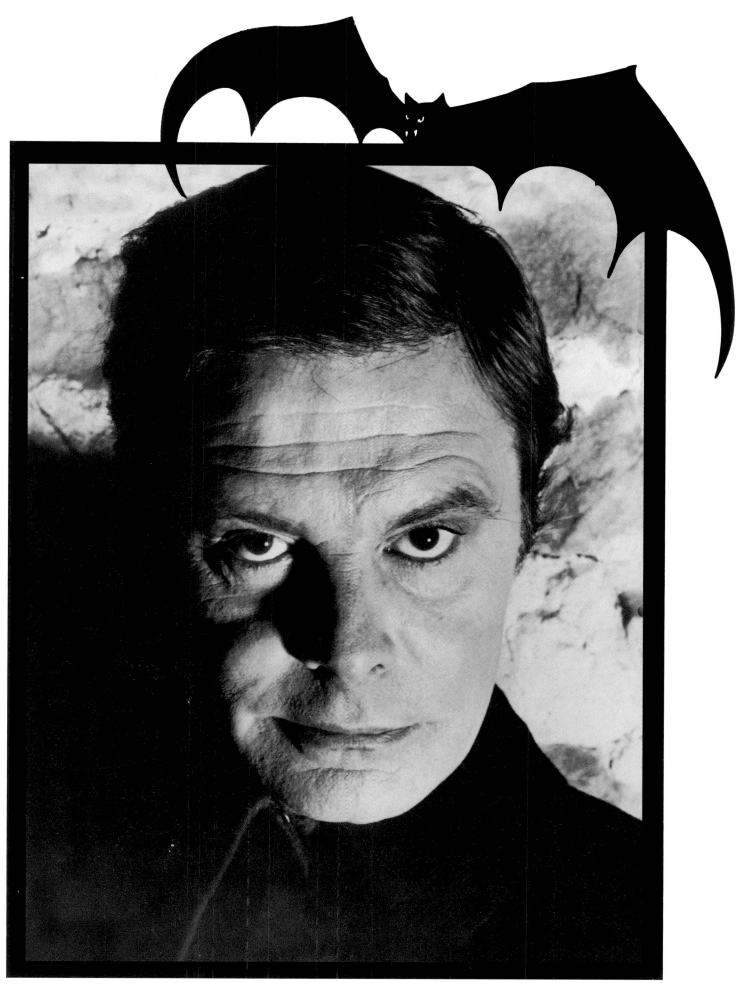

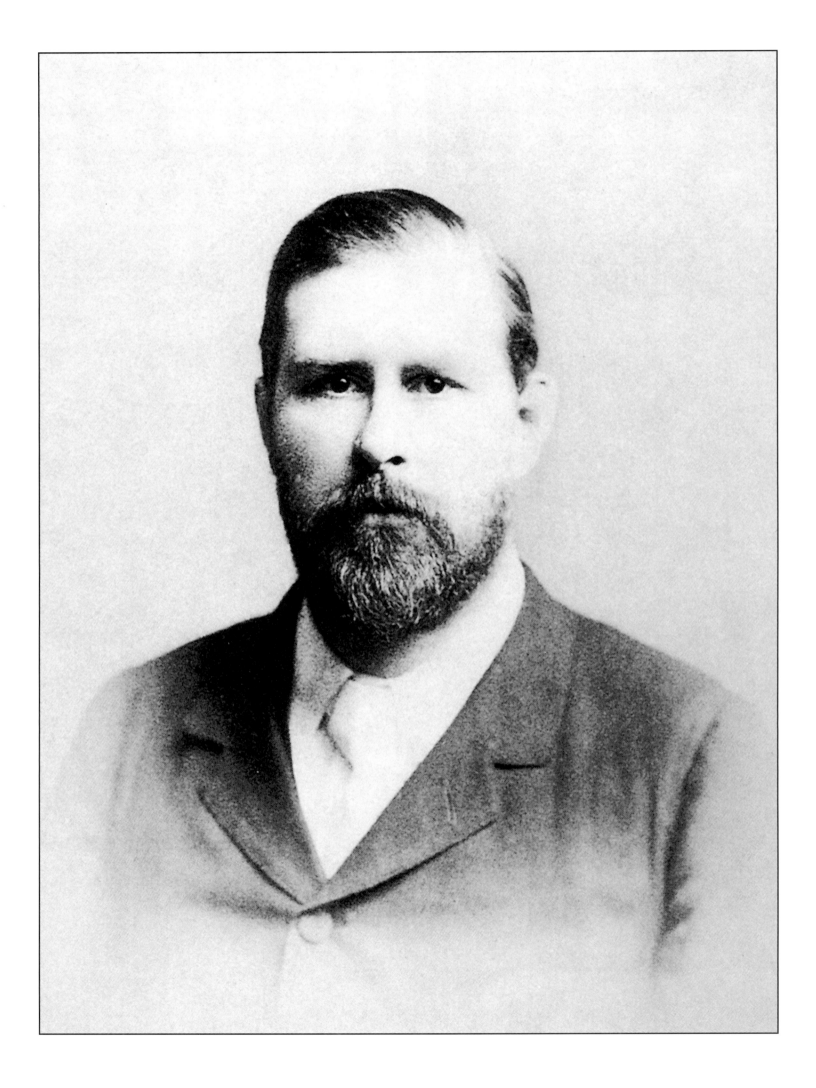

BRAM STOKER AND THE GENESIS OF DRACULA

Bram Stoker, the author of Dracula, was born in Clontarf near Dublin, Ireland, in 1847. A sickly child, he appears to have spent much of the first seven years of life in bed. During this time his mother filled many of his hours with stories and legends from her native Sligo, including narratives of a cholera epidemic. His early imagination was thus shaped by tales of the supernatural and of death.

Whatever the nature of his illness (it was never diagnosed), by the time he entered Trinity College (Dublin) in 1864, Stoker was a strong young man who excelled at university athletics. Upon graduation, he followed in his father's footsteps and accepted a position in the Irish civil service.

It was there that he published his first book, *The Duties of Clerks of Petty Sessions in Ireland* (1879), a book that was by his own later admission "as dry as dust."
During his Dublin period he also published occasional short fiction, including a ten-part serial *"The Primrose Path"* in 1875 and wrote theatre reviews for a Dublin newspaper.
One of these, a review of Henry Irving's Hamlet, led to a meeting with the famous English actor and a subsequent friendship and business relationship that was to last until the actor's death in 1905.

In 1878, shortly after his marriage to the Dublin beauty, Florence Balcombe, (who had also been courted by Oscar Wilde), Stoker accepted an offer of employment as Acting Manager of Irving's new Lyceum Theatre in London.
Stoker's years with the Lyceum were both busy and fulfilling.

73 *Portrait of Bram Stoker.*
From Henry Irving by Laurence Irving,
London, Faber and Faber, 1951.

In his managerial capacity, he was responsible not only for much of the day-to-day operation of the theatre, but also for the organization of its provincial seasons and its several North American tours.

His exposure to hundreds of performances of Shakespeare's major plays left an indelible impression, as evidenced in the numerous distinct resonances in Dracula.

His association with Irving also enabled him to rub shoulders with the social, political and literary elite of London [8].

But most significant was the influence of Irving himself. Stoker would write at length about his idol in *Personal Reminiscences* of Henry Irving (1906), a glowing tribute to the man for whom he felt affection and loyalty.

Of their first meeting, Stoker wrote: "From that hour began a friendship as profound, as close, as lasting as can be between two men".

In spite of speculation to the contrary [9], existing evidence confirms that what Stoker felt for Irving was essentially hero-worship: "my love and admiration for Irving were such that nothing I could tell to others - nothing I can recall to myself - could lessen his worth".

Though he is best known for Dracula, Bram Stoker was the author of several other novels and collections of short fiction, including *Under the Sunset* (1882), *The Jewel of Seven Stars* (1903), *The Lady of the Shroud* (1909), *The Lair of the White Worm* (1911) and *Dracula's Guest and Other Weird Stories* (published posthumously in 1914).

In addition to *Personal Reminiscences of Henry Irving*, his non-fictional publications included *A Glimpse of America* (1996) and *Famous Imposters* (1910) [10].

He died in 1912, just five days after the sinking of the luxury liner, Titanic.

Thanks to the discovery of Stoker's working notes for *Dracula*, it is possible to trace some of the origins of his masterpiece of gothic horror.

74 Florence Anne Lemon Balcombe,
drawing by Oscar Wilde.
Harry Ransom Humanities Research
Center Art Collection,
The University of Texas, Austin.

Auctioned at Sotheby's in 1913, these papers were acquired by the Rosenbach Museum & Library in Philadelphia in 1970.

They remained there in relative obscurity until they were fortuitously discovered in the mid-1970s by two professors from Boston College, Raymond McNally and Radu Florescu, who had visited the Museum to examine an original German woodcut of Vlad the Impaler.

Comprising over eighty pages of manuscript and typescript notes, photographs and a newspaper clipping, these working notes include early draft outlines for the book as well as the author's own list of source-texts that he consulted for background information.

The earliest pages reveal that he began the novel in March 1890, apparently in London, though it is clear that he also worked on it while on vacation in Whitby and later in Cruden Bay, Scotland, and while on tour.

He was to continue it for seven years, whenever his busy schedule would permit [11].

75 Portrait of Oscar Wilde in 1876.
The William Andrews Clark Memorial Library,
University of California, Los Angeles.

The original title for the book was *The Un-Dead*, the name on the title page of a 529-page typescript copy of Dracula (dated 1897) discovered in an old trunk on a farm in Pennsylvania in 1977 and now held by a private collector in California.

The final title appears to have been a last-minute decision. As late as 18 May 1897, a version of the new work was presented as a dramatic reading at the Lyceum under the title *Dracula*; or *the Un-Dead*.

Performed as a means of protecting its theatrical copyright, Dracula; Or The Un-Dead was a cut-and-paste version of the novel read as a five-act play before a small group of theatre employees and passers-by.

The programme contained a play-bill, a list of the cast, a synopsis of the scenes and a sheet of general information.

The cast, drawn from the theatre's supporting ranks, included an actor named "Jones," the first in a long line of actors to play the part of Count Dracula, while actress Ellen Terry's daughter, Edith Craig, played Mina.

76 Portrait of Henry Irving in 1876 from *Reminiscences of Henry Irving* by Bram Stoker, London, Heinemann, 1906.

77 The Lyceum Theatre's façade, 1895, photograph.
London, Victoria and Albert Picture Library.

78 The Lyceum on opening night,
The Graphic, May 21 1881.

Speaking parts were also assigned to an Attendant at Asylum, Coastguard, a Servant, Swales and one Vampire Woman. Lengthy segments follow the novel verbatim.

There is a well-known, though possibly apocryphal story about Henry Irving's response to this four-hour performance: when he was asked how he liked it, he answered "Dreadful!"

Just six days later, on 24 May, Bram Stoker wrote a short note to William Gladstone: "I am sending you a copy of my new novel Dracula which comes out on the 26th." The book, with its new title in red lettering on yellow binding, had an initial run of three thousand copies. It was not, as is often assumed, an instant success; the explosion of interest was to occur later, unfortunately for Stoker, after his death.

No letters of outrage about its moral or sexual content appeared; rather, it was perceived as a horror story and nothing more. Contemporary reviews were mixed.

79 The Beefsteak Club Room at the Lyceum Theatre, *English Illustrated Magazine*, September 1890.

The Athenaeum attacked it for lacking "constructive art in the higher literary sense. It reads at times like a mere series of grotesquely incredible events."

The Spectator referred to it as "clever but cadaverous romance" whose "strength lies in the invention of incident, for the sentimental element is decidedly mawkish."

An item in the *Bookman* advised readers to "keep Dracula out of the way of nervous children." Others were more positive: "I could not put the book down until I had finished it" (*Sunday Special*); *The Detroit Tribune* considered it "as vivid and thrilling as (Poe's) 'The Black Cat,' with vastly more detail";

80 Bram Stoker, drawing by Alfred Bryan, 1885. Stratford-upon-Avon, Bram Stoker Collection, Shakespeare Centre Library.

81 Bram Stoker and his family,
drawing by George du Maurier,
Punch, September 11 1886.

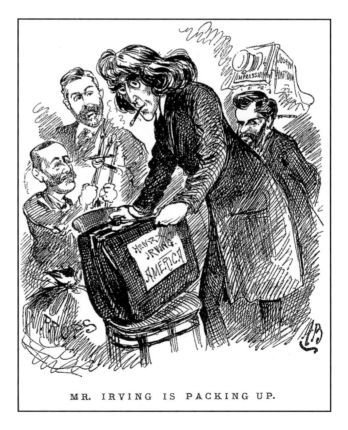

MR. IRVING IS PACKING UP.

82 The Lyceum's American tour,
cartoon from *The Entr'Acte*,
October 6, 1883.

83 Bram Stoker wearing a HMS
Dracula cap , cartoon.
Ellen Terry Memorial Museum.

another commentator even predicted that the novel would be "reprinted in ... 2000 A.D." (*The Sketch*). Among the favourable comments that Stoker personally received was Arthur Conan Doyle's note that it was "the very best story of diablerie which I have read for many years, " while a young Winston Churchill consented to be interviewed by Stoker, partly because "you are the author of Dracula."

84 Banquet at Saint James' Hall,
cartoon from *Illustrated Sporting
and Dramatic News*, July 14, 1883.

85 Bram Stoker's working notes for *Dracula*.

Anthony Hope Hawkins (*The Prisoner of Zenda*) observed that Stoker's vampires "had robbed him of sleep," and Mary Elizabeth Braddon (*Lady Audley's Secret*) found Dracula superior to her own vampire story Good *Lady Ducayne*.

Perhaps the most praiseworthy (and subjective) observations were made by Stoker's mother and his wife. Shortly after publication, the former wrote, "No book since Mrs Shelley's *Frankenstein* ... has come near yours in originality, or terror."

In 1926, in a foreword to a serialization of the novel in *The Argosy*, his widow pronounced it "an astonishing work" and "the most fascinating and enthralling" of all of her late husband's writings [12].

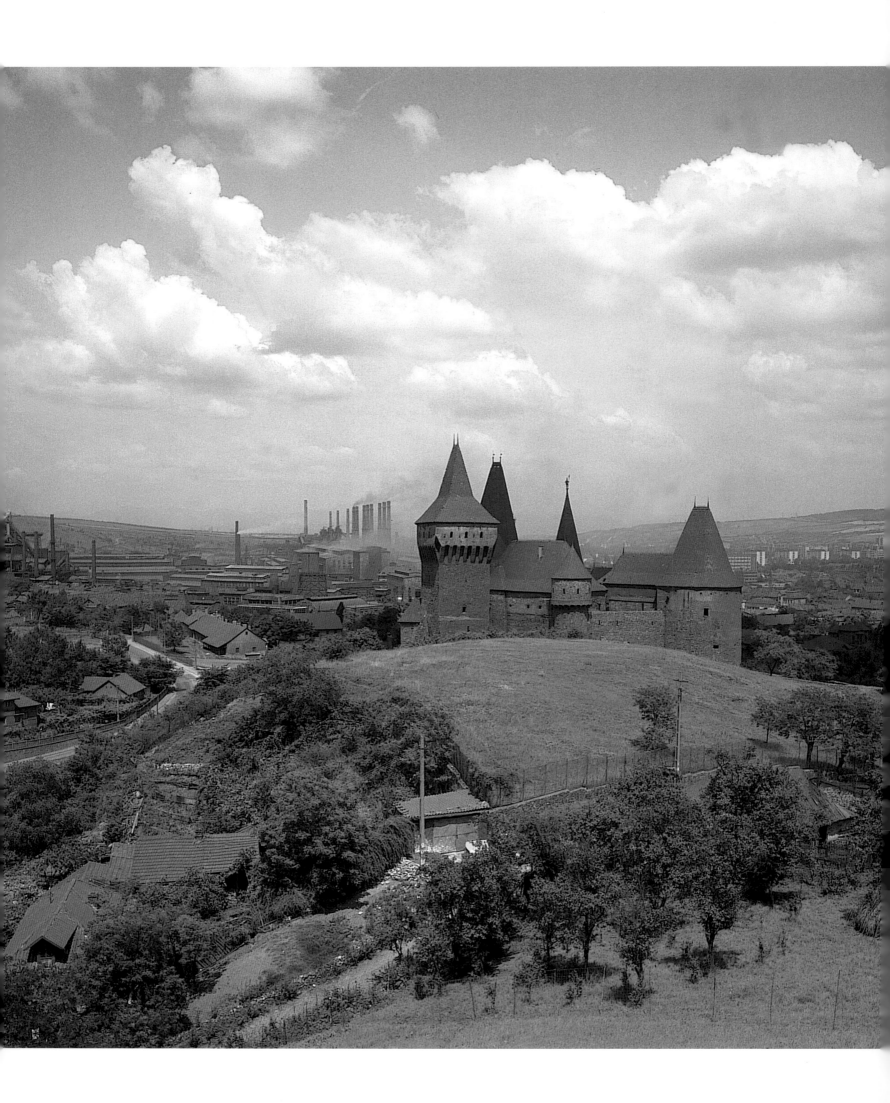

TRANSYLVANIA

So powerful has been the impact of Stoker's novel on Western popular culture that Transylvania is known to most people today only as the homeland of vampires [13].

Why did Stoker select Transylvania, a region he had never visited? In the 1890s when Stoker was writing Dracula, Transylvania was part of the Habsburg Empire. (It joined the united principalities of Moldavia and Wallachia to form the modern state of Romania after the First World War).

Though Transylvania had appeared many times in Western literature before *Dracula* [14], it was the travel writing of the nineteenth century that brought it to the attention of writers of Gothic fiction. These travelogues, which reflected an increased interest in the more remote parts of Europe, habitually presented their readers with invidious comparisons between Western science and civilization and Eastern superstition and barbarism.

These accounts, with their references to the "absurdities of superstition," and their reports of belief in all sorts of witchcraft, ghosts, fairies, werewolves and vampires, combined with descriptions of the landscape with its "dreadful precipices" and "awful crags and chasms," were a natural attraction for Gothic writers.

Although most literary vampires were not connected with Transylvania or the Carpathians before *Dracula* debuted in 1897 [15], there were notable exceptions. A collection of supernatural tales by Alexander Dumas (père), *Les Mille et un Fantomes* (1849), includes a story about a vampire which haunts the Carpathians where "All that nature has to show of strange and wild and grand is seen in its complete majesty".

86 Hunedoara Castle.

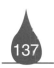

87 Borgo Pass,
site of fictional Castle Dracula
in Bram Stoker's novel.

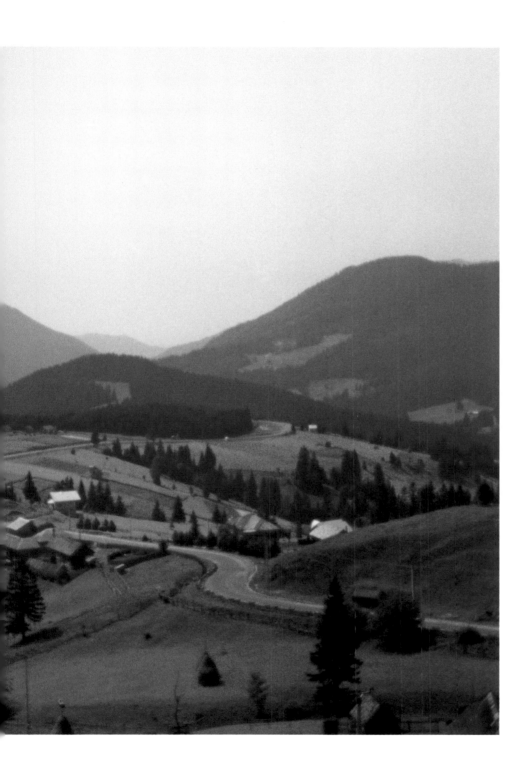

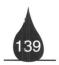

In *"The Mysterious Stranger"* (anonymous, 1860), a vampire Count terrorizes a family in this area. The best-known work may be Jules Verne's romantic adventure, *The Castle of the Carpathians* (1892).

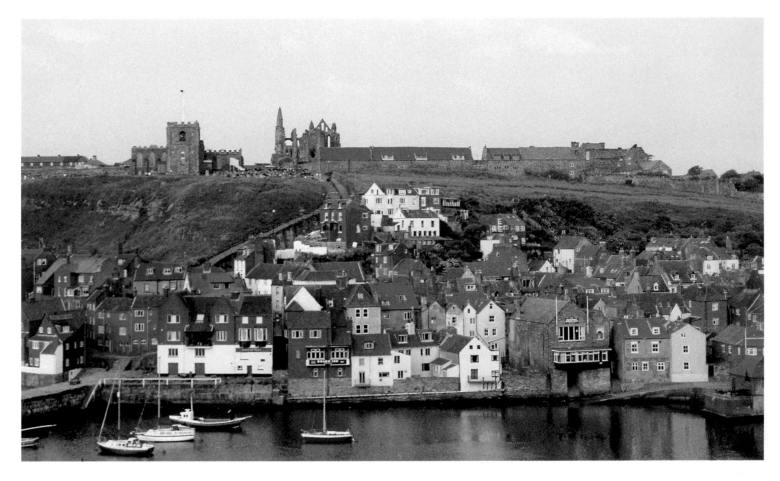

88 The Town of Whitby in England
where Bram Stoker found, in summer 1890,
the name Dracula.

Although the strange events in this novel admit to rational explanations, the narrator cites the prevalence of beliefs in a host of supernatural creatures, including vampires that "quenched their thirst on human blood".

This book also contains an illustration of a Gothic castle, typical of the prototype from which Stoker drew his description of Count Dracula's stronghold.

Stoker originally intended to have his vampire Count come from Styria, the Austrian setting used by Le Fanu in *Carmilla*. What apparently changed his mind was his reading of *Transylvanian Superstitions*, an article by Emily Gerard that appeared in The Nineteenth Century in 1885. The Scottish wife of a Hungarian cavalry officer who had been stationed for two years in Transylvania, Gerard had recorded her observations and impressions of local custom and lore. She claimed to have encountered among the peasants a belief in the "nosferatu":

More decidedly evil, however, is the vampire, or nosferatu, in whom every Roumenian peasant believes as firmly as he does in heaven or hell ... every person killed by a nosferatu becomes likewise a vampire after death, and will continue to suck the blood of other innocent people till the spirit has been exorcised, either by opening the grave of the person suspected and driving a stake through the corpse, or firing a pistol shot into the coffin. In very obstinate cases it is further recommended to cut off the head and replace it in the coffin with the mouth filled with garlic, or to extract the heart and burn it, strewing the ashes over the grave.

Though the word "nosferatu" (used by Stoker in *Dracula* and the title of an early movie based on the novel) is assumed to be a Romanian synonym for "vampire," its etymology is a mystery. Romanian linguists claim that there is no such word in their language (or, apparently, in any other language). Gerard presumably mistranscribed something she heard while in Transylvania: "necuratul" (a synonym for "diavol" - devil), the Greek word "nosophoros" (plague carrier), or even the Romanian word "nesuferit," meaning "unbearable."

Having decided on Transylvania, Stoker set out to research the history, geography and customs of the region in order to lend realism to his tale of the supernatural.

From Charles Boner's _Transylvania: Its Products and Its People_ (1865), he gleaned information about fires that had ravaged the town of Bistritz, and found references to the "Mittel Land."

An insert map in Boner provided Stoker with the names of Bistritz and Klausenburg (the German spellings used in Dracula), as well as the "Borgo Pass" in the mountainous region east of Bistritz, where Stoker locates Dracula's castle. Major E.C. Johnson's _On the Track of the Crescent_ (1885) gave him details on the mixture of nationalities in Transylvania (Magyars, Saxons, Wallachs and Szekelys), local foods (such as "mamaliga" and "impletata") as well as a suitably Gothic description of the Carpathian range:

"The Carpathians, towering aloft in their savage grandeur, are a spectacle not readily to be forgotten.
They are almost inaccessible, and their steep and rocky sides are cut by numerous chasms".

Details about the local gypsies, wines and modes of transportation came from A. F. Crosse's _Round About the Carpathians_ (1878).
Stoker borrowed more than information from these writers; he absorbed an attitude that permeates his text and is to a great extent responsible for the charges of racism and xenophobia that have been levelled against his novel.
Emily Gerard, in a condescending tone typical of much of the travel literature of the time, says of Transylvania that "Nowhere else does this crooked plant of delusion flourish as persistently and in such bewildering variety".
In _Dracula_, the English solicitor Jonathan Harker notes, with a similar smugness, "I read that every known superstition in the world is gathered into the horseshoe of the Carpathians, as if it were the centre of some sort of imaginative whirlpool" [16].

Similar sentiments can be found in Mina Harker's comment, when she travels to Transylvania to help hunt down Dracula: "the people ... are very, very superstitious".

Harker's condescending remarks about the local residents owe much to Johnson's description of "funny little female figures in sheepskin jackets" and Boner's reference to the "full development of the figure" of local women.

Harker's references to poor roads and unpunctual trains are also examples of the contempt for the non-technological societies that permeates the text of *Dracula*.

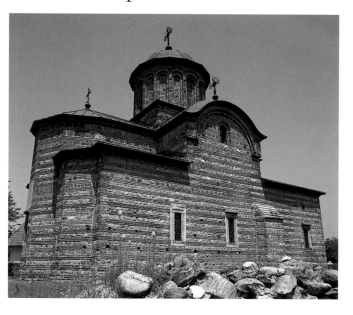

Dracula depicts Transylvania as a backward region inhabited by wild animals and superstitious peasants, hence it is an appropriate residence for a monster who emerges from his lair to threaten Victorian England.

The novel opens and closes in Transylvania. In spite of the fact that only the first four and final chapters take place in Transylvania, it leaves an indelible impression on the reader. As a world of dark and dreadful things, it has assumed the dimensions of myth and metaphor, of a land both beyond the forest and beyond civilization.

One recent scholar even depicts it as "first and foremost the site, not of superstition and Gothic romance, but of political turbulence and racial strife," while the Carpathians are associated with "cultural upheaval and ... a dizzying succession of empires".

89 Church of Curtea de Arges.

Royal Lyceum Theatre.

Sole Lessee and Manager:

HENRY IRVING.

DRACULA
OR
THE UN-DEAD.

FIRST TIME.

WHY DRACULA?

Stoker's original choice of name for his vampire was Count Wampyr. He found the name "Dracula" in the summer of 1890 in the town of Whitby, a seaside resort on the northeast coast of England.

His source was a book he borrowed from the Public Library, William Wilkinson's _An Account of the Principalities of Wallachia and Moldavia_ (1820). Here he found (and transcribed almost verbatim into his Notes) the following information:

Wallachia continued to pay it (tribute) until the year 1444; when Ladislas King of Hungary, preparing to make war against the Turks, engaged the Voivode Dracula to form an alliance with him. The Hungarian troops marched through the principality and were joined by four thousand Wallachians under the command of Dracula's son....

Their Voivode, also named Dracula,* did not remain satisfied with mere prudent measures of defence: with an army he crossed the Danube and attacked the few Turkish troops that were stationed in his neighbourhood; but this attempt, like those of his predecessors, was only attended with momentary success.

Mahomet, having turned his arms against him, drove him back to Wallachia, whither he pursued and defeated him. The Voivode escaped into Hungary and the Sultan caused his brother Bladus to be named in his place. He made a treaty with Bladus, by which he bound the Wallachians to perpetual tribute.

*Dracula in the Wallachian language means Devil. The Wallachians were, at that time, as they are at present, used to give this as a surname to any person who rendered himself conspicuous either by courage, cruel actions, or cunning.

90 Program for dramatic reading of _Dracula_ or _The Undead_ at the Lyceum Theatre, 1897. Bram Stoker collection, Shakespeare Centre Library, Stratford-upon-Avon.

In spite of many assertions to the contrary [17], Wilkinson's rather vague account is Stoker's only known source of information about the historical Dracula. Significantly, Dracula is never referred to in Wilkinson as "Vlad"; indeed, the term "Dracula" is used interchangeably for both father (Vlad Dracul) and son (Vlad Tepes). There is no reference to Vlad's fondness for impalement, and no hint of his numerous atrocities. What seems to have attracted Stoker was the footnote.

What better name for a vampire who, as a reading of the novel will confirm, was to be associated with the devil, than the mysterious and foreign-sounding "Dracula"? He supplemented the scanty material from Wilkinson with scraps of historical facts gleaned from a variety of other sources and forged a "history" for his Count. For example, Count Dracula (unlike Vlad) was one of the "Szekelys" who, according to Johnson, who claimed to have been descended from Attila and the Huns. That such detail does not apply to the historical Dracula is immaterial. Bram Stoker never intended his Count to be based on Vlad the Impaler.

91 Henry Irving as Mephistopheles,
drawing by Sir Bernard Partridge.
London, Victoria and Albert Museum.

Dracula

DRACULA AS A VAMPIRE NOVEL

It was _Dracula_ that firmly entrenched the vampire in literature. So influential has this novel been that to this day, every author working in the genre is conscious of writing in its shadow.

What Stoker succeeded in doing was to bring together many disparate threads from folklore and legend, the Gothic novel and earlier vampire fiction into a novel that resonates with the fears and anxieties of his time as well as our own.

His notes show clearly that he had intended to write a vampire novel from the outset, even before he settled on the name "Dracula" and the Transylvanian locale.

Even though his Count Dracula was to become the most famous of all vampires, the vampire had already been well established in literature. Possibly Stoker was familiar with Polidori and Rymer, and may have read Richard Burton's translation of the Arabic tale _Vikram_ and _the Vampire_ (re-issued in London in 1893).

He certainly knew _"Carmilla"_ by fellow Dubliner, Le Fanu. Its influence can be seen not only in Stoker's original choice of setting, but in his delineation of the female vampire, in particular the three female vampires in Dracula's castle and their effect on Jonathan Harker.

The sexual themes of Dracula certainly owe much to Le Fanu's tale of repression, especially the theme of the respectable Victorian gentleman's anxieties about aggressive, unbridled female sexuality.

But he had other sources. In an interview conducted shortly after the publication of his novel, Stoker remarked that "the knowledge of vampire superstitions shown in Dracula was gathered from a great deal of miscellaneous readings".

When asked whether there was any historical basis for the legend, his reply was as follows: "It rested, I imagine, on some such case as this. A person may have fallen into a death-like trance and been buried before the time.

Afterwards the body may have been dug up and found alive, and from this a horror seized upon the people, and in their ignorance they imagined that a vampire was about".

Apparently, Stoker was familiar with the writings of Calmet, extensively quoted in one of his sources, Herbert Mayo's *On the Truths contained in Popular Superstitions* (1851).

He was also aware of a residue of belief in vampires in the USA. His notes include a newspaper clipping from the New York World (2 February 1896) entitled *Vampires in New England*.

This article records several cases of suspected vampires (victims of consumption) in Rhode Island, whose corpses were exhumed and subjected to prescribed rituals.

Also noted were the famous vampire sightings of the eighteenth century, with a suggestion of the origins of the legend in Greece: "a belief was entertained to the effect that Latin Christians buried in that country could not decay in their graves, being under the ban of the Greek church."

The article pointed out the most terrifying aspect of the legend, that a victim of a vampire would in turn become a vampire.

Jonathan Harker describes Count Dracula as follows:

92 Oscar Wilde as a vampire, cover design
for Georg S. Viereck's *Das Haus des Vampÿrs,* 1907.

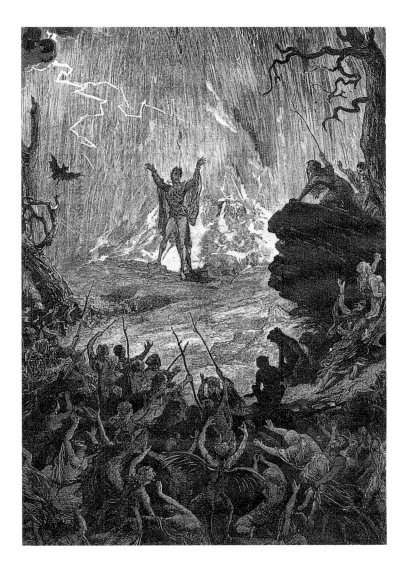

Within, stood a tall old man, clean shaven save for a long white moustache, and clad in black from head to foot, without a single speck of colour about him anywhere....

His face was a strong - very strong - aquiline, with high bridge of the thin nose and peculiarly arched nostrils; with lofty domed forehead and hair growing scantily round the temples, but profusely elsewhere. His eyebrows were very massive, almost meeting over the nose, and with bushy hair that seemed to curl in its own profusion.

The mouth, so far as I could see it under the heavy moustache, was fixed and rather cruel-looking, with peculiarly sharp white teeth; these protruded over the lips, whose remarkable ruddiness showed astonishing vitality in a man of his years. For the rest, his ears were pale and at the tops extremely pointed; the chin was broad and strong and the cheeks firm though thin. The general effect was one of extraordinary pallor...

93 Henry Irving as Mephistopheles, *Faust*, act IV, drawing from Illustrated *Sporting and Dramatic News*, January 16, 1886.

I could not but notice that they (his hands) were rather coarse - broad, with squat fingers.
Strange to say, there were hairs in the centre of the palm. The nails were long and fine, and cut to a sharp point.

For this physical description, Stoker relied heavily on folkloric and literary sources. *The Book of Were-Wolves* (1865) by Rev. Sabine Baring-Gould (author of the famous hymn *"Onward Christian Soldiers"*) provided him with the broad, coarse hands with squat fingers, long, fine nails cut to a sharp point, and hairs in the centre of the palms.
Other features - the aquiline nose, domed forehead, massive eyebrows, heavy moustache covering a "fixed and rather cruel-looking" mouth, and his "extraordinary pallor" owe much to the villains of earlier fiction.

Anyone familiar with nineteenth-century Gothic literature knows that many of these features had by Stoker's time become conventions of the Gothic villain, that morally depraved individual whose separation from virtue had led to isolation.

In light of the fact that Dracula contains a direct allusion to Cezare Lombroso, it is possible that Stoker had that physiognomist in mind when delineating the Count's features. In his *Criminal Man* (1875) Lombroso describes the typical criminal as having an aquiline nose, bushy eyebrows and pointed ears.
Some scholars have suggested that Stoker had specific individuals in mind as physical models for Dracula, notably Vlad the Impaler and Stoker's employer, Henry Irving.

While there is no evidence that he accessed either a portrait or a physical description of Vlad (in spite of claims to the contrary), it is possible that Irving's performances of numerous stage villains (most notably Mephistopheles in *Faust*) were influential.

94 Goya, *Capricho 73, The Sleep of reason produces monsters,*
1797-1798, etching with aquatint, 21.6 x 15.2 cm.

So powerful has been the impact of Stoker's novel that his prescriptions concerning the strengths and limitations of vampires have shaped common knowledge of the legendary creature.

The Count has the strength of twenty men, can shape-shift at will into other forms (notably wolf, bat and even mist and elemental dust); he can control the weather; his hypnotic power can immobilize his victims. His unnatural state is also evident in that he survives solely on human blood, casts no shadow and shows no reflection in a mirror.

Most devastating is that he possesses the ability to make others into creatures like himself.

He is, however, confronted with limitations: he may not initially enter a dwelling without an invitation; his supernatural power ceases during daylight hours [18]; he is repelled by religious symbols such as the crucifix and eucharistic wafer; he cannot tolerate garlic; he can cross running water only at the slack or the flood of the tide. Though he is powerful, he can be destroyed through staking and decapitation [19].

Dracula is replete with indelible images that still have the ability to strike anxiety and fear: the Count lying in his earth-box, like a filthy leech gorged with blood; the Captain of the *Demeter* (the ship that transports Dracula to England) tied to his wheel, crucifix in hand; the wolf bursting through the window at the Westenra estate; the staking of Lucy; Dracula forcing Mina to drink from the self-inflicted wound in his chest; the appearance of rats at Dracula's Piccadilly abode. Perhaps the most memorable is Harker's account of one of the strange things he observed while a prisoner in Castle Dracula: "My feelings changed to repulsion and terror when I saw the whole man emerge from the window and begin to crawl down the castle wall over that dreadful abyss, face down, with his cloak spreading around him like great wings". This scene so impressed T.S. Eliot that, according to Valerie Eliot in a letter to TLS in 1973, he used the image in Part V of "*The Wasteland*":

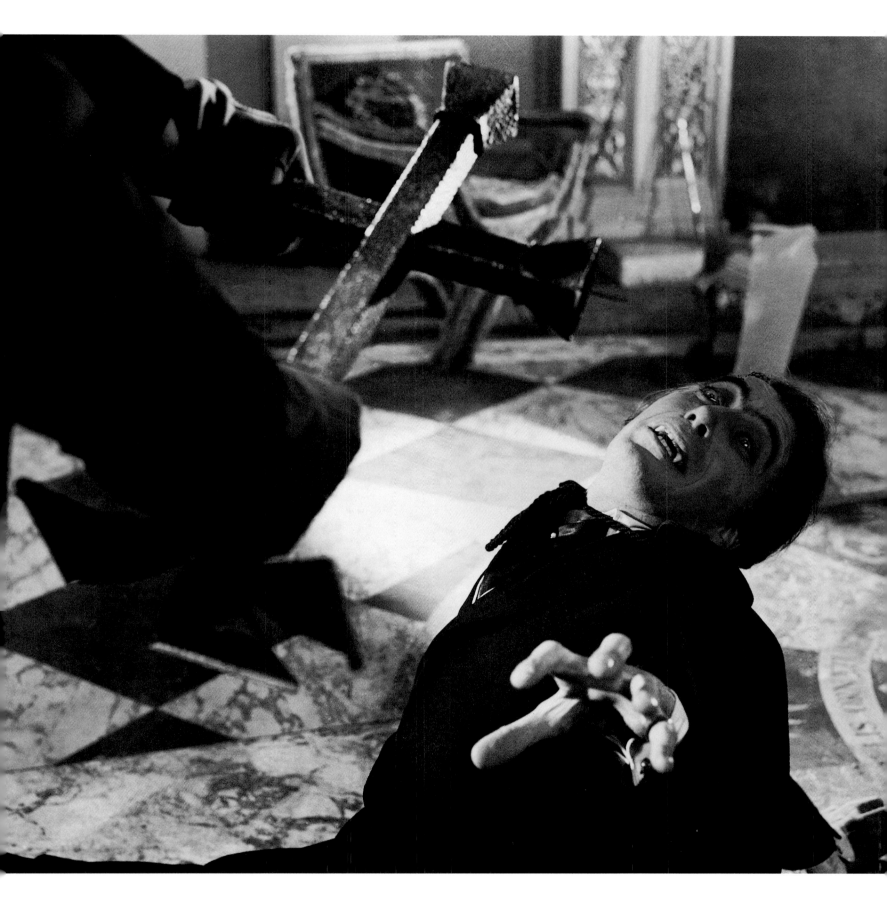

95 *Horror of Dracula,* 1958.

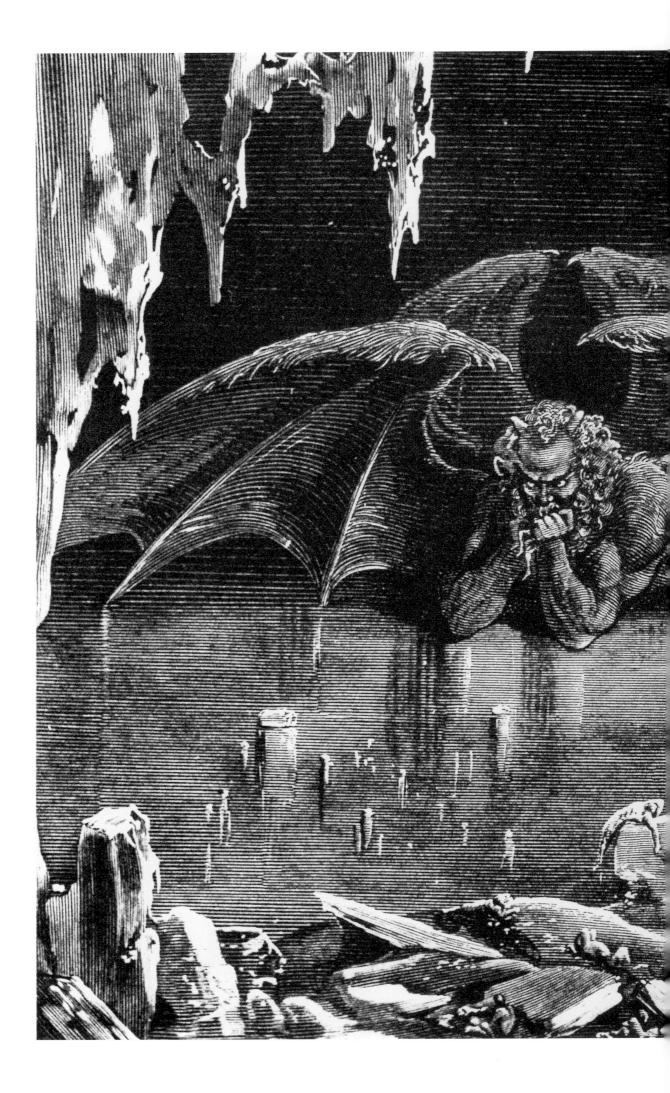

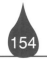

96 Gustave Doré's
illustration for *Dante's
Inferno*,
engraving. Paris,
Bibliothèque nationale.

155

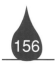

97 Movie still from a Romanian film
(Doru Nastase), 1978.

"And bats with baby faces in the violet light/Whistled, and beat their wings/And crawled head downward down a blackened wall."

Perhaps the best known (and most parodied and trivialized) image is that of the Count changing into a bat. Wherever Stoker found his information about vampire bats, it was not in anything he read about the Carpathians. Native only to Central and South America, the vampire bat (more accurately "Desmodus rotundus") appears to have derived its name from the vampire of European folklore.

Like the vampires of folklore, these bats feed on blood, though primarily that of livestock.
A vampire bat will cut the skin of its sleeping prey with razor-sharp teeth; rather than suck the blood, it laps it up, much as a cat laps milk.

The literary association of the bat with the vampire commenced in the nineteenth century. Before its introduction into vampire fiction, the bat had served as an apt icon of horror and monstrosity, as in works by Goya (the frontispiece to *Caprichos* and The Consequence from his series *The Disasters of War*) and in a number of Gustave Doré's illustrations for Dante's Inferno.

An early edition of *Varney the Vampyre* used the motif on its cover illustration, while a connection between vampires and bats appeared in both *"The Mysterious Stranger"* and Richard Burton's *Vikram and the Vampire*, re-issued in 1893.

Stoker expanded the link by having his Count Dracula shape-shift into a bat, a motif that was readily adapted by the movies for special effects.
In his pursuit and seduction of Lucy, for example, Dracula frequently transmutes himself into a large bat that flaps at her window for the purpose of drinking her blood. This motif found its way into the movies [20].

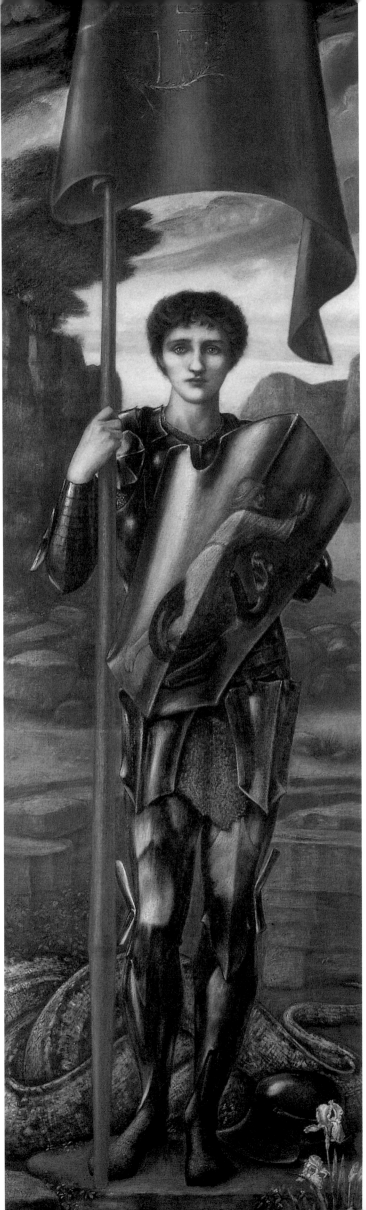

98 *Saint George* by Edward
Burne-Jones, 1897-1898.
Oil on canvas, 247 x 120 cm.
Kronberg, Hessische
Hausstiftung Collection.

Dracula

INTERPRETING DRACULA

Long dismissed as a horror story and nothing more, Dracula is now considered by many scholars to be a classic [21]. Though most will admit to its artistic flaws, they point to the fact that the novel is, as one scholar has noted, a "textually dense narrative which brings together a multiplicity of discursive fields".

Dracula's links with a wide range of academic disciplines such as anthropology, biology, history, law, literature, medicine, political science, psychology, religion and sociology provide many avenues of interpretive pursuit.

The "standard" reading of _Dracula_ holds that it replays the ancient struggle between good and evil.

In this respect, it is both a Gothic romance and a morality tale which reworks the pattern of medieval chivalric stories of knights in shining armour saving damsels in distress from fire-breathing dragons.

Indeed, Dracula has many similarities to the legend of St George and the Dragon:
Dracula is the dragon and Van Helsing is a Merlin figure, while one of the hunters' most effective weapons is the Cross; Van Helsing even refers to the vampire hunters as "knights."

Such familiar elements enable readers to find security in the reassurance that good will triumph over evil.

One can expand this to consider the novel as a reaffirmation of Christian faith in the face of late nineteenth-century skepticism.

Dracula upholds the Christian premise that faith can overcome the power of Satan. Biblical phrases resonate through the text. Not only is Count Dracula associated with the devil and repelled by holy symbols, he is also an inverted image of Christ whose arrival is heralded by Renfield, his insane John the Baptist. In a mockery of the Holy Eucharist, Dracula offers the gift of immortality through the drinking of blood.

While this reading may be outdated, it leads to an interesting counterpoint, for though Dracula appears to confirm an absolute division between good and evil, it simultaneously blurs the boundaries between natural and supernatural forces.

Although the mysteries are explained, the explanations themselves question rational thinking and the reader is left with the uneasy feeling that all may not be well. This has encouraged scholars to pay more serious attention to the text.

The earliest scholarly analyses of Dracula were essentially applications of Freudian and Jungian psychology to the sexual subtext of the novel.
In 1959, Maurice Richardson claimed that the novel is a "blatant demonstration of the Oedipal complex".

But even more important is Wolf's *A Dream of Dracula* (1972) which holds that Dracula's greatness "lies in the ways in which Stoker fuses the Christian allegory of his vampire tale with the other matters he exposes even as he tries to avoid knowing what they mean".

These "other matters" are "the configuration of sex, blood and death", as well as a "spectrum of incest possibilities, marriage, homosexuality, immortality and death" bound together by blood; he sees Dracula as a "visionary" novel which "squirms with primordial, dark or forbidden news from the abyss".

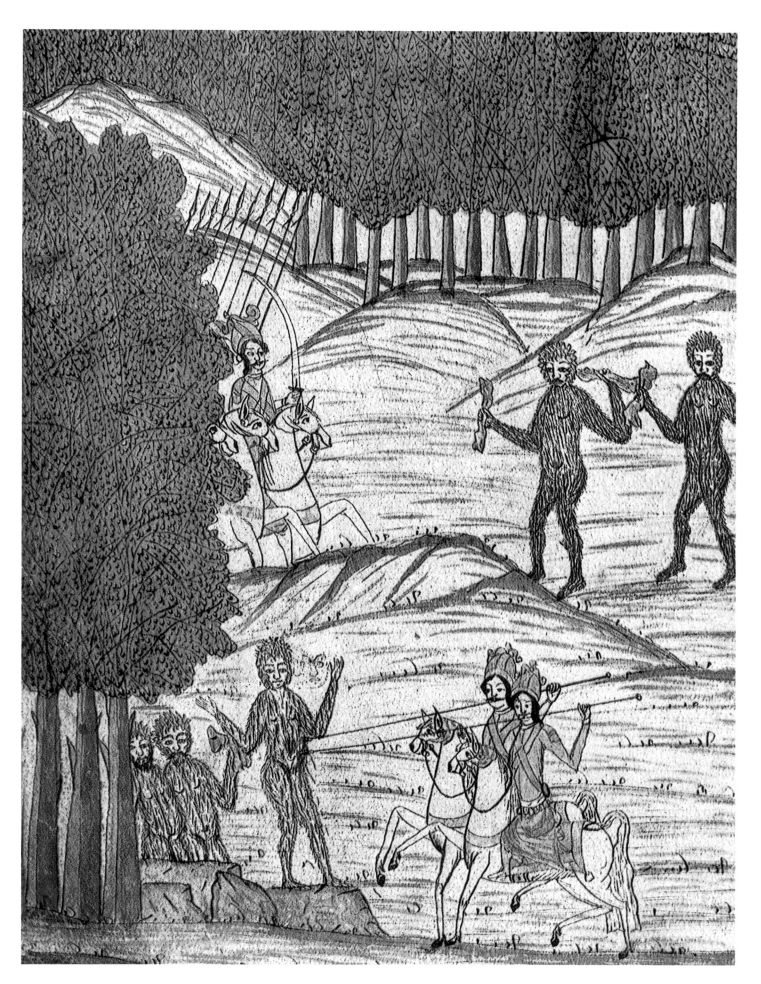

99 Nastase Negrule,
*Battle of Alexander of Macedonia against
Barbarians,* 1790. Bucarest.

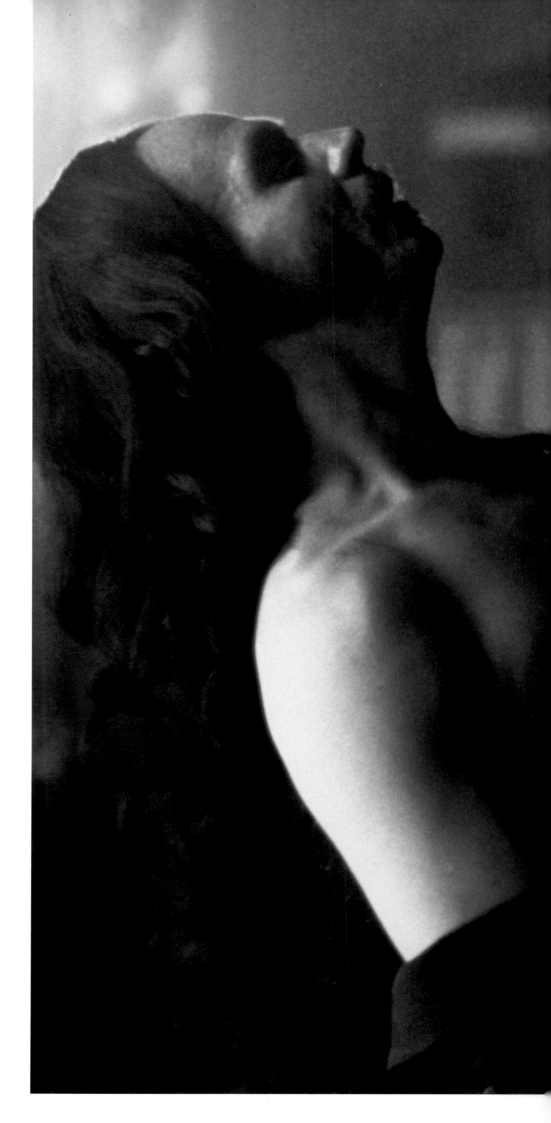

100 Sex, blood and death are intimately linked in Bram Stoker's novel, *Bram's Stoker Dracula* by Francis Ford Coppola, 1992.

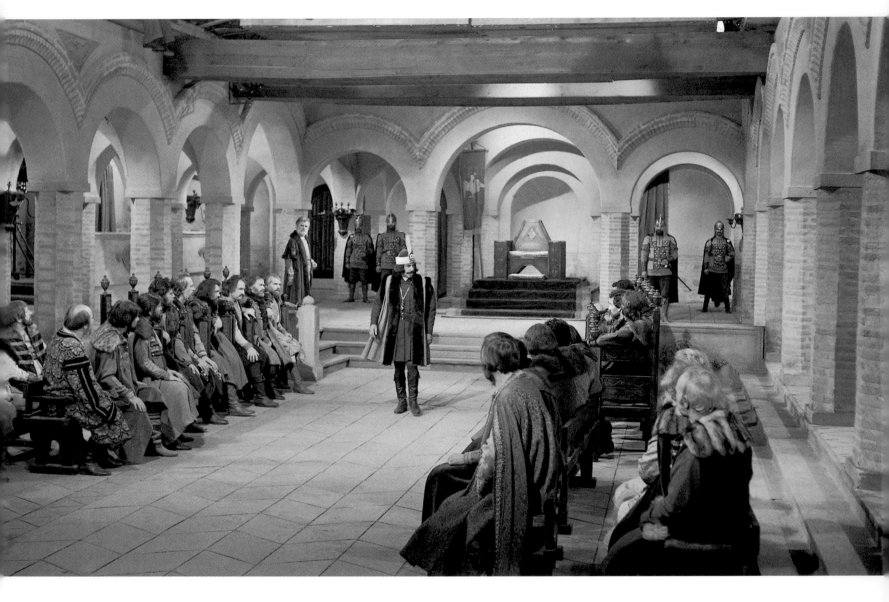

101 Movie still from a Romanian film (Doru Nastase),
1978.

Count Dracula can also be seen as raw sexual energy, and Jonathan's venture into the Borgo Pass as a journey into the libido.

Also in 1972, Christopher Bentley examined Dracula in the context of Ernest Jones's article on vampires in On the Nightmare: he focuses on sexual undertones in the sucking and the transfusing of blood, and draws attention to the phallic symbolism of the wooden stake as well as the novel's covert treatment of perverted sexuality [22].
Recent scholars have come to acknowledge that Dracula is a text which benefits from close contextual reading.
The consensus today is that it has achieved classic status because it provides a useful window on the world of late-Victorian England.

The novel is the product of a society and a culture that was marked by a variety of fears and anxieties, all of which are encoded in the narrative of the vampire who invades England.
Heading the list are anxieties about the transgression of social and moral codes regarding sexuality.
One need only consider *Psychopathia Sexualis*, a study prepared for the medical community in 1886 by Richard von Krafft-Ebing, to appreciate the prevalence of such an attitude. This treatise made it quite clear that all sexual practices other than heterosexual intercourse were to be condemned.
Acts of "depravity" included the whole gamut of equally degenerate acts: sadism, masochism, fetishism, pederasty. lesbianism, exhibitionism, masturbation, nymphomania, bestiality.
At one point, Krafft-Ebing even drew on the "*widespread legend of the vampires*" as having a close connection to acts of sexual sadism.
Whether Stoker was aware of any sexual sub-text in his novel is debatable.
In a note to Gladstone which accompanied a review copy of Dracula, he commented, "there is nothing base in the book." Stoker's stand in favour of censorship and the banning of "unclean books" has also been noted.

An oft-quoted excerpt from his article *The Censorship of Fiction* (1908) reads that "the only emotions which in the long run harm are those arising from sex impulses, and when we have realised this we have put a finger on the actual point of danger". While some use this to support the contention that vampires in Dracula are vampires and nothing more, others argue that the novel is first and foremost about sex, a subject that could be handled by a respectable Victorian writer only through subterfuge and suppression.

An even more productive way of interpreting Dracula is contextual. This approach pays attention to the social, cultural and economic contexts, and argues that Dracula provides valuable insights into life in Victorian England. One such view borrows from psychosexual readings, and focuses on what the text reveals about Victorian attitudes towards women. Dracula, suggests Skal, is "the sexual fever-dream of a middle-class Victorian man, a frightened dialogue between demonism and desire." Not surprisingly, some critics see the text as misogynous, an expression of the Victorian male's fear of female sexuality:

Their fight to destroy Dracula and to restore Mina to her purity is really a fight for control over women. It is a fight to keep women from knowing what the men and women of the Middle Ages, the Renaissance, the seventeenth and eighteenth centuries knew, and what people of the nineteenth century must also have known, even if they did not want to - that women's sexual appetites are greater than men's.

According to this reading, Dracula is feared because of his ability to release unbridled female sexuality.

This is supported through references to the three female vampires in Castle Dracula who make advances on a supine Jonathan Harker, and to Lucy Westenra who in the vampiric state not only tries to seduce her would-be husband but targets children as the victims of her blood-lust. Gail Griffin concludes that the worst horror is not Dracula himself, but the "released, transforming sexuality of the Good Woman".

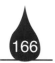

102 Franck Langella, *Dracula*, 1979.

Of course, such readings rely in part on late twentieth-century sexual politics, and it is doubtful that many of the issues they raise would have occurred to anyone reading the novel a century ago. But one of the reasons why Dracula has endured is that it yields such versatile interpretations.

Whether Dracula is a misogynist novel is a subject of much critical debate. The ambivalence centres on the character of Mina, a more modern woman who attempts to carve a niche for herself in a male-dominated world.

On more than one occasion she takes the initiative. It is her idea, for example, to have Van Helsing try hypnosis on her. In many respects, she subverts the stereotypical Victorian view of the Ideal Woman. For instance, she informs us she will continue to use her new technological skills after she is married. The fact that she values knowledge and technology suggests she is no "ordinary" woman.

But is she Stoker's nod of approval towards the "New Woman" of the 1890s, or does he use her character to put these outspoken females in their place? While she apparently rejects these modern women, she does so in such a playful tone that one could read it as begrudging admiration if not tacit approval:

Some of the "New Women" writers will some day start an idea that men and women should be allowed to see each other asleep before proposing or accepting. But I suppose the New Woman won't condescend in future to accept; she will do the proposing herself. And a nice job she will make of it, too!.

However, Mina is a far cry from a "liberated" woman. Her most cherished goal is her marriage to Jonathan, and she looks forward to using her secretarial skills to assist him in his career. She also acquiesces to her exclusion from the pursuit of Dracula since that is what the men want.

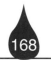

We are left with the distinct possibility that Stoker harboured ambivalent reactions to the changing roles of women in late nineteenth-century England.

"The impression I had was that we were leaving the West and entering the East," writes Jonathan Harker as he approaches Transylvania. Stoker's novel also provides an anglocentric view of the world, exacerbated by contemporary social and political tensions. Count Dracula can be seen as both cultural and racial. Other the fact that he is a foreigner who brings a brand of pollution into England allows the novel to be interpreted in the context of Victorian anxieties about England's role as an imperialist power.

An extensive treatment of this thesis is given by Stephen Arata, who sees the book as a "narrative of reverse colonization" which expresses fears "linked to a perceived decline - racial, moral, spiritual - which makes the nation vulnerable to attack from more vigorous, 'primitive' peoples". The vampire from eastern Europe embodies the threat of deracination from outsiders who can mingle, unrecognized, in the streets of London. That the novel was written at a time of increased immigration from central and eastern Europe supports such a reading. Anglocentrism is also evident in the way the text privileges the technology which represents England's superiority.

Thus the defeat of Dracula celebrates the victory of civilization over savagery. But even here, the text hovers on the edge of uncertainty. For even though "au courant" scientific advances are utilized (blood transfusion, head surgery and hypnosis), ultimately, the tools of science and technology alone are not sufficient: the vampire hunters must employ the rituals of the more primitive world as well. For science brings anxieties of its own. Written in the post-Darwinian world, Dracula raises the spectre of humanity's potential to regress, to slide back down the evolutionary scale.

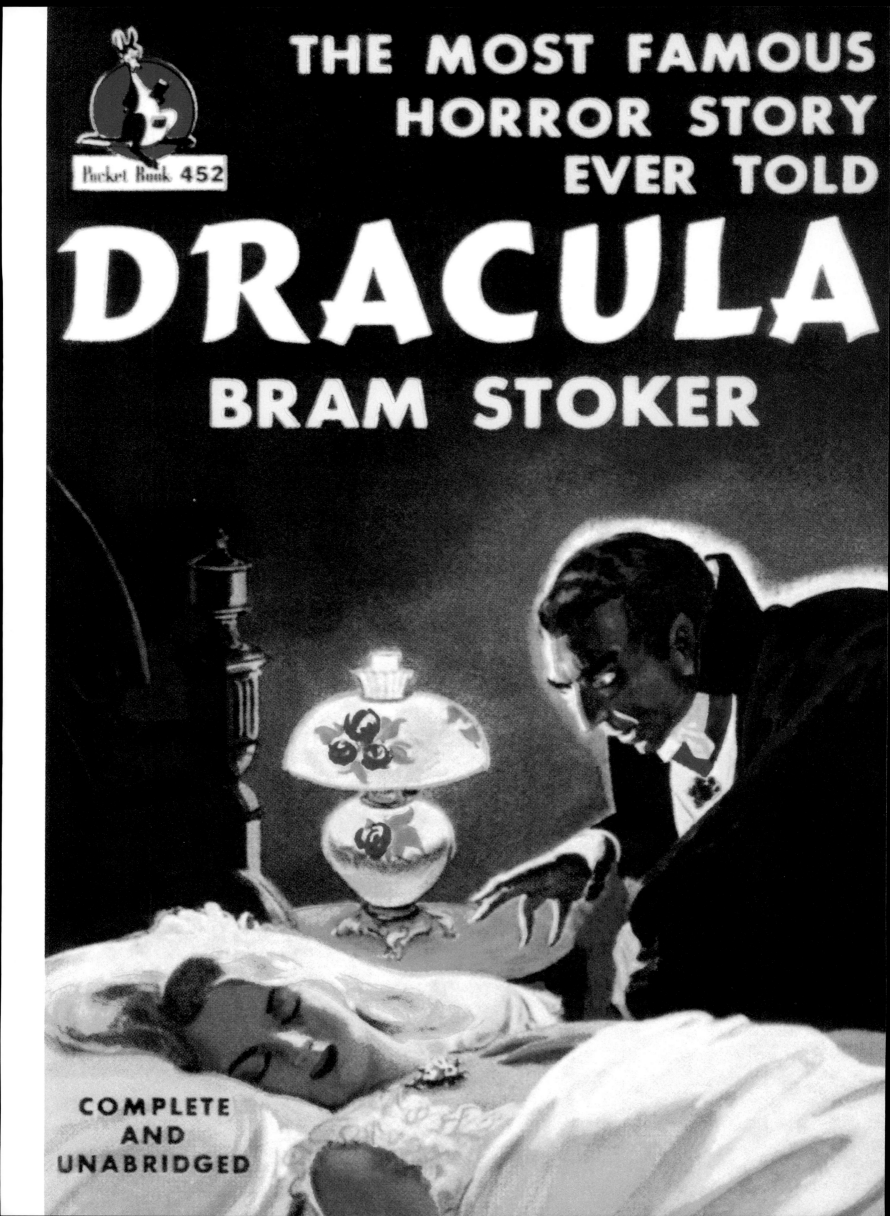

CHAPTER IV
DRACULA THE IMMORTAL

SHAPE-SHIFTING TEXT

Dracula has never been out of print since its first publication by Constable in the United Kingdom in 1897. Within fifteen years, two other significant editions appeared: the first in the USA, published in 1899 by Doubleday & McClure, and another British edition (Rider) in 1912.

Subsequent editions - of which there are over one hundred in English (from both popular and scholarly presses) as well as numerous translations into foreign languages - followed one or the other of these three benchmark texts. In 1901, Stoker prepared an abridged version (also released by Constable), which cut about fifteen percent of the original.

The novel has appeared in a number of illustrated and/or annotated editions. Among the noteworthy illustrated texts are: the Limited Editions Club Edition of 1965, with 1500 numbered copies were signed by the artist, Felix Hoffman, who illustrated the text with woodblock engravings; *The Annotated Dracula* (1975) edited by Leonard Wolf, distinguished by a series of eerie illustrations by Satty; a popular, glossy hard-cover edition, published by 1985 with illustrations by Greg Hildebrandt (several of which were reproduced in an abridged, sanitized edition for children).

103 The Cover of *Dracula*, Pocket Book edition, 1947.

DRACULA

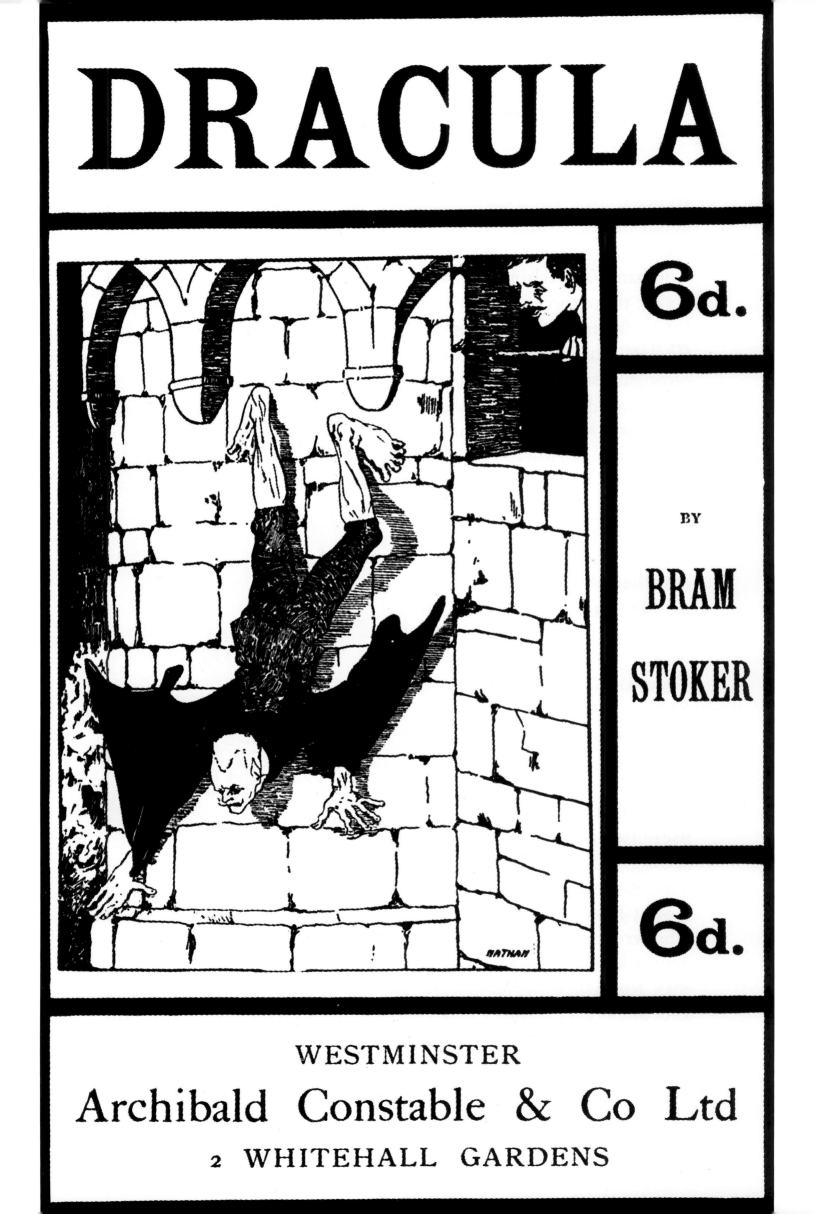

6d.

BY

BRAM
STOKER

6d.

WESTMINSTER

Archibald Constable & Co Ltd

2 WHITEHALL GARDENS

THE COUNT OF MANY FACES

A major challenge confronting any new reader of Dracula is the extent to which popular culture has redefined the original text. Readers often expect one thing and find another; some even impose their own preconceptions onto Stoker's novel, occasionally with ludicrous results [23].

Most people's knowledge of Stoker's Count comes not from the book but from one or more of the dozens of movies dating back to the 1920s that claim to be based on it.

The first extant film adaptation of *Dracula* [24] is *Nosferatu, Eine Symphonie des Gauens*, a black-and-white silent film released in Germany by Prana-Film in 1922.
Considered today a masterpiece of German expressionism, the film, directed by F. W. Murnau, featured Max Schreck as the Count.

It was the subject of a lengthy battle in the British and German courts, as the film producers failed to acquire permission from Stoker's widow to use her late husband's novel. In spite of one court ruling that all copies of the movie be destroyed, it survived, and is considered by many to be the quintessential vampire film.

The first celluloid Dracula, Count Orlock, had more in common with the vampire of folklore: with his rat-like teeth, clawed hands and bald head, he is associated with the coming of the plague.

The movie that defined Count Dracula for much of the twentieth century was released in 1931 by Universal Studios.
It was an adaptation of a stage play written by Hamilton Deane and John Balderston which opened on Broadway in 1927.

105 The cover of Dracula
by Bram Stoker,
Archibal Constable & Co. Ltd.edition,
1901.

Directed by Tod Browning, Dracula featured a Hungarian actor who had played the title role in the Broadway production - Bela Lugosi. The movie was a success, and spawned numerous sequels; indeed, Lugosi's Dracula became the lasting image of the Count, the one that dominated popular culture for much of the century.

Bela Lugosi gave us a cultured aristocrat who is as comfortable in the drawing rooms of England as he is in his castle.

He was dressed in evening clothes with a black opera cape, and spoke with a thick foreign accent (though in Stoker's novel, Count Dracula never wears a cape and speaks excellent English).

Almost thirty years would pass before Lugosi's dominant position would be challenged. In 1958, Hammer Studios of Great Britain released *Horror of Dracula* with Christopher Lee. Based on a new screenplay by Jimmy Sangster, just as much a departure from Stoker as was the Deane-Balderston, this film used the new technique of technicolour to full advantage, and Lee brought to the role a potent combination of aloofness and alluring sensuality.

Other versions of Stoker's novel were released in subsequent decades: *Dracula* (1973) directed by Dan Curtis and starring Jack Palance; Count Dracula (made for TV by BBC, 1978); Dracula (1979, directed by John Badham) starring Frank Langella and going back to the Deane-Balderston text - though with a highly romanticized Byronic Dracula (and with Laurence Olivier as Van Helsing); and a remake of the Murnau classic, Nosferatu the Vampyre directed by Werner Herzog with Klaus Kinski in the title role.

The only one of these to follow Stoker's original text closely was *Count Dracula* (BBC).

Though Louis Jourdan's portrayal of Dracula is as different from Stoker's as are the others, the film does adhere quite closely to the plot-line of the original novel, taking only minor liberties with the text. A major adaptation appeared in 1992 as *Bram Stoker's Dracula*. Heralded by its promoters as a faithful rendition of the novel (hence its title), this blockbuster (which captured three Academy Awards) was directed by Francis Ford Coppola and starred Gary Oldman as the Count.

106 Christopher Lee as Dracula in
Horror of Dracula, 1958..

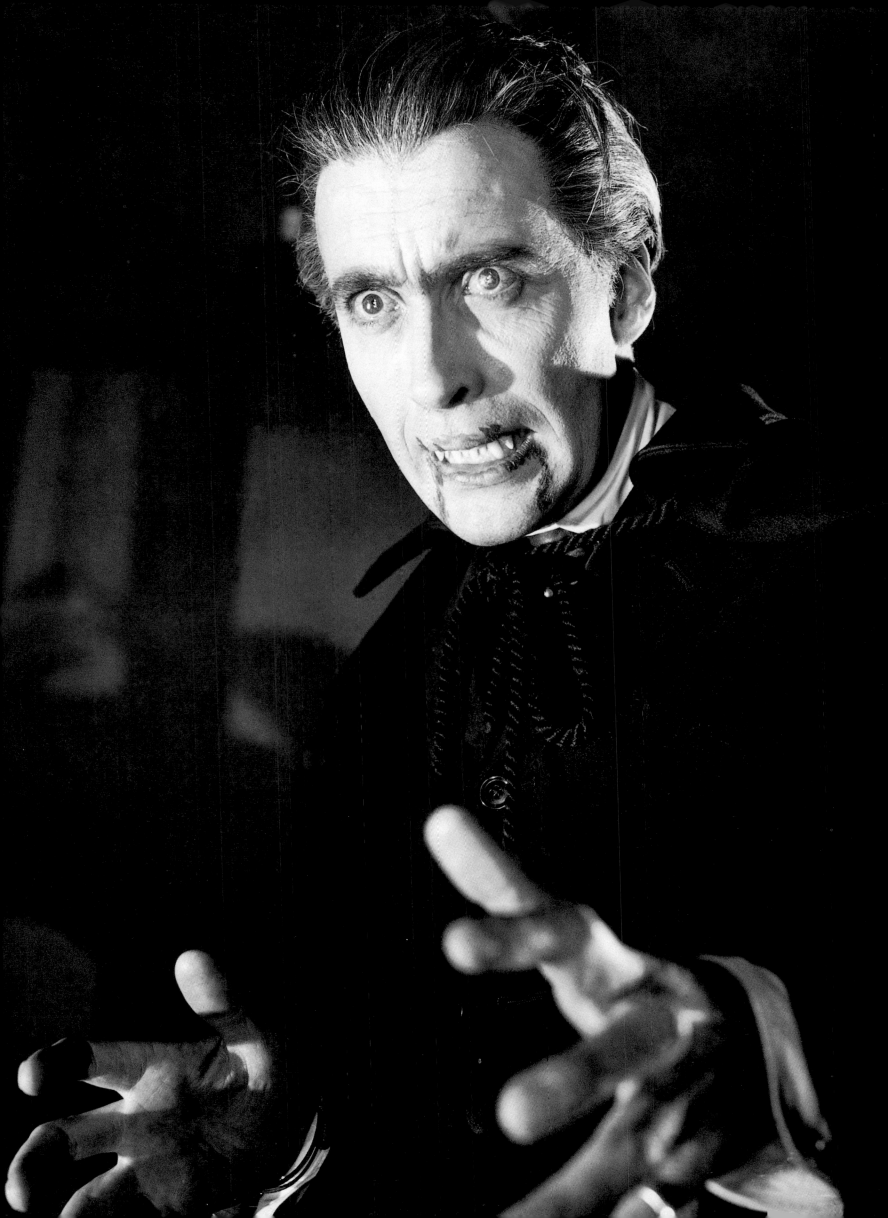

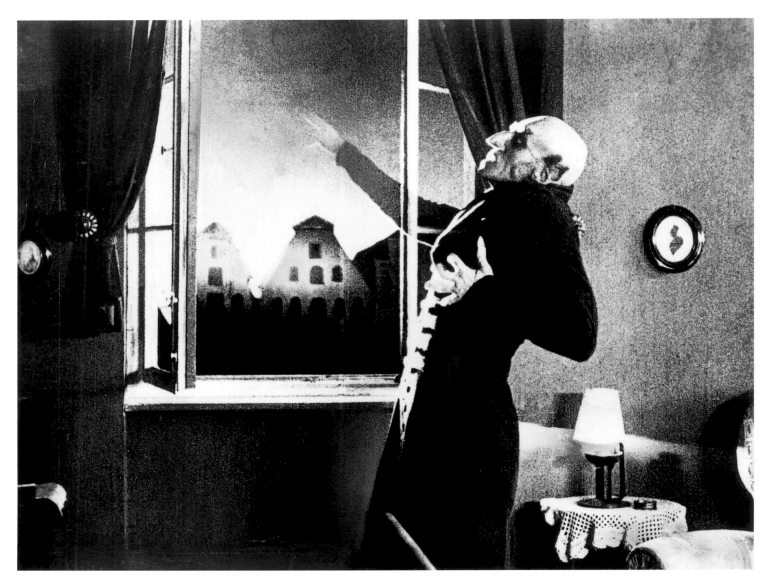

107 Nosferatu destroyed by sunlight
in *Nosferatu the vampire*, 1922.

The altered physical appearance of the Count is not the only discrepancy between book and films. Another difference is the manner in which Dracula is dispatched.

The text is clear about "the sweep and flash of Jonathan's great knife. I shrieked as I saw it shear through the throat; whilst at the same moment Mr. Morris's bowie knife plunged into the heart".

Yet this belief that Dracula can only be destroyed by a wooden stake is so widespread that an entry on *Dracula* in the 1993 edition of

108 Max Schreck as Nosferatu in the movie
of F. W. Murnau,
Nosferatu the vampire, 1922.

Encyclopedia Americana states: "He is in turn pursued by others until his body is overtaken, and a stake is driven through its heart". This method was employed in Hamilton Deane's play and, consequently, in Universal's adaptation of 1931.

The scene of Van Helsing staking the Count became the prototype for many subsequent films, but some movies employ fire, a combination of staking and fire and even an explosion of dust and smoke!

109 A cartoon from *The Tatler Magazine*,
December 14th, 1927.
The Illustrated London News Picture Library.

Sometimes he disintegrates, sometimes he is decapitated, sometimes he is granted a final look of peace.

The Coppola film adheres closely to Stoker's text in some respects, for Harker and Morris use their knives to shear his throat and pierce his heart; but it makes an important departure when it has Mina conclude this task with a sword.

But most often, cinematic Draculas are destroyed by sunlight. Though the text of *Dracula* affirms that the Count can move about freely in daylight (with reduced powers), the notion that Dracula was destroyed by the sunlight is not easily dislodged.

Introduced in the 1922 silent film *Nosferatu*, this motif was not used in the movie of 1931; but it resurfaced in Hammer's adaptation of 1958, where Peter Cushing dramatically pulls open the curtain to expose Christopher Lee to the deadly rays of the sun.

Another variation appears in 1979, when Dracula (Frank Langella) is hoisted into the sunlight where he disintegrates.

The film that is most faithful to Stoker in this respect is *Bram Stoker's Dracula*: the Count (Gary Oldman) moves about freely during daylight, but his powers are reduced.

Dozens of other movies use "Dracula" in their titles, even though they bear no resemblance to the novel.

Ranging from mediocre to dreadful, these include films such as House of Dracula, Son of Dracula, Return of Dracula, Dracula Has Risen from the Grave, Billy the Kid vs Dracula, Blacula, and even Dracula's Dog.

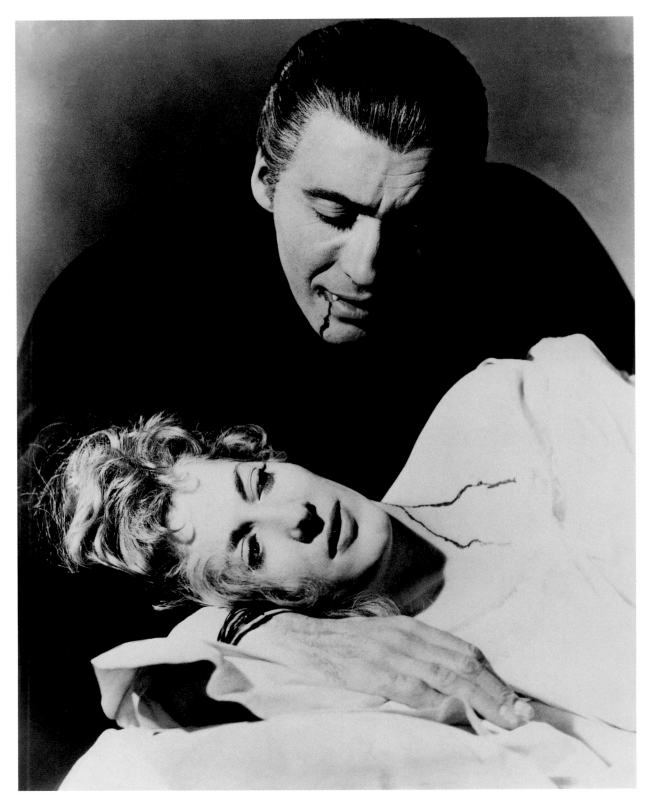

110 Christopher Lee and Melissa Stribling,
Dracula, 1958

111 Louis Jourdan as Count Dracula in the BBC's series, 1978.

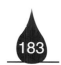

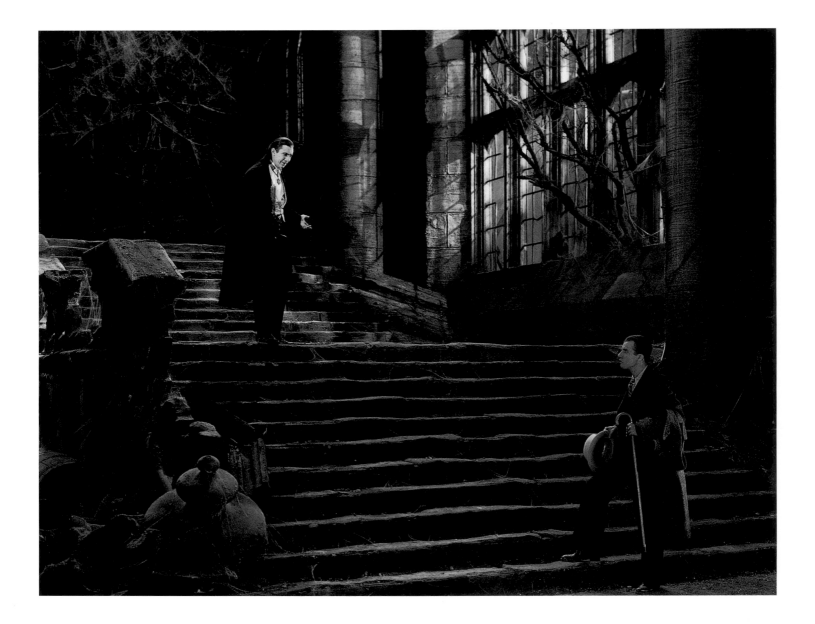

From the movies, the Count has managed to invade every aspect of popular culture. Stoker's vampire archetype has inspired comic books, T-shirts, greeting cards, poster art, cartoons and games; his image graces cereal boxes, candy wrappers and Web sites.

There are Dracula fan clubs and even scholarly organizations devoted to Dracula and vampire studies (for example, the Transylvanian Society of Dracula, the Bram Stoker Society, the Lord Ruthven Assembly and the Count Dracula Fan Club). The Count is a regular feature on the classic children's television programme, *Sesame Street*. In fact, Count Dracula has been sanitized and packaged for children with hundreds of books on the market, mostly since 1980.

112 Jonathan Harker meets Dracula for the first time.
Dracula by Tod Browning, 1931.

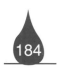

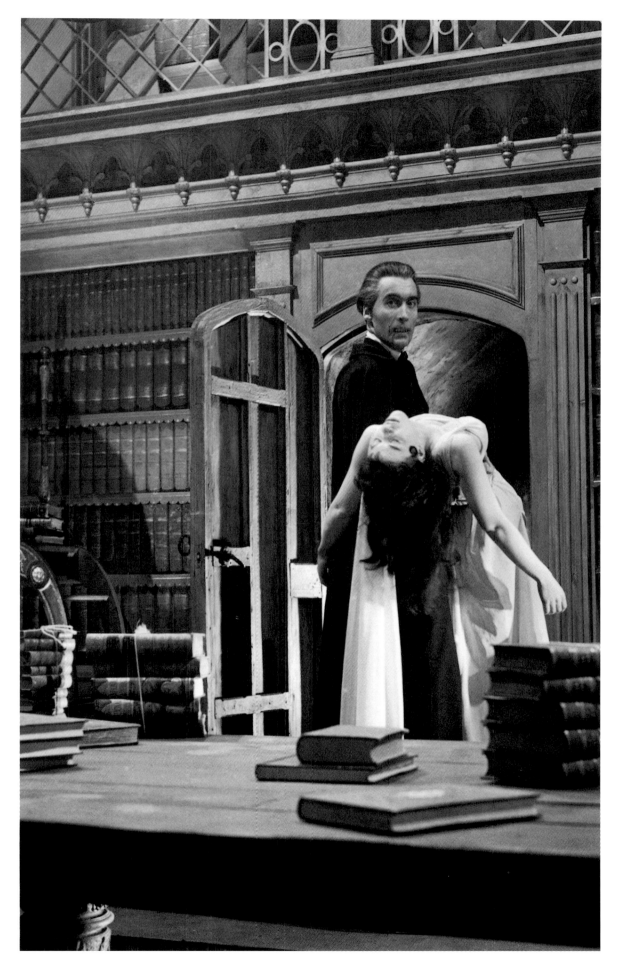

113 Christopher Lee,
Dracula, 1958.

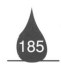

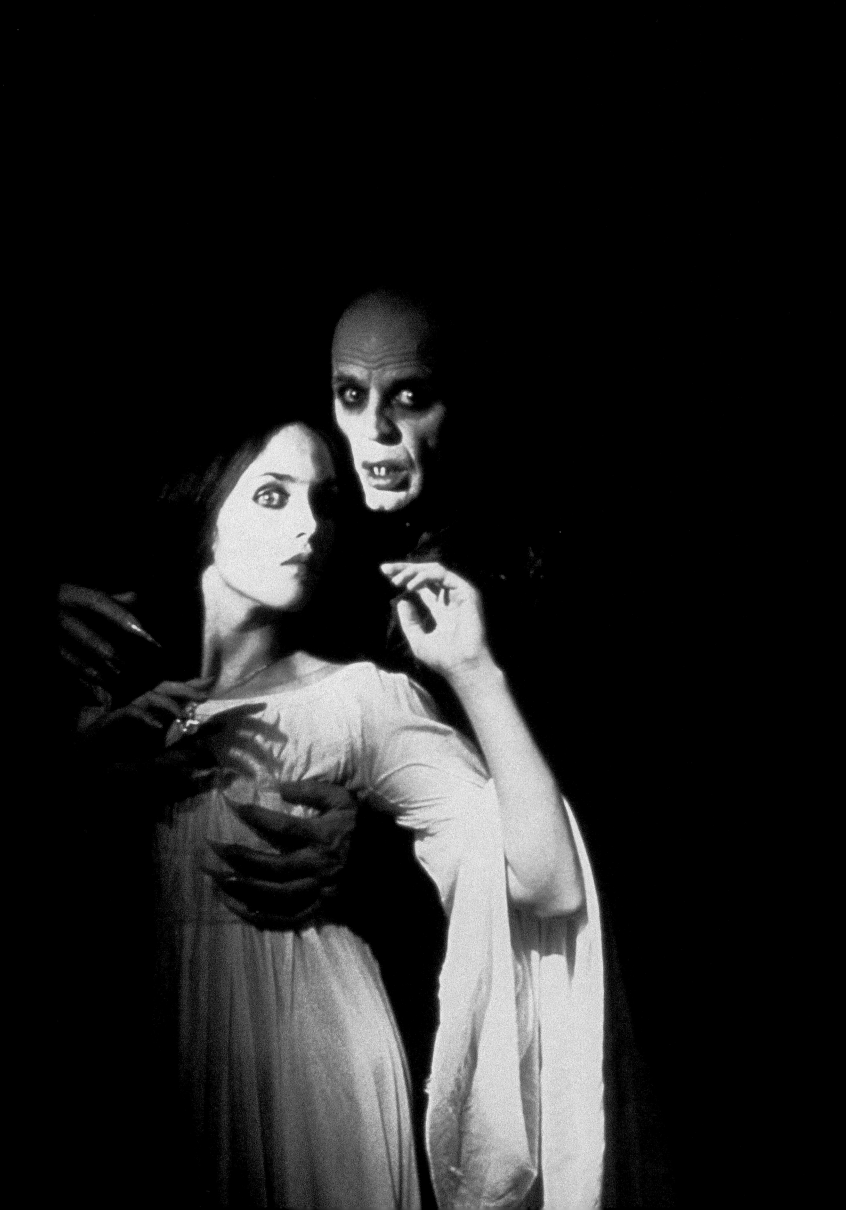

Popular favourites are Bunnicula (Deborah & James Howe, 1979), the vegetarian vampire; the "Little Dracula" series by Martin Waddell including *Little Dracula at the Seashore, Little Dracula Goes to School and Little Dracula's First Bite*; Ann Jungman's *Vlad the Drac* series; and from Germany, *Der Kleine Vampir* (Angela Sommer-Bodenburg, 1982) with its many sequels.

Other titles of children's books - *Fenella Fang, Vampire Mom, The Little Vampire Activity Book* - attest to the versatility of the most adaptable of monsters.

Interest in Bram Stoker and his Dracula underwent an upsurge during the 1990s. Part of this was due to the release in 1992 of the movie *Bram Stoker's Dracula*, with its cast of well-known actors.
Then in 1997, the centenary of Dracula was marked by a number of special events, including fan conventions, scholarly conferences and exhibits both at the Writers Museum in Dublin and the Rosenbach Museum in Philadelphia.
Four countries (the USA, Canada, United Kingdom and Ireland) issued commemorative postage stamps.

One of the most interesting developments during the decade was the appearance of a number of new productions of Dracula for ballet. The Houston Ballet's Dracula, choreographed by Ben Stevenson, opened in 1997 to packed houses.
With music by Franz Liszt, this highly spectacular production features flying vampire brides, as well as a soaring Count Dracula with cloak spread like huge bat-wings.

In October 1998, Canada's Royal Winnipeg Ballet offered its own production which opened in Winnipeg and has since toured much of Canada.
With music by Gustav Mahler, this adaptation (unlike the Houston production) adhered much more closely to Stoker's plot and characters.

114 Klaus Kinski and Isabelle Adjani in
Nosferatu The Vampyre, 1979

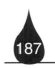

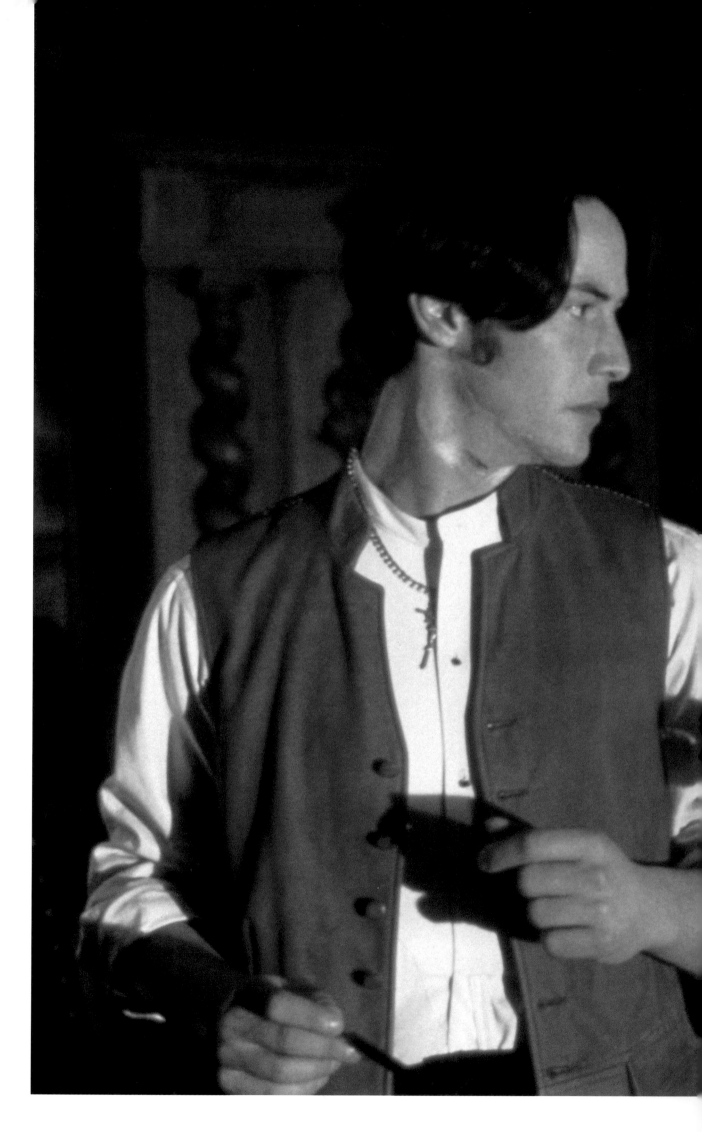

115 Dracula and Jonathan Harker in *Bram Stoker's Dracula*, 1992.

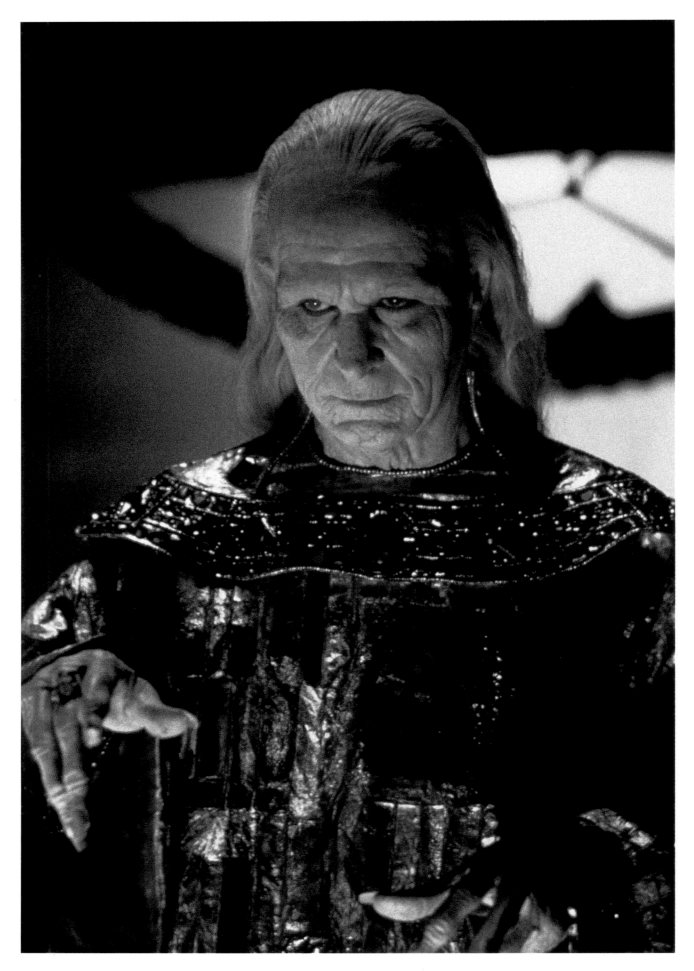

116 Gary Oldman as Dracula in *Bram Stoker's Dracula*
by Francis Ford Coppola, 1992.

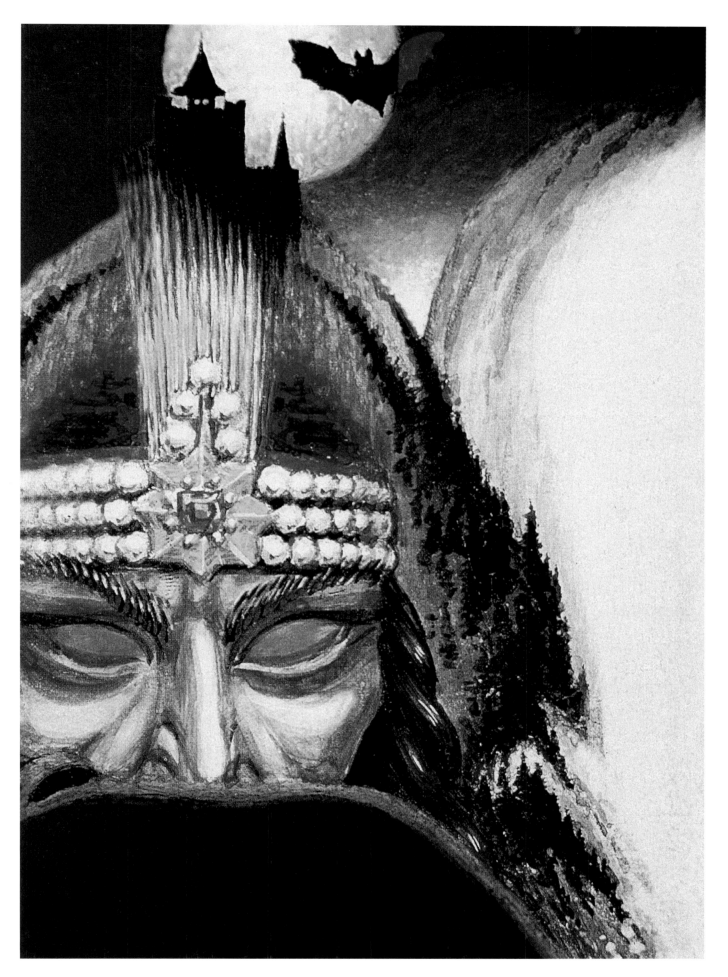

117 Contemporary postcard. .

Meanwhile in the United Kingdom, the Northern Ballet Theatre had been touring the UK with a *Dracula* of its own (Christopher Gable and Michael Pink, with original music by Philip Feeney).

Dracula has also been adapted as a chamber musical, directed by Richard Ouzounian and performed at the Stratford Festival (Canada) during its 1999 season. It appears that the Count will never die.

While Dracula has remained in the public eye for over one hundred years, Stoker's vampire Count has also spawned a wide variety of mutations. Vampires are everywhere; many of them bear little or no resemblance to Count Dracula.

Vampire novels and films (numbering in the hundreds) offer bloodsuckers from every walk of life: alienated youth, musicians, university professors, airline pilots and police detectives. Some are vampires by choice, others are biological mutants, still others are extra-terrestrial visitors.

Vampires grace our television sets in series such as *Dark Shadows, Forever Knight and Buffy the Vampire Slayer*. The icon of the vampire has been altered to reflect changing social and cultural attributes.

Due primarily to the fiction of Anne Rice, the one-dimensional vampire that was Count Dracula has developed into a more complex, ambiguous figure.

Gone are the clear distinctions between good and evil that mark (at least on the surface) Stoker's novel. Today's vampires reflect the very moral ambivalence that characterizes the post-modernage.

118 American Medal bearing the effigy of the historical Vlad, Dominic Nycol, 1993, New York.

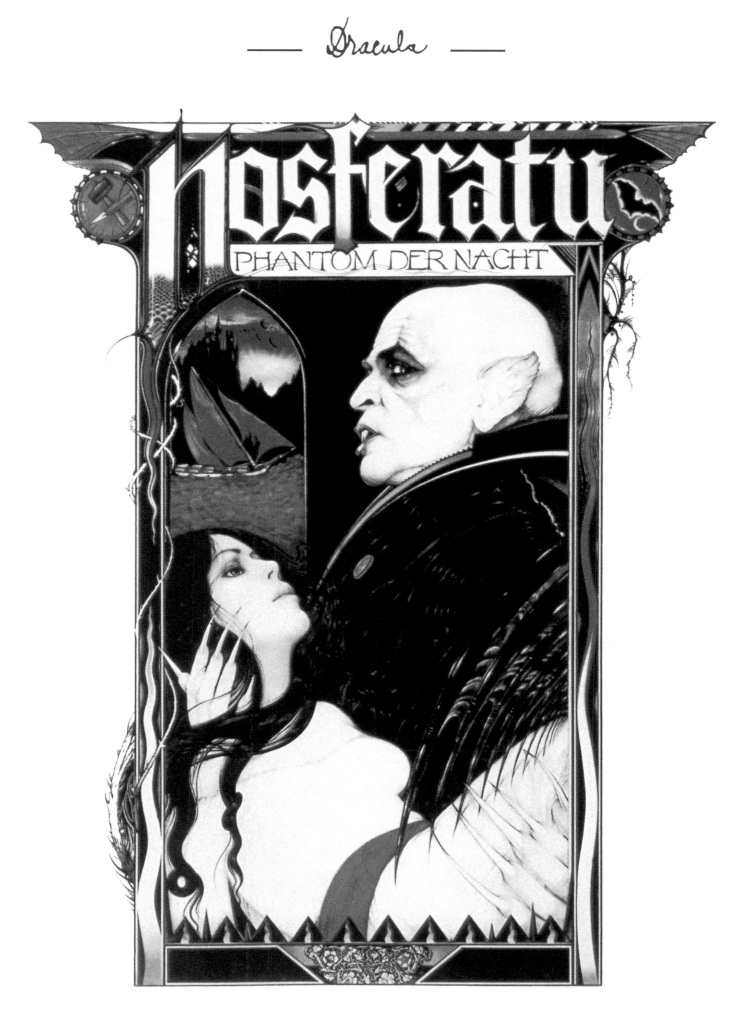

119 Poster of Werner Herzog's *Nosferatu,*
Phantom of the Night, , 1979

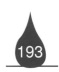

THE COUNT AND THE VOIVODE

One factor that has contributed significantly to the explosion of interest in Dracula since 1970 is the widely held (and fallacious) assumption that Stoker was inspired by the life and atrocities of Vlad the Impaler.

The oft-quoted line from Stoker used to support this position is Van Helsing's assertion that Count Dracula "must have been that Voivode Dracula who won his name against the Turk". While there can be no doubt that Stoker borrowed the name "Dracula" (which happened to be a name used by Vlad), no evidence exists to support the contention that the author of Dracula knew much more about the historical namesake.

Although for many people today the two have become almost synonymous, the nature of the connection is highly speculative. And that speculation runs rampant.

For example, it has been suggested that Stoker drew the concept of the staking of a vampire from his knowledge of Vlad's penchant for impaling his enemies on stakes; that Renfield's fondness for insects and small animals is a re-enactment of Vlad's habit of torturing small animals while he was held prisoner in Hungary; or that Count Dracula is repelled by holy symbols because Vlad betrayed the Orthodox Church by converting to Roman Catholicism.

Such conjecture has arisen from a basic assumption (yet to be proved) that Stoker knew much more about Vlad than what he read in William Wilkinson; that his other major sources were the Hungarian professor Arminius Vambery and his own readings in the British Museum (both of which are indirectly alluded to in the novel) [25]. Most of this is nonsense.

120 One of Dracula's various aspects in *Bram Stoker's Dracula*, 1992.

That the character of Count Dracula was based on Vlad the Impaler was a central premise in the works of two American historians, Raymond McNally and Radu Florescu.

While earlier scholars had hinted at such a connection [26], it was *In Search of Dracula* (1972) that cemented it in the public mind. Accepting McNally and Florescu's theories as fact, various and sundry enthusiasts have championed tenuous connections between Count Dracula and Vlad Tepes to the point where it has become increasingly difficult to separate fact from fiction.

Much of this enthusiasm comes from a genuine and understandable excitement that there had, indeed, been a Dracula.

In fact, this has been one of the most important factors bringing Dracula and his progeny into the mainstream of academic scholarship. But the combination of fact and conjecture opened the floodgates, with the result that for most, the two Draculas are the same. One even encounters (in print) the statement that vampire legends originated with Vlad the Impaler!

The blurring of boundaries between the historical and fictional Draculas has, not surprisingly, found its way into fiction and film. Several stories and novels feature vampires named Vlad Tepes.

In *Dracula Began* (1976), Gail Kimberly combines accounts of Vlad's youth with the story of how he became a vampire living in present-day Romania.

A more ambitious effort, Peter Tremayne's *Dracula Unborn* (1977), is the first novel in a trilogy in which Vlad became a vampire by selling his soul for immortality and eventually emerges as Count Dracula. The text fuses facts about the historical figure, such as the feast at Târgoviste and the construction of his fortress at Poenari, with details from Stoker's novel.

Tremayne's portrait of Vlad Dracula is almost identical to Stoker's description of Count Dracula.

121 Dracula 97,
drawing by Mark Williams for
the centennial celebration.

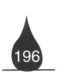

DRACULA 97

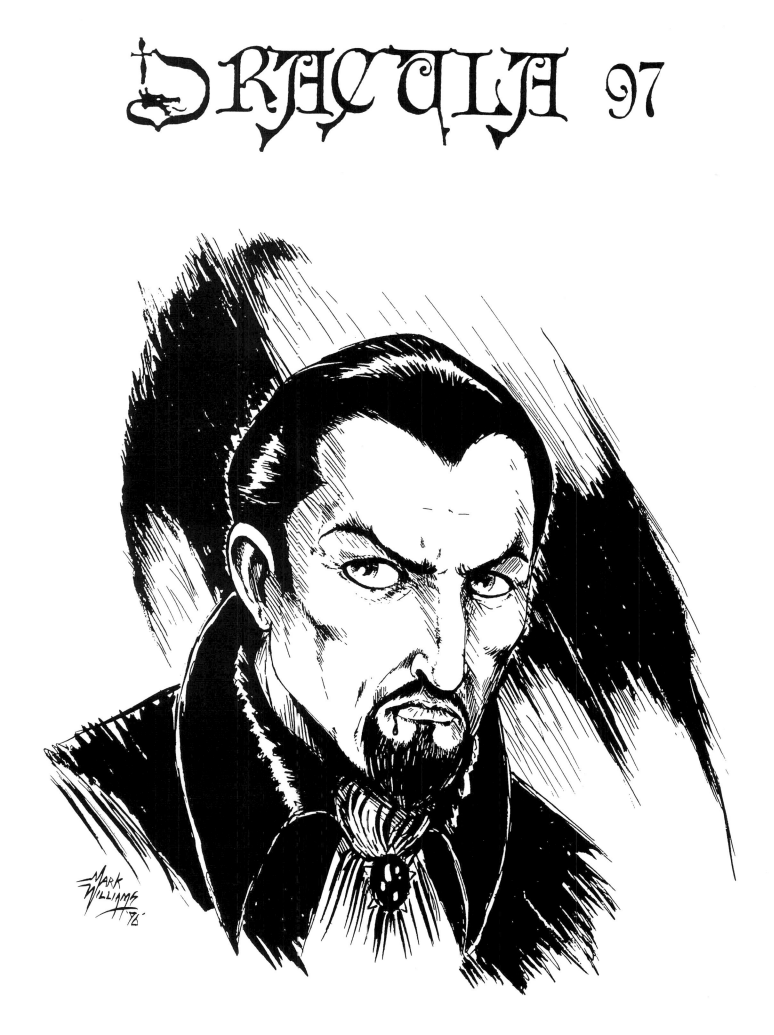

August 14 - 17, 1997
Westin, LAX

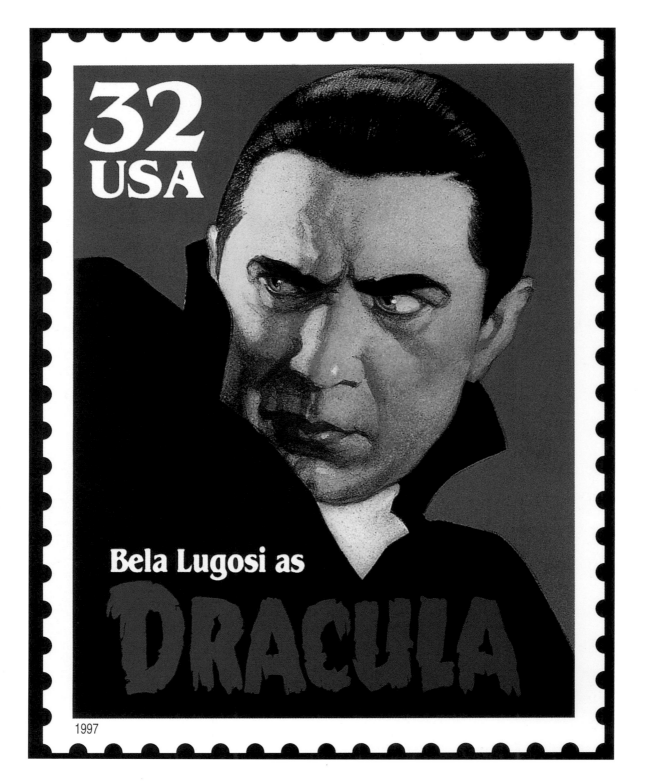

32 USA

Bela Lugosi as

DRACULA

1997

At the end of the novel, Dracula is saved from the flames of his fifteenth-century castle and survives another four hundred years to spread evil and horror across the face of the earth as a vampire.
The sequels, The Revenge of Dracula and Dracula, My Love develop the historical-fictional connections. Donald Glut's *Frankenstein Meets Dracula* also grafts elements of the historical Vlad on to Stoker's Count,

122 A centennial american postage stamp
with Bela Lugosi as Dracula, 1997.

working on the premise that the Count as voivode was so evil in life that he returned after death as one of the undead, and as such became the subject of Stoker's novel.

Numerous variations on the theme appear in other works, including Philip Daniels' *The Dracula Murders*, Fred Saberhagen's *The Dracula Tape* (and its sequels) and Jeffrey Sackett's Blood of the Impaler.

In Asa Drake's Crimson Kisses (which was revised as *I Am Dracula* under the author's real name, C. Dean Andersson), Vlad becomes "The King of the Vampires" with the help of his gypsy lover, while the vampire in Raymond Rudorff's *The Dracula Archives* is descended from both the Dracula and the Bathory clans.

This preoccupation with creating fictional connections between Dracula and his namesake peaked Kim Newman's Anno Dracula, Vlad Tepes is both a vampire and, as the husband of Queen Victoria, the Prince Consort of Britain.

The sequel, *The Bloody Red Baron*, provides an alternative history of the intrigue that preceded the First World War, with Vlad playing a decisive role.

Jeanne Kalogridis's trilogy, *The Diaries of the Family Dracul*, one of the most elaborate attempts to merge the two, builds a genealogical tree from Vlad to his nineteenth century descendants, providing a prequel to Dracula which converges with Stoker's novel. Other writers have extended these connections to include the late Communist dictator of Romania, Nicolae Ceaucescu.

123 Contemporary postage stamps.

Dan Simmons' *"All Dracula's Children"* makes Vlad Dracula Ceaucescu's Dark Advisor and draws on the ironic fact that the dictator was executed in Vlad's fifteenth-century capital city, Târgoviste.

The story "Voivode" by Douglas Borton takes the connection a step further: Ceaucescu is a reincarnation of Vlad Tepes who has survived as a vampire; his lair is hidden in the recesses of Vlad's fortress at Poenari.

The Voivode-Count connection also appears in movies. The earliest film to make a link between them is a Turkish movie titled *Drakula Istanbul'da* (1953). The screenplay by Unit Deniz is an adaptation of the Turkish novel, *Kazikli Voyvoda by Riza Seyfi*, a loose (and extensively abridged) translation of Stoker's opus.

A year after the publication of *In Search of Dracula*, the Dan Curtis production of Dracula (a.k.a. Bram Stoker's Dracula), written by Richard Matheson and starring Jack Palance, presented Vlad and Count Dracula as one and the same.

Also in the 1970s, Christopher Lee appeared as Vlad in a documentary film based on Florescu and McNally's *In Search of Dracula*. The use of an actor who is so often associated with the role of Count Dracula was instrumental in forging the link even more firmly.

Although the BBC television production of *Count Dracula* (1978) includes a brief image connecting the Count to the Impaler, it was not until Francis Ford Coppola's blockbuster of 1992, Bram Stoker's Dracula, that the Count's vampiric state was fully explained in terms of events in Vlad's life. According to the script, Vlad Tepes's wife commits suicide and is damned by the church.

The grief-stricken voivode exclaims defiantly, "I renounce God. I will arise from my own death to avenge hers with all the powers of Darkness." The next time we see him, he has become a vampire.

In addition, the Count's desire for Mina is rendered as the continuation of a love affair which was tragically aborted in the 1460s.

Thus fiction has made Vlad what he never was in life - a vampire – and has thus granted him, like his literary counterpart, immortality.

124 Douglas Paraschuk, costume designs for Dracula, 1999. Stratford Festival.

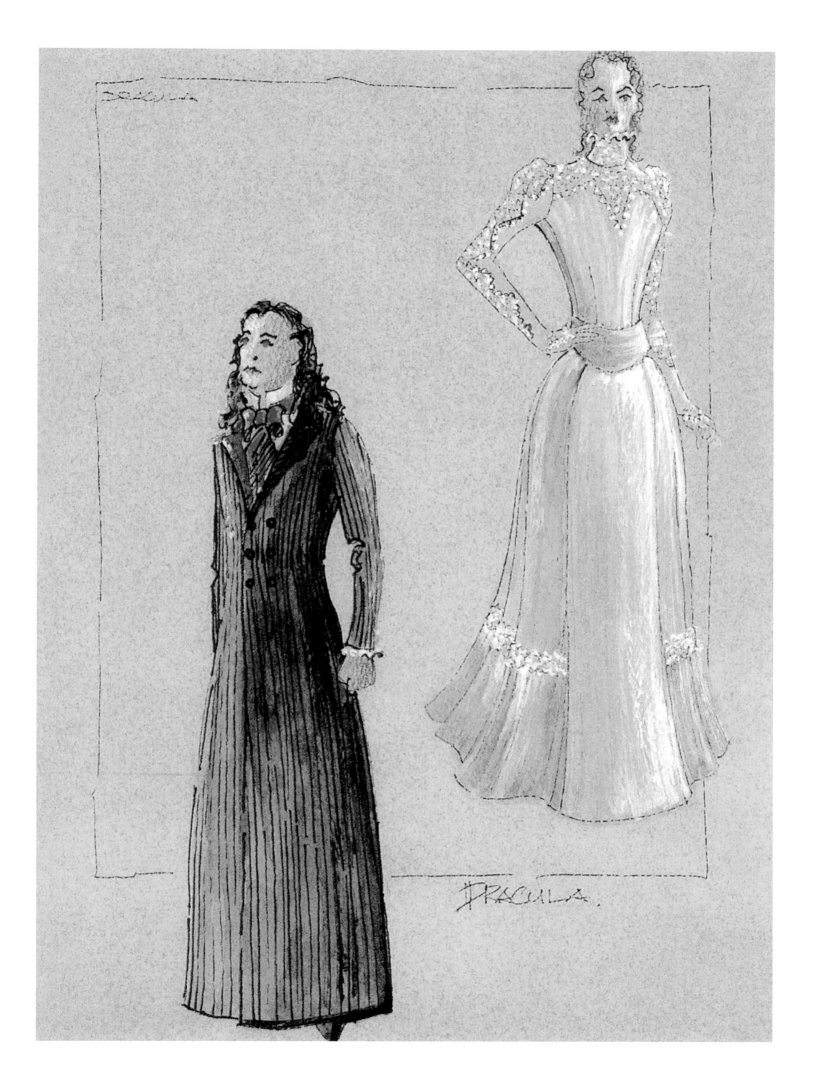

DRACULA.

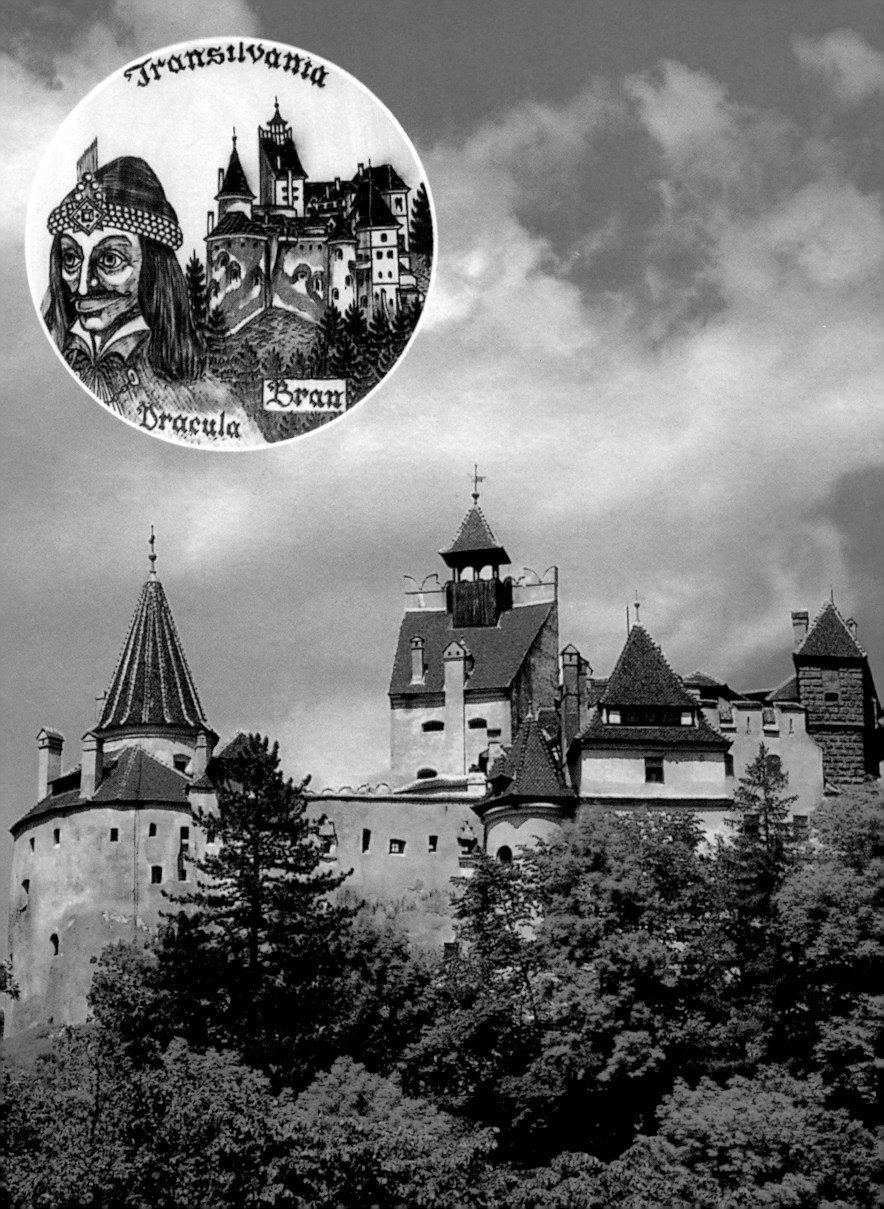

Transilvania

Dracula

Bran

THE DRACULAS IN ROMANIA

Not surprisingly, the "vampirization" of Vlad has been met in Romania with a mixed response, ranging from amusement to indignation. Sporadic interest in Vlad had continued throughout the first several decades of the twentieth century; for example, the poem *Vlad Tepes* by Tudor Arghezi (1940), the short story *Soimul* by Radu Theodoru (1967) and Georgina Viorica Rogoz' novel Vlad, fiul Dracului (1970) maintained the sympathetic image of the Wallachian voivode.

But it was the decade of the 1970s that saw the most significant output. Part of this was no doubt motivated by a desire to counteract the association made by Florescu and McNally between the historical hero and a supernatural vampire. This, however, was only one factor. By the early 1970s, Communist dictator Nicolae Ceaucescu had consolidated his power in Romania and was developing a clearly nationalistic policy.

He revived elements of traditional Romanian nationalism, coupled with a xenophobia which targeted (among others) ethnic Hungarians and gypsies. Included were constant references to the great heroes of the past, one of whom was Vlad, whom he elevated to a place of honour. The prevailing view was that, while Vlad was ruthless (few will deny that), his ruthlessness was necessary under the circumstances in which he found himself and in this respect he was little different from other contemporary leaders in Europe.

A number of historical articles and books about Vlad appeared in Romania in the 1970s, especially in 1976, when the country commemorated the 500th anniversary of his death. Perhaps the most interesting publication, in that it directly addresses the Stoker connection, is a book by Nicolae Stoicescu entitled *Vlad Tepes* (1976).

125 Bran Castle.

 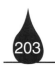

Stoicescu clearly expresses resentment about how the historical figure of Dracula has been appropriated by the West and converted into a popular horror icon:

"Whoever knows something about Vlad Tepes may smile on reading such nonsense, but this nonsense ascribed to *Dracula* [the novel] is highly popular and overshadows the true image of the Prince of Walachia".

126 A Romanian postage stamp bearing the portrait of Vlad Tepes, 1959.

"Those," continues Stoicescu, "who would like to go on cultivating Dracula the vampire are free to do it without, however, forgetting that he has nothing in common with the Romanian history where the real Vlad Tepes whom we know by his deeds holds a place of honour". Stoicescu takes great pains to separate Vlad not only from the Dracula legend of the decadent West, but from the highly propagandistic accounts in the fifteenth-century German texts.

Writing of the Brasov atrocities, he declares that Vlad did what was customary in his time "to ensure the freedom of his country's trade, and ... to remove the claimants to his throne who had been given shelter in Transylvania and punish their supporters".

During the 1970s, the Communist government also undertook many practical projects to reinforce Vlad's reputation as a national hero: the erection of statues, the naming of streets, the issuing of a commemorative postage stamp and the restoration of the Poenari fortress. In 1978, a feature movie entitled *Vlad Tepes* was produced which, according to Stoicescu, "portrays the true personality of a great prince". With strong political overtones, it comprises thinly veiled parallels between Vlad's political and military policies and the position taken by the Communist Party with respect to nationalism, the aristocracy, foreigners and the maintenance of law and order.

As for Count Dracula, the fictional vampire was practically unknown in Romania until the fall of Communism in 1989. While there were a few concessions made to Western tourists who came to the country during the 1970s in search of the vampire Count, Stoker's novel and the movies based on it were not available. However, since 1989 that has started to change.

In 1991, *Dracula* was finally translated into Romanian. That same year saw the founding of the Transylvania Society of Dracula, an international organization of scholars and researchers dedicated to the study of both Draculas.

Folklorists, historians and literary scholars from around the world meet regularly to share their findings and exchange views on Stoker's Dracula as well as Vlad Tepes.

127 A statue of Vlad Tepes in Romania.

DRACULA TOURISM

Romania is the centre of Dracula tourism. But this has created an interesting dilemma for Romanians: how to accommodate this demand while at the same time keeping clear the distinction between the fictional vampire and their own national hero. It is no easy task. Confronted with hundreds of Western tourists who visit Transylvania because of an interest in Count Dracula, Romanians are faced with a challenge: how to cope with the invasion of a "native son" who was never theirs to begin with. Sometimes confusion results.

For example, how have officials dealt with the inevitable request by tourists to visit "Castle Dracula." For years, they have been repeatedly taken to the wrong place – to Bran Castle. This edifice, located not far from Brasov, is a magnificent thirteenth-century castle that certainly looks sufficiently Gothic. It has, however, absolutely nothing to do with the Dracula of Stoker's novel and very little connection with the historical figure. After the publication of *In Search of Dracula*, the term "Castle Dracula" began to be applied by some to Vlad's fortress at Poenari. But that name is misleading, given that it is never used locally, and further blurs the distinction between the prince and the vampire. Where, then, is Castle Dracula?

In Stoker's novel it is located in the Borgo Pass, in the mountains east of Bistria.

It was, of course, a figment of the Irish author's imagination, augmented by an obscure notation on an old map. But today, especially for those tourists who want to experience the fictional Dracula, the Castle Dracula Hotel awaits them. Opened in the early 1980s, it offers a panoramic view of meadows, forested slopes and distant mountains. More important for Western tourists on the Dracula trail, it is located in the region selected by Bram Stoker.

128 Roy Thomas
and Esteban Maroto,
Dracula : Vlad the Impaler,
March 1993. Topps Comics.

Many Romanians are concerned about promoting their country as "Draculand." And with good reason! Tour guides have to contend with uninformed tourists who insist that Vlad Dracula was a vampire and that Count Dracula is buried at Snagov [27]. This, however, can be handled by providing informed tour guides who are well versed in both Draculas.

The most successful tours are those conducted by informed guides who take visitors to sites associated with both the historical voivode (his birthplace in Sighisoara, his palace at Târgoviste, the ruins of his fortress at Poenari, the Old Court in Bucharest and his presumed place of burial at Snagov Monastery) and the fictional vampire of *Stoker's Dracula* (Bistria and the Borgo Pass) – and who know the difference.

129 Bucarest 98. Contemporary postcard.

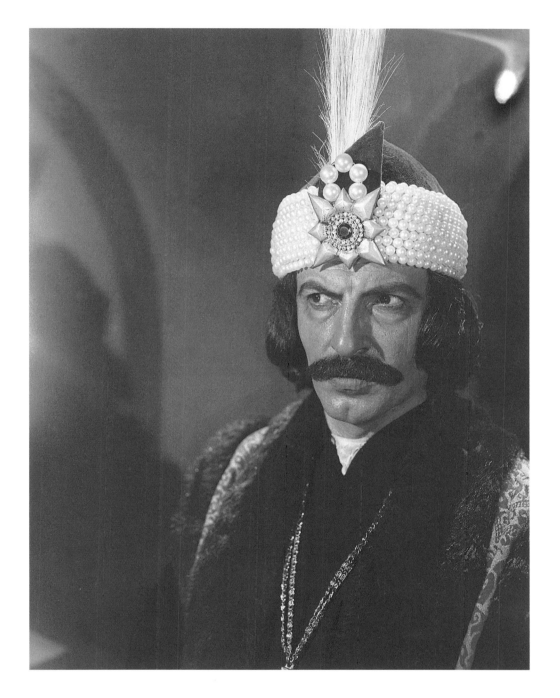

There is no doubt whatsoever that interest in Vlad Dracula in the West is directly connected with the popularity of Stoker's novel (both the book itself and its offsprings).

Yet Vlad is much more than just the historical figure whose name was appropriated for the world's most famous literary vampire. He is a significant figure in Romanian history.

130 _Vlad Tepes_ in a Romanian movie (Doru Nastase), 1979.

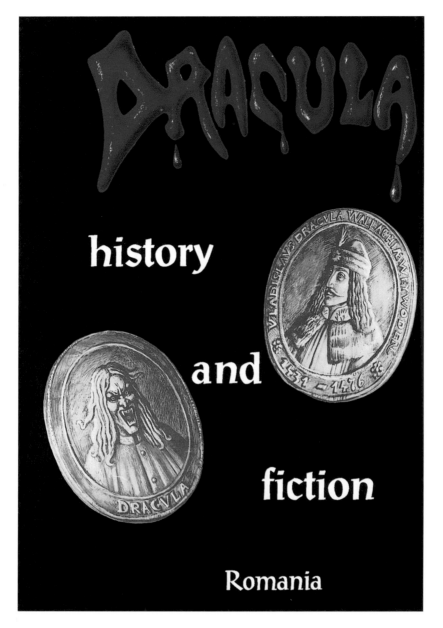

Though many Westerners are baffled that a man whose political and military career was as steeped in blood as was that of Vlad Dracula, the fact remains that for many Romanians he is an icon of heroism and national pride. It is this duality that is part of his appeal.

Romania is not the only destination for Dracula enthusiasts. For those whose interest focuses more on Bram Stoker and his novel, the town of Whitby is a major attraction.

Not only was Stoker familiar with the town (he conducted some of his research for Dracula while there), it plays a prominent role in the novel. Whitby is where the ship bringing Dracula to England runs aground;

131 Vlad The Prince and Vlad The Impaler, cover of a tourist brochure.

Whitby is where the Count comes ashore in the form of a large dog; Whitby is where Lucy Westenra first encounters the vampire in the graveyard. Today, with the impressive ruins of Whitby Abbey in the background, the town looks much as it did in the 1890s.

Local tourist officials offer visitors a map of a "Dracula trail," and have dedicated a park bench to Bram Stoker and his famous novel. Also recognizing Stoker after decades of neglect is the city of Dublin, which now includes within its boundaries the place where Stoker was born – Clontarf. Due in large part to the efforts of the Bram Stoker Society and the Bram Stoker International Summer School, the author of *Dracula* is finally being given the acclaim that he deserves in the land of his birth.

132 Hotel Castle Dracula, Bistrita-Nasaud, Romania.

THE EVER-WIDENING CIRCLE

Why has *Dracula* endured? What is there about this particular novel that has enabled it to become a cultural icon? This is a complex matter. Almost everyone in the Western world has heard of Dracula, whether he or she has read Bram Stoker's opus or not. Indeed, Jan Perkowski points out that "Dracula the Vampire has achieved a separate existence beyond the confines of Stoker's novel" and now functions in an "antithetical opposition" to Santa Claus.

What has enabled Dracula to flourish to such an extent that many people now consider it a "classic"? On one level, it is only a horror story about a vampire, but if it were no more than that, it would not have remained in print for more than a century, nor would it have inspired hundreds of novels, stories, movies and a plethora of merchandise.

Nineteenth-century literature is replete with sinister, foreign noblemen, but no other villain has captured the public's imagination as Count Dracula has. Part of the reason for his appeal is that he is a vampire, a supernatural creature, a monster that is capable of attracting as well as repelling. The vampire's mystique lies in its ability to evoke a response that is not entirely rational, directing itself to the darker side of our nature that we have been taught to deny. The irrational can be a frightening realm, for it houses our primal fears and anxieties. Some people feel a need to reconnect with this part of the self and horror literature such as Dracula facilitates this experience vicariously.

In the early 1990s, folklorist Norine Dresser conducted a survey to ascertain the reasons for the popularity of vampires in contemporary America. She found that "almost everyone knew what they were and could accurately describe their characteristics".

133 The Emblem of the first World Dracula Congress in Romania, May 1995.

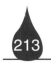

She posed the question, "What do you believe accounts for the appeal of the vampire – for yourself and for others?"

The most frequent response was sexuality and eroticism. While some believe that this is dangerous because it may encourage unhealthy desires, others see it as a healthy way of releasing hidden passions and fantasies. We are also fascinated by beings who transcend our human limitations, even when their success involves a Faustian pact with the devil. The vampire's power over the natural order is most evident in its promise of immortality. Although death is inevitable, a Promethean spark within us seeks to transcend all limitations. We try to perpetuate ourselves through our work or our offspring, or we seek comfort in the promises of religion.

But for many people today, traditional religions no longer offer satisfactory explanations of why we are born, why we die, or what happens to us after death. The vampire, who has faced death and survived, presents an alternative to traditional religious beliefs about life after death.

Part of the fascination with vampires comes not from a fascination with death or a denial of it, but from a love of life and a longing for youth and vitality in a society that places a premium on youth and beauty. Part of the fascination may include Western society's love affair with the image of the outlaw.

As "a spectre that frequently rises at the boundaries of social, religious and sexual conformity" the vampire appeals to the non-conformist as well as the alienated. For some, the vampire's appeal is rooted in a desire to taste "forbidden fruit." Christianity often associates the supernatural with the powers of evil.

In this context, communing with vampires becomes a vicarious pact with the forces of darkness in which the vampire serves as a spirit guide to the underworld of the self. The vampire serves to challenge the way we perceive the world and ourselves because of the feelings of ambivalence it inspires in us.

Little wonder it maintains its power and influence.

Though interest in vampires has expanded far beyond the pages of Stoker's novel, Dracula still stands at the centre of that supernatural world. The novel, which interfaces with every major discipline in the arts and humanities, has left an indelible mark. Its combination of universality and versatility is almost unprecedented in the annals of literature. What Stoker's character Abraham Van Helsing says of the spread of vampirism is a valid commentary on the phenomenal impact of the novel itself: "And so the circle goes on ever widening, like the ripples from a stone thrown in the water".

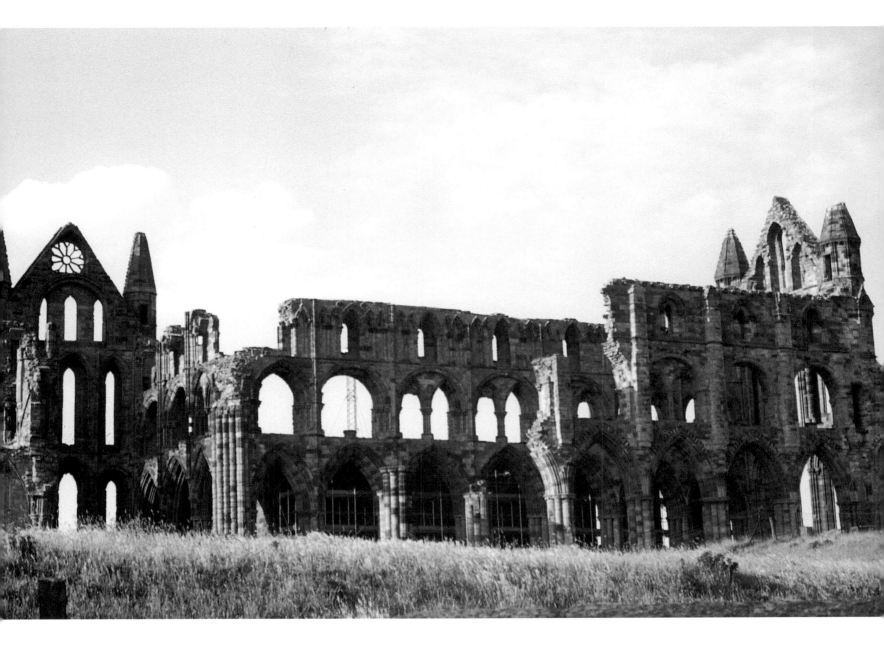

134 Ruins of Whitby Abbey,
XIIth century, England.

PICTURE LIST

NOTES

NOTES

1 For detailed accounts of these sources, including the excerpts quoted in this chapter, see Raymond McNally and Radu Florescu, *In Search of Dracula* (revised edition), Boston: Houghton Mifflin, 1994; Radu Florescu and Raymond McNally, Dracula: *Prince of Many Faces*, Boston: Little, Brown, 1989; Kurt Treptow (ed), Dracula: *Essays on the life and times of Vlad Tepes*, New York: Columbia UP, 1991.

2 Most of the extant copies reside in European libraries and museums, including Landesbibliothek (Weimar), Landesbibliothek (Stuttgart), Bayerische Staatsbibliothek (Munich), Biblioteca Academiei Romane (Bucharest), Kongelige Bibliotek (Copenhagen), and the British Museum (London). One (Nuremberg 1488) has found its way to the Rosenbach Museum & Library in the American city of Philadelphia.

3 For details, see Melton 86-88, 164-66; and Introvigne 118-36.

4 Treatise on Vampires and Revenants: *The Phantom World* is the title of a recent edition (Desert Island Books, 1993). A translation of Dom Augustin Calmet's original title is Dissertation on those Persons who Return to Earth Bodily, the *Excommunicated, the Oupires or Vampires, Vroucolacas*, etc., while the English translation of 1850 is entitled *The Phantom World*; or, the *Philosophy of Spirits*, Apparitions etc. His book went through two French editions in 1746 and 1749, and then the third of 1751 *appeared under a new title Traité sur les Apparitions des ésprits et sur les vampires ou les Revenans de Hongrie, de Moravie, etc.*. It appeared in a German edition in 1752 and an English edition in 1759 (reprinted in 1850 as *The Phantom World*).

5 A full account of several such cases reported in new England is provided by Christopher Rondina in Vampire Legends of Rhode Island..

6 In 1820 alone, six other vampire plays (ranging from serious to burlesque) appeared on the Paris stage, including "Le Vampire" (a vaudeville farce by Eugène Scribe), "Les Trois Vampires" (Brazier, Lurieu & d'Artois de Bournnonville) and B.L. Emile's "Encore un Vampire." For a complete listing as well as analysis of this phenomenon, see Roxana Stuart, Stage Blood: Vampires of the 19th-century stage.

7 Though "Carmilla" has been eclipsed by Dracula, it has had some impact. Movies based on the tale include *Et Mourir de Plaisir* (also released as *Blood and Roses*) 1961, directed by Roger Vadim and *The Vampire Lovers* (a 1970 Hammer film starring Ingrid Pitt).

8 Among his friends and acquaintances were Alfred Lord Tennyson, William Gladstone, Richard Burton, Franz Liszt, Mark Twain and Walt Whitman.

9 Such speculation includes: that Stoker was in love with Irving; that Stoker's hero-worship was accompanied by fear and resentment and that Count Dracula is in reality Stoker's representation of Irving as metaphorical vampire.

NOTES

10 Several of Stoker's works, long out of print, have been reissued by the Dracula Library of Desert Island Books, a British publishing company. Among their recent titles are: *The Jewel of Seven Stars, The Primrose Path, The Lady of the Shroud, Snowbound: The Record of a Theatrical Touring Party, The Shoulder of Shasta* and *A Glimpse of America.*

11 The nature of its composition, along with what appears to have been Stoker's somewhat cavalier attitude towards careful editing, might account for the significant number of inconsistencies in the text of Dracula. These range from minor discrepancies (a sudden change in the colour of a character's hair) to major contradictions (such as the failure to employ the oft-repeated means of destroying the Count).

12 For details on the reception of Dracula in 1897, see Barbara Belford, *Bram Stoker: A Biography of the Author of Dracula* and Carol A. Senf, *The Critical Response to Bram Stoker.*

13 *In American Vampires*, folklorist Norine Dresser reports on a survey in which 574 students were asked where vampires come from. Half answered "Transylvania" (112). In 1994, I tried a survey of my own with a class of 40 first-year university students. Every single one of them had heard of it (though about one-third did not believe it was real); but all connected it immediately with either Count Dracula or vampires.

14 The most prominent examples include the following: William Shakespeare, Pericles (IV, ii); Captain John Smith, *The True Travels. Adventures and Observations* (1630); John Milton, *Areopagitica* (1664); Robert Browning's poem The Pied Piper of Hamelin (1842).

15 In fact, earlier accounts of vampire legends make scant references to Transylvania. Calmet's *Treatise on Vampires and Revenants* mentions it only once; by contrast, it includes many stories from Hungary, Poland, Moravia, Silesia and Serbia. Joseph Ennemoser's *The History of Magic* (1854) refers to Wallachia rather than Transylvania as the land "where the blood sucking vampire hovered the longest, a superstition of the most revolting kind" (qtd in Farson 124). Montague Summers notes in *The Vampire in Europe* that Hungary had the reputation of being a region that is "most terribly infested by the Vampire and where he is seen at his ugliest and worst" (132).

16 All quotations from Dracula are taken from *Dracula Unearthed*, edited and annotated by Clive Leatherdale.

17 And there are many. That Vlad the Impaler was the "inspiration" for Count Dracula is for most a "given." Various scholars make claims (all speculative) about what Stoker knew about Vlad and how he found the information: that the source was a Hungarian professor named Arminius Vambery; that Stoker found one of the German pamphlets that was housed at the British Museum; that he saw one of the woodcut portraits; that he read the report of the papal legate; that he somehow had access to Beheim's poem.

NOTES

There is no conclusive evidence to support any of these claims. For a detailed analysis of this matter, see Chapter 5 of my book Dracula: *Sense & Nonsense* (Westcliff-on-Sea: Desert Island Books, 2000).

18 Contrary to popular perception, Count Dracula is able to function during the daytime – at least in Bram Stoker's novel – though he loses his supernatural strengths. That Dracula must avoid the sunlight at all costs is an invention of the cinema.

19 One of the most perplexing inconsistencies in the novel centres on the method used to destroy Count Dracula. Even though Van Helsing and others insist that a wooden stake must be driven through his heart, when the time comes the Count is dispatched with two knives.
Explanations for this departure range from carelessness on Stoker's part to his intention to write a sequel.

20 While the first film based on Dracula – *Nosferatu* (1922) – did not feature bats, the 1931 classic Universal Studios Dracula starring Bela Lugosi certainly did. This was the movie that provided the twentieth century with its most enduring images of Count Dracula – bats included –- images that survive to this day. In many film versions (unlike the novel) vampire bats are permanent residents of Castle Dracula and, of course, are of Transylvanian vintage.

21 The academic climate had to change before Dracula could be taken seriously. For one thing, there has been a shift in the attitude towards "formula" literature, away from the perception that it is inferior to the concession that it encodes its own purposes and justification. The postmodernist challenge of the traditional literary canon has been accompanied by a reluctance to elevate one type of literature over another. This has had a marked impact on the study of Gothic literature in general and of Dracula in particular.

22 Numerous literary critics have focused on psychosexual readings. See, for example, the following essays in Margaret L. Carter (ed), Dracula: *The Vampire and the Critics* (Ann Arbor: UMI Press, 1988): Christopher Bentley, *"The Monster in the Bedroom: Sexual Symbolism in Bram Stoker's Dracula"*; Christopher Craft, *"Kiss Me with Those Red Lips: Gender and Inversion in Bram Stoker's Dracula"*; and Phyllis Roth, *"Suddenly Sexual Women in Bram Stoker's Dracula."* Count Dracula has been seen as representing the violation of every Victorian sexual taboo: non-procreative sexuality, abnormal sexuality, fellatio, bisexuality, incest and the abuse of children.

23 Impressions left by the movie versions of Dracula have been so strong that for many, they have taken the place of the novel. Some oft-quoted lines attributed to Stoker have no precedent in the novel: "I never drink - wine" and "I want to drink your blood" - neither of which appear in the novel.

24 Two earlier film versions are frequently mentioned: a 1920 black-and-white from Russia and a 1921 from Hungary. No copies of either survive. For a detailed analysis of the major films based on Dracula, see David J. Skal, Hollywood Gothic and James Craig Holte, *Dracula in the Dark.*

NOTES

25 Much has been written of what Stoker may have learned from Vambery. Claims have been made that the Hungarian professor supplied Stoker with information on Transylvania, vampire lore and Vlad himself; some suggest that Vambery may even have introduced Stoker to some of the fifteenth-century materials about Vlad.

But all of this is speculation based on circumstantial evidence. We do know that the two met at least twice. While we do have a record of these meetings (Stoker refers to both in his 1906 book, *Personal Reminiscences of Henry Irving*), there is nothing to indicate that the conversation included Vlad, vampires or even Transylvania.

Furthermore, there is no record of any other correspondence between Stoker and Vambery, nor is Vambery mentioned in Stoker's notes for Dracula.

As for the theory that what Van Helsing in the novel learns from Arminius (generally seen as a tribute to Vambery) parallels what Stoker himself gleaned from Vambery, just about every scrap of this material can readily be traced to Stoker's known sources. While Stoker did conduct some research at the British Museum, there is no evidence to indicate that he discovered further material about the historical Dracula.

26 Investigations into possible connections between the Count and the Voivode began before the publication of *In Search of Dracula*. In 1958, Bacil Kirtley stated that "Unquestionably the historical past that Van Helsing assigns the fictional vampire Dracula is that of Vlad Tepes, Voivod of Wallachia" (14).

In 1962, Stoker's first biographer, Harry Ludlam, asserted that Stoker had "discovered that the Voivode Drakula or Dracula had earned for himself the title of 'the Impaler,' and that the story of his ferocity and hair-raising cruelty in defiance of the Turks was related at length in two fifteenth-century manuscripts, one of which spoke of him as 'wampyr'" (113).

In 1966, Grigore Nandris connected the vampire Dracula with the historical figure.

He even claimed that available portraits of Vlad were "adapted by Bram Stoker to suit his literary purposes" (375).

27 At times, local entrepreneurs give in to the temptation to trivialize their history and culture in order to cater to the visitors. During my visits to Romania, I have seen a number of examples of this crass commercialism.

A salesperson in the medieval square of Sighisoara was selling small portraits of Vlad with fangs and who was quoted in a local paper as saying "I sell it only to foreigners – Romanians would be angry."

In other locations one can find questionable souvenirs.

I saw a postcard of Bran Castle (labelled "Dracula's Castle") complete with a small icon of a Western-style vampire with widow's peak and black cape who is superimposed on the photograph of the castle as if welcoming unsuspecting tourists.

Even worse, at Bran Castle itself I found a T-shirt depicting Vlad with fangs extended, leaning over a bare-breasted and willing female victim. Equally tacky is the decision of at least one tour group to offer a Halloween party at "Casa Vlad Dracul" (Vlad's birth house) in Sighisoara.

Such promotion flies in the face of both history and culture, and serves only to exacerbate the resentment that many Romanians already feel about Dracula-centred tourism.

BIBLIOGRAPHY

B. Belford, *Bram Stoker: A Bibliography of the*
 Author of Dracula,
 New York, Knopf, 1996.

G. Byron, *Dracula,* Mcmillan Press Ltd, 1998.

M. L. Carter, *Dracula: The Vampire and the Critics,*
 Ann Arbor: UMI Press, 1988.

F. F. Coppola, *Bram Stoker's Dracula:*
 The Film and the Legend, 1992.

J. Ennemoser, *The History of Magic,* 1854.

D. Farson, *The Man Who Wrote Dracula:*
 A Biography of Bram Stoker, 1996.

C. Frayling, *Vampyres: Lord Byron to Count Dracula,*
 London, Faber and Faber, 1991.

C. Leatherdale, *Bram Stoker's "Dracula" Unearthed,*
 Westcliff-on-sea: Desert Island Books, 1998.

C. Leatherdale, *Dracula: The Novel and the Legend -*
 A Study of Bram Stoker's
 Gothic Masterpiece, 1993.

R. Mc Nally
et R. Florescu,

In Search of Dracula: History of Dracula and Vampires, Boston, New York, Houghton Mifflin Company, 1994.

R. McNally
et R. Florescu,

Dracula: Prince of Many Faces, Boston: Little Brown, 1989.

E. Miller,

Dracula: Sense & Nonsense, Westcliff-on-Sea: Desert Island Books,

2000.

E. Miller,

Dracula: The Shade and the Shadow, 1998.

P. J. Riley et al. ,

Dracula: The Original 1931 Shooting Script, 1990.

C. Seignolle,

Histoires et Légendes du Diable, Tchou Editeur, 1973.

D. J. Skal,

V is for Vampire: the A to Z guide to everything undead, Plume Books, 1996.

B. Stoker,

Personal Reminiscences of Henry Irving, 1906.

R. Stuart,

Stage Blood: Vampires of the 19th century stage, Bowling Green: Bowling Green State UP, 1994.

K. Treptow,

Dracula: Essays on the life and times of Vlad Tepes, New York: Columbia UP, 1991.

L. Wolf,
C. H.Bing (illustrator),

The Essential Dracula/Including the Complete Novel by Bram Stoker: Notes, Biblioggraphy and Filmography Revised, 1993.